RODIN

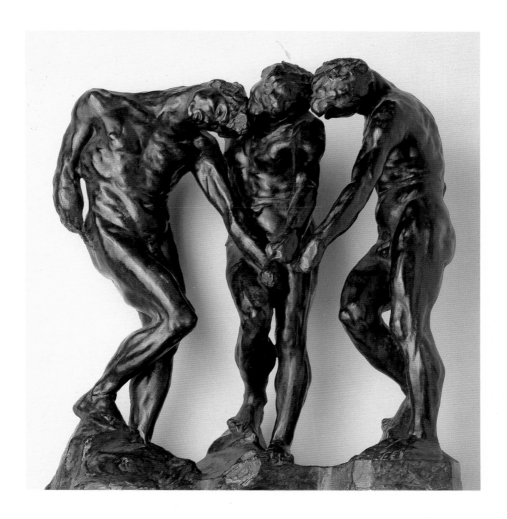

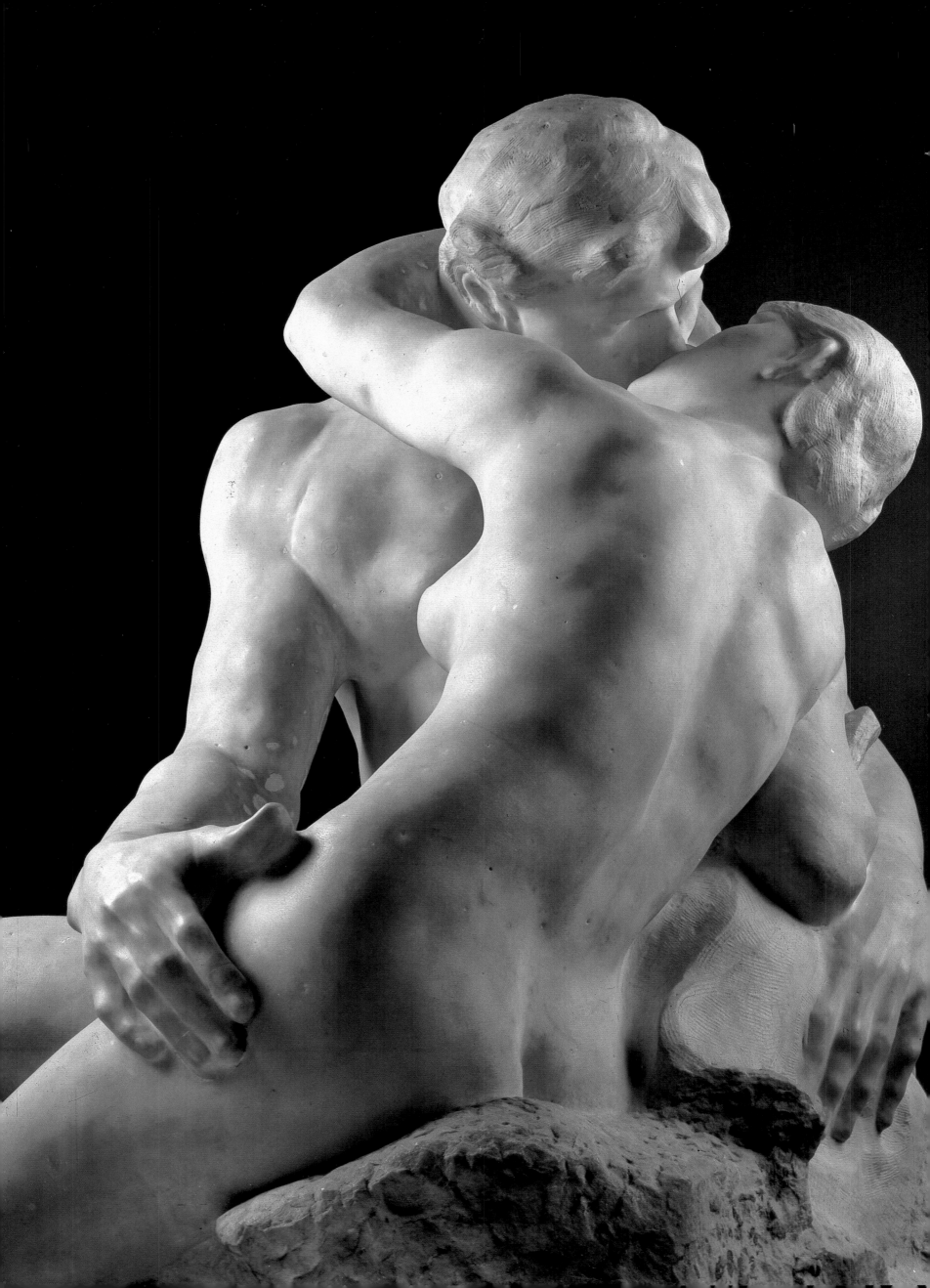

RODIN

TIM MARLOW

SMITHMARK

This edition published in 1992
by SMITHMARK Publishers Inc.
16 East 32nd Street
New York, New York 10016.

SMITHMARK books are available for bulk
purchase for sales promotion and premium
use. For details write or telephone the
Manager of Special Sales, SMITHMARK
Publishers Inc., 16 East 32nd Street, New
York, NY 10016, (212) 532 6600

Produced by Brompton Books Corp.,
15 Sherwood Place,
Greenwich, CT 06830

ISBN 0-8316-7433-9

Printed and bound in Spain by Cayfosa, Barcelona

10 9 8 7 6 5 4 3 2 1

Page 1: *The Three Shades*, 1880

Page 2: *The Kiss* (detail), 1886

Contents and List of Plates

Introduction

There is a compelling tendency in any study of a great artist to focus on the idea of greatness through originality; of a challenge to existing values. This is particularly true of the avant garde in the late nineteenth century, struggling to emerge in the face of a rigid, academic orthodoxy. In many respects the career of Auguste Rodin has come to encapsulate that struggle: Rodin, a giant of a man, both artistically and physically, is widely perceived to be the 'father of modern sculpture' who shattered the canons of a sculptural tradition which could be traced back to classical Greece and Rome and who paved the

way for a radical reinvention of sculptural practice and ideology in the twentieth century. In some respects these claims can be upheld, for Rodin did indeed attack the essentially neo-classical values of the Académie Française. In much of Rodin's work idealized notions of beauty give way to vivid, candid realism, even ugliness (in some people's eyes); static monumentality and completeness allied with a stylized unity give way in some of his later work to dynamic clay 'sketches,' often fragmentary and deformed yet presented in exhibitions as finished works. There is little doubt that Rodin's art comes closer to ex-

pressing pure and deeply personalized feeling than anything that preceded it in the history of Western art. Nonetheless he remains strangely rooted in the French acadmic tradition: indeed, he was elected to the Académie Française, although ironically, the official vote was cast a few days after his death. Fundamentally, however, Rodin remained an heir to the Romantic movement, an artist much of whose subject matter – inspiration, passion and heroism – was derived from the prevailing ethos of early-nineteenth-century art.

Unlike many contemporary painters, notably the Impressionists, whose art developed largely independent of official recognition, Rodin relied heavily on state and municipal commissions. Indeed many of his greatest and most radical works emerged under the aegis of official patronage. This is not to undermine his achievements or his genius, rather it serves to highlight a fundamental difference between Rodin and certain major early-twentieth-century artists. Picasso and other pioneering modernists attempted an almost primitive reinvention of artistic practice, whereas Rodin operated far more in the context of restoring and then re-evaluating official art. As he wrote towards the end of his life: 'it is not thinking with the primitive ingenuity of childhood that is most difficult, but to think with tradition, with its acquired forms and with all the accumulated wealth of its thought.'

François-Auguste-René Rodin was born in Paris on 12 November 1840, the same year, as art historians love to point out, in which Monet was born and a year after Sisley and Cézanne. His father, Jean-Baptiste, was a minor official at the Prefecture of Police who had moved to Paris with his second wife, Marie, around 1830, along with a whole host of provincial migrants attracted to the capital after its first major period of industrialization. The family, which also included a girl, Maria, who was born in 1838, two years before Rodin, were devout Catholics with petit-bourgeois aspirations. Rodin himself remained a self-proclaimed member of the working class all his life. He came to believe essentially in a secular republican society, a view which was in tune with the

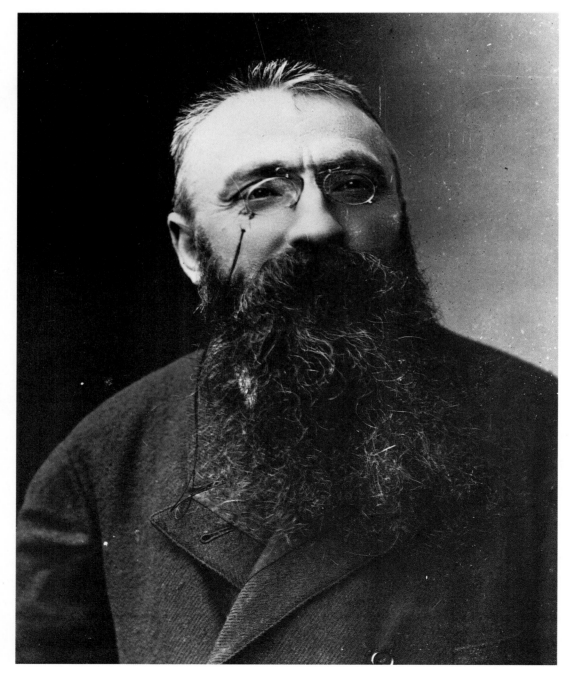

social and political developments in Paris after the proclamation of the Second Republic in 1848, realized more fully in the Parisian Commune of 1871 and the subsequent development of the Third Republic in the 1870s. His early education, however, was at the Roman Catholic Ecoles Chrétiennes near the Val de Grace in the Latin Quarter of the city. He was not gifted academically: in fact at the age of eleven his family sent him off to an uncle's boarding school at Beauvais to improve his appalling command of reading and writing. After three unhappy years he returned to his family in Paris. Years later in a letter to a friend he wrote: 'you know that I am no scholar, and that having to write and speak embarrasses me; clay and pencils are my natural means of expression.' Back in 1854 he had yet to encounter the joys of modelling in clay, but he drew prolifically and with an obsessive enthusiasm on any paper he could lay hands on, even the magazine pages in which his mother's grocer wrapped prunes.

The story of his adolescence has a familiar ring to it: a boy bored by his academic studies who has a certain talent for drawing decides that he wants to become an artist, much to the dismay of his family who think it a dangerous and thoroughly unsuitable vocation. Finally, with grudging acceptance of the inevitable, they acquiesce.

Rodin enrolled at the Ecole Imperiale Spéciale de Dessin et de Mathémathiques, otherwise known as the 'Petite Ecole' in the fall of 1854 and began a three-year program learning not only the rudiments of drawing, but also the skills of craftsmanship, from jewelry-making to interior decoration. In other words, the training was as much for artisans as for would-be artists. This is a significant factor in the years immediately ensuing when Rodin relied heavily on a basic craftsmanship to earn a living while simultaneously trying to develop as a fully fledged sculptor. Later Rodin said of the Petite Ecole:

They had preserved a little of the eighteenth century . . . good antique models and excellent teachers. The years at the Petite Ecole were the germinating [period] of my life, where my own nature planted itself on a firm ground without hindrance . . . where I received the only instruction of my life.

It was thus that the myth of the self-taught artist emerged.

Instruction at the Petite Ecole was given both by craftsmen and by practicing artists. These included the sculptor, Jean-Baptist Carpeaux, and the architect Viollet-le-Duc, who was working on restoring the stone carvings on the West front of Notre Dame as well as Horace Lecoq de Boisbaudrin who seems to have exerted the greatest influence on Rodin. Lecoq's method of teaching centered around encouraging students to draw as much from memory as from life models and antique casts. Rodin recalled his teacher's words: 'The true object of study is nature. He who takes his style from this master will attain the greatest originality.'

In attempting to capture the form and energy of a moving figure, Lecoq encouraged his students to trace the outline with their fingers in the air and then to close their eyes and repeat the exercise so as to fix the image in the mind and to feel what was to be drawn. Rodin's realization of the dominant lines of mass in much of his later work, as well as his ability to simplify form before recreating detail, can be traced in part to his early education at the Petite Ecole. This is not to say that drawing studiously from the antique was neglected; far from it, in fact, for at the age of 15 he won a bronze medal for drawing from casts. It did, however, mean that he was never slave to stylized and monolithic classical sculpture.

The next stage was to move on to three-dimensional modelling with the material which became a source of inspiration and the vehicle for so much of his sculptural exploration: clay. 'When I saw clay for the first time,' he recalled, 'I felt as if I were ascending into heaven. I made separate pieces – arms, heads, feet - then tackled an entire figure. I grasped the whole thing in a flash, and did so with as much facility as I do today. I was in transports.'

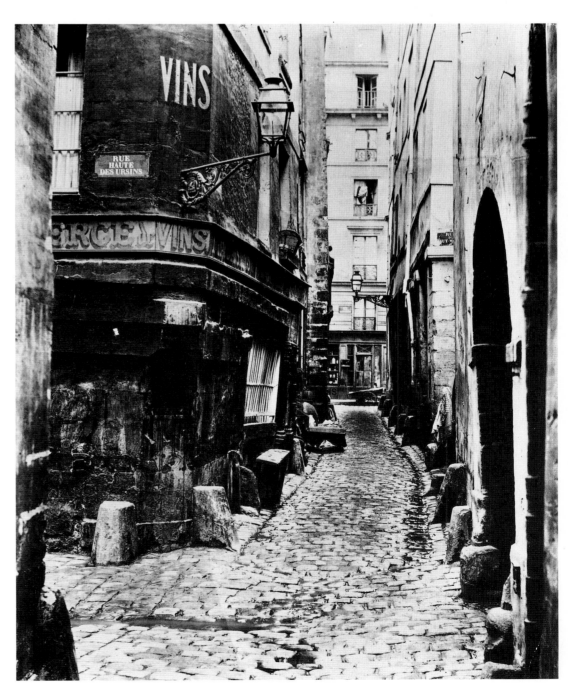

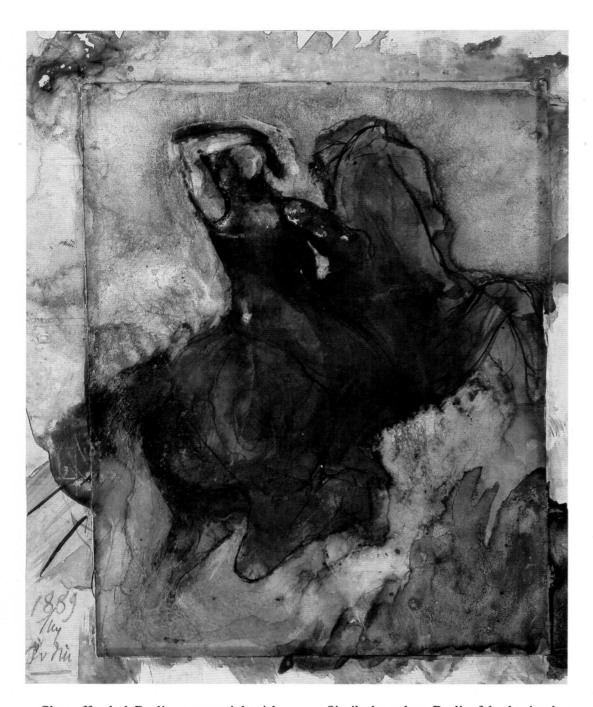

Clay afforded Rodin a material with which he could extend the practice of drawing. Its flexibility and the speed of execution which it offered enabled him to produce vast numbers of quick sketches. Throughout his later career he continued to draw and model in clay, moving from one medium to the other with little or no difficulty. Visitors to his studio in later years recalled how he would stare intensely either at his model or into space while his hands worked fast and furiously with either pencil or clay, generating images and forms. In time these became part of a vast reservoir of source material, some of which were incorporated into sculptural commissions but much of which simply lay about the studio, stimulating ideas and inducing a fecund and sympathetic atmosphere for work in his own creative sanctuary.

Similarly, when Rodin felt the inadequacies of his academic education after he began to study at the Petite Ecole and subsequently enrolled at the Collège de France to study history and literature, he began to read poetry as a source of private visual imagery. Homer, Virgil, and especially Dante together with contemporary writers such as Musset, Lamartine, and Victor Hugo were devoured voraciously, not in the manner of a literary scholar, but more intensely to generate his own ideas and more personal reflections on the human condition. It was a reservoir from which he drew long and deep in subsequent years.

Rodin's burgeoning ambition to become a sculptor had, by 1857, led him to apply three times at six-monthly intervals for admission as a sculptor student to the Grande Ecole des Beaux-Arts. Each time he was rejected. His drawings were accepted but on each occasion he failed to pass the sculpture examination, mainly it would seem, because his essentially eighteenth-century manner and taste, derived from his teachers at the Petite Ecole, did not accord with the classical taste of his examiners. Rejection was a serious blow, not least because in order to gain acceptance in the official salons and to win any significant public commissions artists had to graduate through the Grande Ecole. But it also dented his ego and instilled in him a sense of persecution which was to be exacerbated in the future. It also compounds a more recent notion that Rodin was a modern radical, rejected by the conservative establishment. While this idea may be applicable in certain instances later on, at this stage in the late 1850s it is misleading.

Sadly, none of his earliest pieces survive, save for a bronze bust of his father, made in 1860. Coolly precise and technically adequate, it represents the work of a competent craftsman learning his sculptural trade.

With the benefit of hindsight, it can be claimed that Rodin's rejection by the Grande Ecole broadened both his attitude and his technique. Forced to support himself and continue his training without formal tuition, he took a series of odd jobs which included working for a firm of decorators, Blais, Crucher, and Legrain, who taught him how to cut and carve stone and also, curiously enough, to work with precious stones as a jeweler's assistant. He also mixed plaster and removed mould marks for a sculptor called Constant Simon who taught him the art of modeling in plaster. While Rodin, his apprentice, was struggling to render a leaf in three dimensions, Simon watched him and suggested that he focus exclusively on the contour lines and then move around the plaster form until from each angle his modeling corresponded exactly with the profile of the leaf visible at that vantage point. Much later Rodin acknowledged his debt to Simon and explained how he adapted the method:

I place the model in such a way that it stands out against the background and so that the light falls on the profile. I execute it, and move both my turntable and that of the model, so that I can see another profile. Then I turn them again, and gradually work my way around the figure.

In many of his subsequent works, for example, *The Walking Man* and the *Torso*

of Adèle, Rodin suggests a number of contour lines in his figures. In doing so, he foreshadows the multi-perspectival viewpoint, so central to the pioneering Cubist paintings of Picasso and Braque, where figures and objects are fragmented and then reconstructed as if from a whole variety of different viewpoints, a practice which reveals something of what the artist perceives as the essential, and not just the visible form as well as suggesting a strong sense of movement and dynamic force. Here perhaps is a first glimpse of Rodin as pioneering Modernist.

In 1862 Rodin suffered the first major crisis of his life. His sister, Maria, was traumatized after the end of a painful affair with Barnouvin, one of Rodin's young painter friends. She took vows to become a nun with the Sisters of the Doctrine. Tragically, after a two-year novitiate she contracted peritonitis and after an unsuccessful and agonizing operation she died. Rodin, who had nursed her

during her last few days, was shattered and in turn entered a monastic order, the order of the Fathers of the Holy Sacrament, as brother Augustin. While the grief-stricken Rodin wrestled with the idea of a monastic vocation for over a year, the head of the order, Father Pierre-Julien Eymard considered Rodin's artistic vocation and finally persuaded him to devote his life to sculpture. His encouragement was practical as well as spiritual and he commissioned a portrait bust by the young sculptor. Father Eymard was subsequently canonised although his dealings with Rodin over the bust were not exactly saintly – he refused to pay for it, mainly on the grounds that his hair was rendered 'hornlike,' perhaps in the manner of Michelangelo's *Moses*. Nevertheless, his influence on Rodin's career is not unimportant and the work charts a growing technical accomplishment together with a moving sense of physical presence and personalized (as opposed to stylized) character.

Furthermore, the immediate consequence of Rodin's departure from the order was that he rented a studio in the rue de la Reine Blanche and worked for eighteen months on what has been described as his first sculptural masterpiece. *The Man with the Broken Nose*, originally made in plaster and then cast in bronze, exists in a fragmented form, damaged as a result of the near-freezing conditions in Rodin's studio. It was originally described as a mask. The craggy face depicted belonged to a neighborhood odd-job man called Bibi.

Although certain critics have seen in this sculpture references to Roman Republican portraiture, it is the vivid and 'lived-in' quality of Bibi's face which seems to have attracted Rodin and the

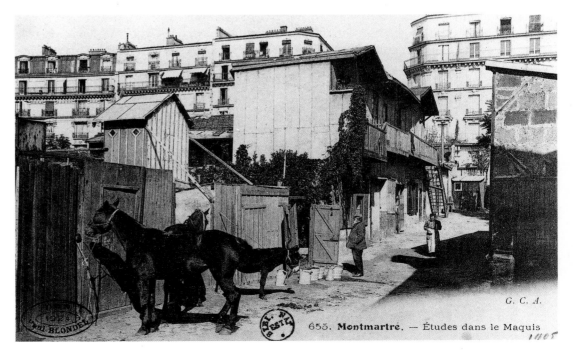

G. C. A.

655. Montmartre. — Études dans le Maquis

Below: *Portrait of AugusteRodin* by Pierre-Auguste Renoir. This lithograph was made toward the end of 1914 when Rodin traveled to the South France.

Right: A winter view down the rue St Vincent in Montmartre circa 1900.

realization of which in sculptural form is the main achievement of the work.

'He had a fine head; belonged to a fine race – in form – no matter if he was brutalized. It was made as a piece of sculpture solely and without reference to the character of the model as such. I called it *The Broken Nose*, because the face of the model was broken. The mask determined all my future work. It was the first piece of good modelling I ever did. From that time, I sought to look all around my work, to draw it well in every respect. I have kept that mask before my mind in everything I have done.'

Republican but not Roman in sentiment, the sculpture expresses the nobility in human form irrespective of social class which Rodin sought and found in his models. Here also for the first time is evidence of the shifting viewpoint and multiplicity of contour derived from Constant Simon's advice on modelling.

Rodin submitted the plaster of *The Man with the Broken Nose* to the Salon of 1864 and it was rejected. Later, however, he had it carved in marble, disguised as a Roman senator and gave it the title of *Portrait of M B* which either fooled or impressed the Salon jury of 1875. In many respects, however, the initial failure or rejection does not seem to have hurt Rodin deeply, for, at the risk of cliché, it can be said that he began to feel that his own artistic voice was emerging, a voice which would later be heard loud and clear.

In the same year, 1864, while Rodin was working on a decorative commission for the Gobelins theater, he met the woman whom he was finally to marry 52 years later, in the year that he died. Rose Beuret was a seamstress when they first met and she became Rodin's long-suffering mistress soon after, having a son by him in 1866, to whom Rodin gave only his first name. Rose was never his muse but she posed for several major works, the first of which, the life-sized *Bacchante*, was accidentally destroyed during a studio move. 'In style and modelling,' Rodin said of the lost *Bacchante* 'it was like the *Broken Nose* . . . very firmly modeled, possibly a little cold.' Other works for which she posed, notably the allegorical *Mignon* from 1867-68 and the passionate, angry *Bellona* from 1879, record what art historian Catherine Lampert has described as her 'high cheekbones, her fiery close-set eyes, and her marvellous profile.' In these sculptures there is also a feeling of tenderness which endured throughout their long relationship and which belies her unsophisticated and apparently jealous nature.

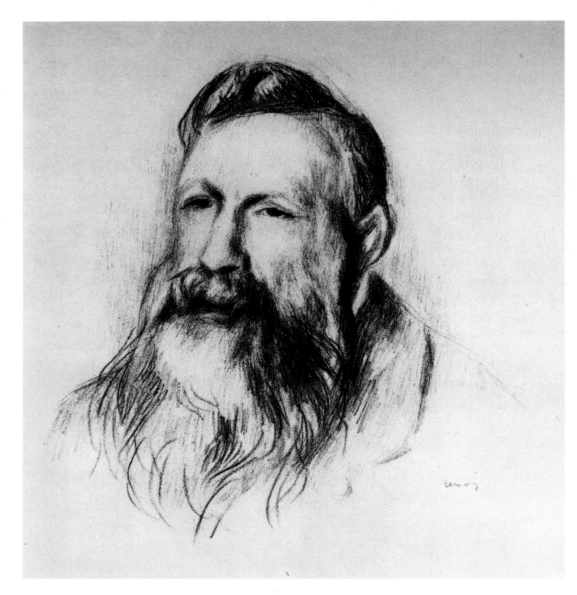

Rodin's behavior toward Rose was often lamentable, but in his letters to her and frequently to friends and acquaintances he acknowledged the importance of her unflinching devotion to him. In 1914 he still commissioned photographic portraits of her.

By the middle of 1870 France was at war with Prussia and Rodin enlisted in the army, joining the National Guard in Paris and reaching the rank of corporal. He continued to make sculpture, producing at least two portrait busts of officers of his battalion. However in 1871 he was discharged on the grounds of his myopia. This disability might, in part, help to account for his poor academic performance as a schoolboy: quite literally, he could not see the blackboard. Perhaps more significantly, it helps to explain a tendency to position himself very close to his model when working. In turn, the feeling of incredible intimacy which exists in so many of his sculptures has its origins in his short-sightedness.

Amid the social and political upheavals in Paris during the Commune of 1871,

essentially the first, if short-lived, workers' socialist uprising, employment was hard to find in general and for artists and craftsmen in particular. Thus Rodin left the city to renew a working relationship with the successful French sculptor Albert-Ernest Carrier-Belleuse in Brussels. For all his Republican sentiments, Rodin was less of a social and political animal than an artistic one. In Brussels Rodin worked on the sculptural decorations for the Palais de la Bourse. Soon, however, Rodin and Carrier-Belleuse fell out over Rodin's right to market certain small bronzes (notably two miniature busts, *Suzou* and *Daria*), which ostensibly he had made but which Carrier-Belleuse was signing and selling. This was a widespread practice and one that Rodin had encountered in the preceding decade, also with Carrier-Belleuse. However exploitative it may have been, it expanded Rodin's sculptural vocabulary and, as Catherine Lampert has pointed out, 'what Rodin had learnt about the business side of a thriving sculptor's studio would be immensely valuable later on.'

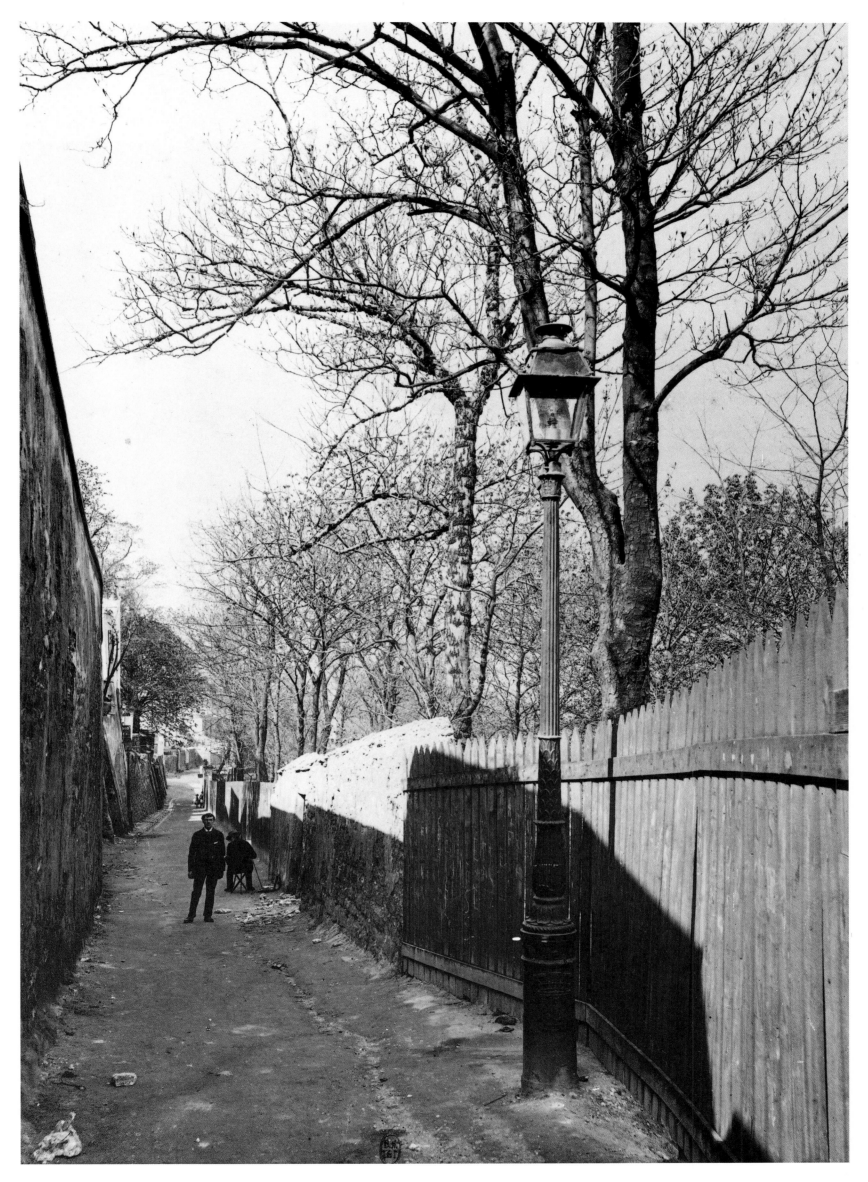

Below: *Despair*, circa 1890. Although it is barely visible from the ground, a version of this figure appears in the upper section of the left door of *The Gates of Hell*. Contorted with gloom, it is both an acrobatic and enigmatic image of woman.

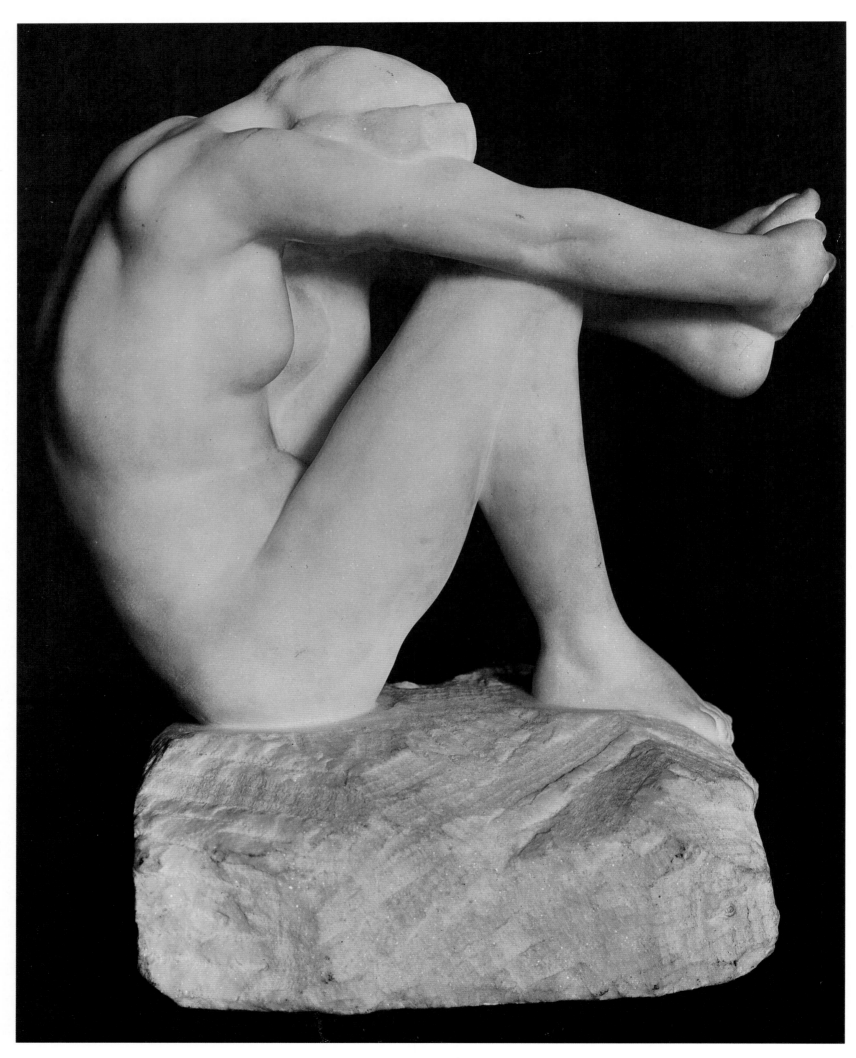

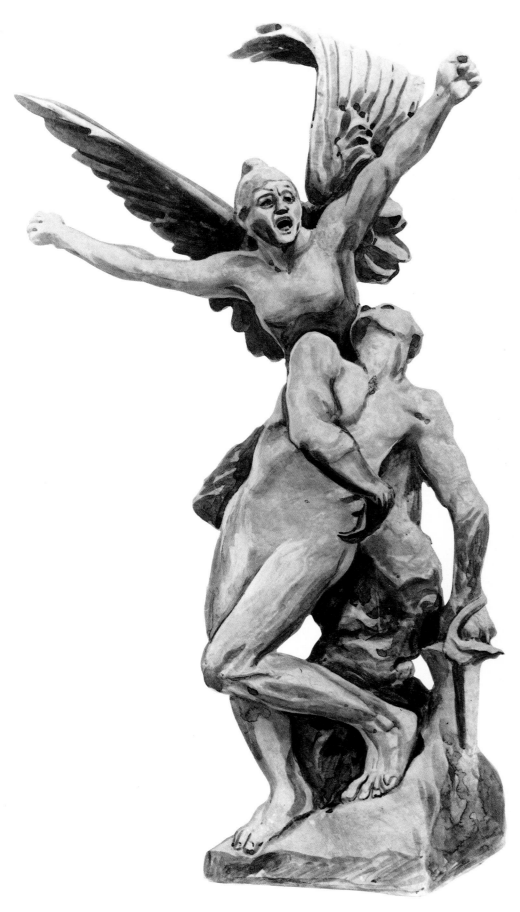

sults however, Rodin felt, suggested the work of another artist:

I worked on those figures with the greatest ardor from a decorative point of view, and it was while I was making the figure of the sailor that I was struck with its resemblance to the statues of Michelangelo, though I had not had him in mind. The impression astonished me, and I wondered what should cause it . . . My studies had been a blind search after the movement of figures, and in making this one, I was, for the first time, impressed with its resemblance to the compositions of the great Florentine. To satisfy my mind of the reality of this resemblance to confirm my hope of its depth and value, either as the result of long years of effort, or as the effect of my admiration for him, I made a lot of sketches to see if I could get the same character, but without success.

Rodin's gravitation toward the art of Michelangelo became more vivid, and indeed more literal, at the end of 1874 when he set off for Italy in anticipation of a series of exhibitions devised to celebrate the 400th anniversary of Michelangelo's death. The whole venture took him from Reims to Rome and was a voyage of discovery, as he explained to Rose in a letter from Rome.

I have received three lasting impressions: Reims, the Walls of the Alps, and the Sacristy, which one does not analyze the first time one sees it. You will not be surprised to hear that I have been working on a study of Michelangelo ever since I arrived in Florence and I believe that the great magician is letting me into some of his secrets.

Rodin remained in Brussels and went into partnership with a younger Belgian sculptor, Antoine van Rasburgh, early in 1873. In theory each sculptor was to sign the work destined for their respective countries, but arguments soon ensued and the partnership which was intended to last for twenty years fell apart after four. During this period, the partnership produced two stone groupings *Amors Presenting Trophies* and *Arts and Sciences* for the Palais des Académies, and about ten caryatids for buildings on the Boulevard Auspach, some of which are now in the Musée Rodin in Paris. In 1874 Rodin and von Rasburgh were invited to Antwerp to make a commemorative monument dedicated to a former Burgomaster, J F Loos. The project was commissioned by Julius Pecher, a wealthy ship-owner who harbored aspirations to be a sculptor and who, with the artists' consent, signed the finished work.

Nomenclature and attribution aside, the Antwerp work represented a further development in Rodin's practice and ambition, in that he was trying to make three-dimensional forms based on the two-dimensional images of Rubens, Antwerp's most famous artistic son. The re-

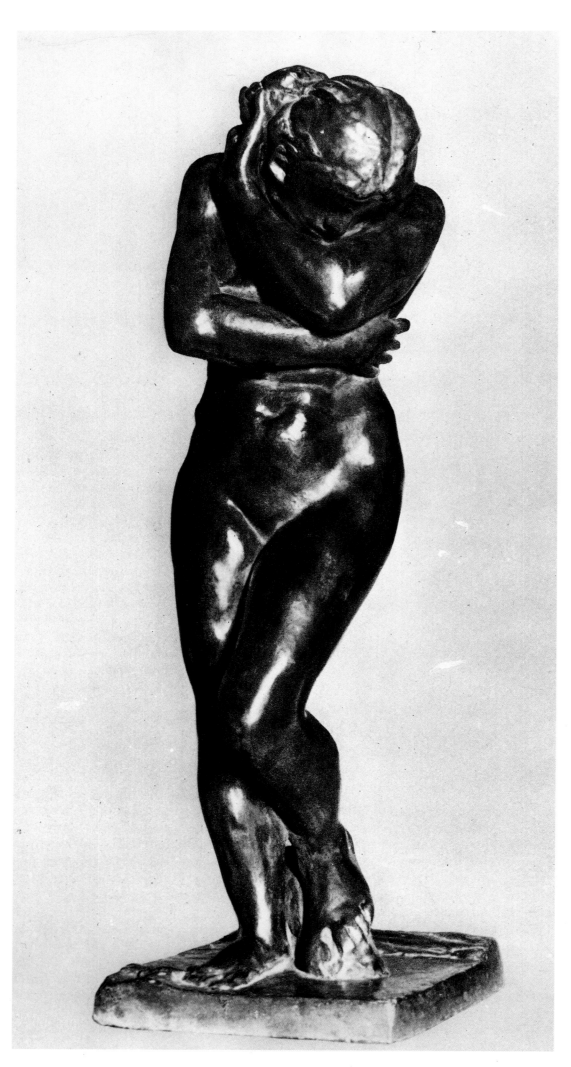

Individual works from the ancients to the Renaissance and beyond made their impact and Italy itself became what was later described as 'a series of sensual impressions,' but it was the sculpture of Donatello and the ouevre of Michelangelo which stood out above all. Rodin spent a whole week studying the 'great magician's' Medici tombs in the Sacristy of San Lorenzo in Florence by day and in the evenings he made sketches in his room 'not of his works but of figures . . . imagined and elaborated in order to understand his techniques, and doubtless, it could be added, his artistic spirit and imagination.

When Rodin returned to Brussels, three important works appear to have emerged: 'the Ugolino group,' of which there is no trace, but which was referred to frequently in early biographies, and the Danteesque theme which was soon to be taken up again to devastating effect; *Adam,* which was interrupted for several years; and finally, in 1877, a figure which became known as *The Age of Bronze.*

When the life-sized figure was first shown in Brussels soon after in the Paris Salon in May 1877 the critical response was one of admiration tempered by indignation. This was because it was felt, in certain quarters, that Rodin must have made it from casts of a living model. He had done nothing of the sort, but the criticism was a backhanded compliment to Rodin's technique of modelling from life.

Essentially the criticism was misinformed and a little lazy: few were prepared to listen to Rodin's defense or even spend time looking at the sculpture to see the subtle licence he had taken with the anatomy of his model, a Belgian soldier called Auguste Neyt, in order, as he put it, 'to enhance the truth' of his sculpture.

The Age of Bronze is an indirect homage to Michelangelo's *Dying Slave,* a figure with its chest thrust out and balanced by flexed hips with the weight firmly on the left leg. In both sculptures the figure holds a hand to its head. Whereas the *Dying Slave* clasps his breast with the other hand, Rodin's figure holds up the left hand, suspended and clutching at thin air. This apparently meaningless gesture further bemused the critics: 'is this the statue of a sleepwalker?' asked one. In fact Rodin's original intention was to have his figure holding a spear. This, allied with the fact that its initial title was *The Vanquished,* suggests that Rodin's original aim was to evoke a sense of disillusionment and youthful suffering in the aftermath of

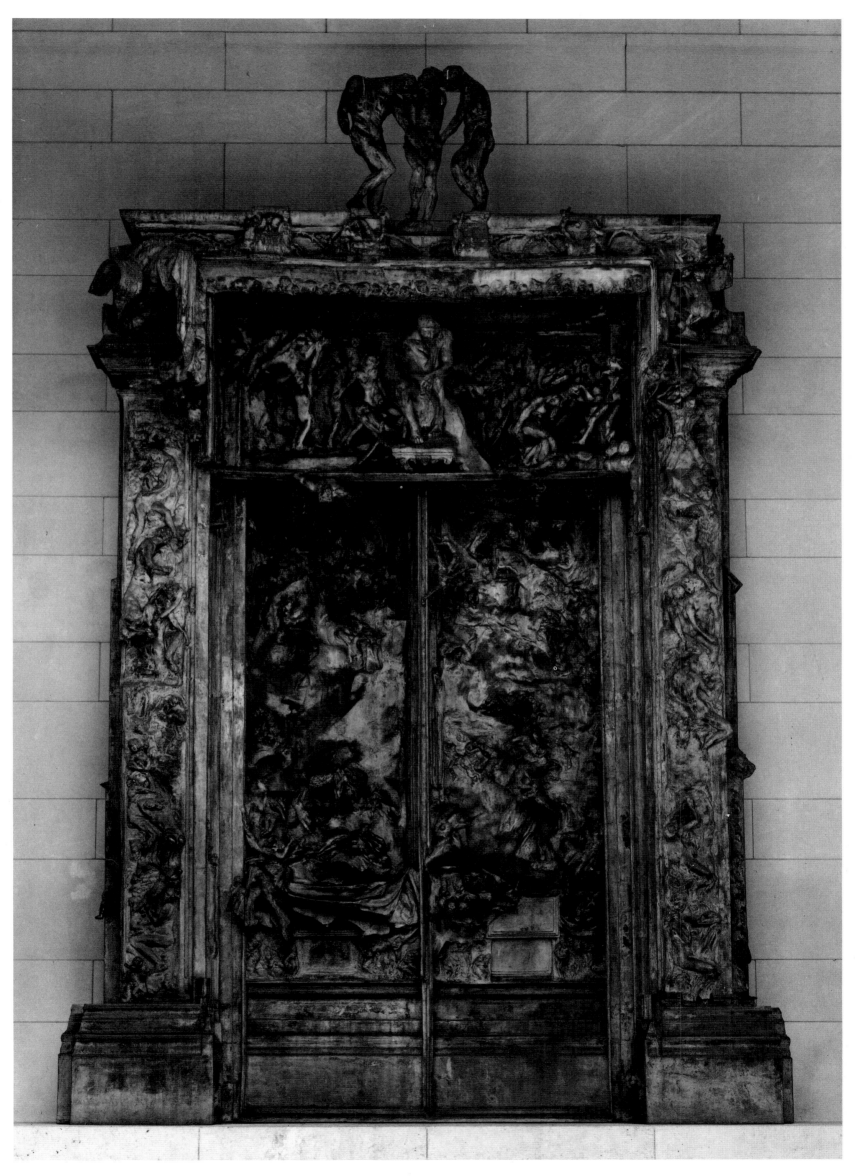

the Franco-Prussian War. Ultimately, however, with the spear removed, the gesture is an ambivalent one which, as art historian Albert Elsen has commented, 'has intrigued, annoyed and haunted those who have studied it . . . leading to various conjectures [ranging] from the impulse to suicide to primeval man's awakening to the consciousness of life.'

The attention generated by *The Age of Bronze* seems to have served Rodin well. Three years later it won third prize at the Salon and was acquired by the state and put in the Jardins de Luxembourg where it remained until 1889. More immediately, it provided the impetus for a second major life-sized figure, that of *St John the Baptist Preaching*, made in 1878-80 in Paris where

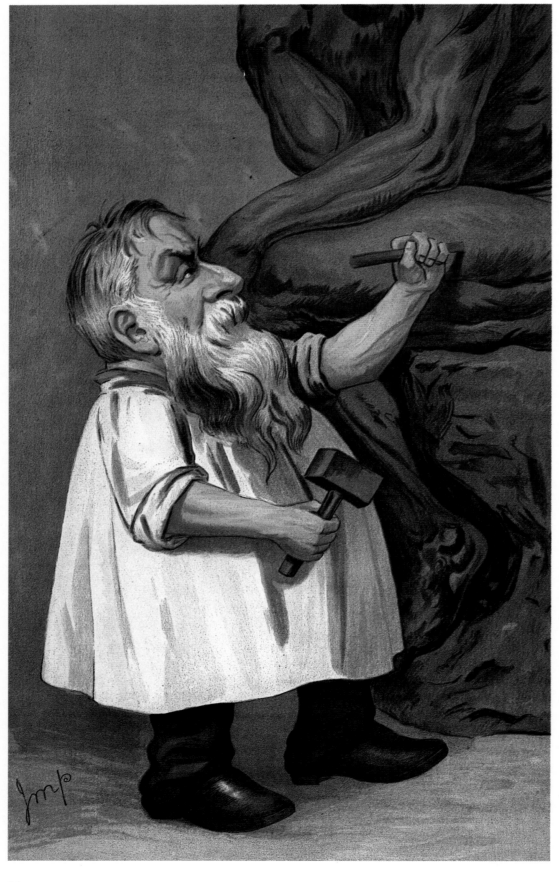

Rodin now returned. The vigorous stance of St John was inspired by an Italian visitor to his studio, a man named Pignatelli. It seems to have been adopted not least to dispel the suspicion that he had ever worked from casts of live models. His right arm gesturing upwards commandingly, St John thrusts his right leg forward towards the viewer, frozen in mid-stride but filled with a dynamic force that is both physical and spiritual. Rodin, in his own words, was exploring 'the progressive development of movement' and wanted the figure to be perceived, as Albert Elsen explains, 'as if it were passing through successive stages.' Here is a sculpture of a human body charged with expressive energy. 'I have always endeavored to express the inner feelings by the mobility of muscles' Rodin once stated. In the study he made for *St John the Baptist* which was later turned into *The Walking Man*, he focussed almost exclusively on feeling and force in a manner which is abstracted and without precedent. *The Walking Man* is headless and without arms, stripped of all rhetorical accessories. The sculpture is resolved through its raw surface and dynamic charge. It was not until the end of the century when his reputation was fully established that Rodin could show *The Walking Man* as a finished sculpture.

There is always the risk of hyperbole in describing the onset of a burst of intense creativity in the career of a great artist. Even with this in mind it seems appropriate to proclaim that the body of work which Rodin produced from 1870 to 1895 in general, and from 1880 to 1885 in particular, would sustain comparison with work by any artist over a similar timespan taken from the whole history of Western art. Rodin's output was monumental, his achievement momentous.

In July 1880 Rodin was invited to design a huge portal with sculpture reliefs for the proposed Museum of Decorative Arts. This later became known as the *Gates of Hell*. Although the commission was never realized in situ, the gates remain the greatest public sculpture of the nineteenth century. At the same time they can be seen to have functioned as Rodin's private laboratory for sculptural exploration.

The *Gates of Hell* was the last in a long tradition of monumental sculptured portals, whose origins can be traced back to the late Roman Empire. The most obvious precedent, particularly in view of Rodin's recent visit to Florence, was Ghiberti's doors for the Florentine Baptistry. Indeed, as a contemporary observer com-

mented: 'They will provide us with a counterpart to the Baptistry portal in Florence, the work of Lorenzo Ghiberti that Michelangelo said deserved to be called the Gates of Paradise.'

Rodin's choice of subject matter, however, was vastly different:

They left to me the choice of subject. As much as possible I had decided to choose a subject such that the lies thrown at me could not be repeated. I had no idea of interpreting Dante, though I was glad to accept the Inferno as a starting point because I wanted to do something small, in nude figures. I had been accused of using casts from nature in the execution of my work and I had made the St John to refute this, but it only partially succeeded. To prove completely that I could model from life as well as other sculptors, I determined . . . to make the sculpture on the door of figures smaller than life. I had a great admiration for Dante. Dante is not only a visionary, but also a sculptor. His expression is lapidary in the good sense of the word. I lived a whole year with Dante . . . drawing the eight circles of his Hell.

The 'year with Dante' resulted in sketchbook after sketchbook, not to mention sheafs of scrap paper filled with pencil studies and 'black' gouaches of heavily worked single and coupled figures which were, as Catherine Lampert has remarked 'the first locus of the gravity-less, time-less settings for amoral observation' in some of Rodin's subsequent work. They are stupendous graphic achievements in themselves as well as functioning as an imaginative workshop for the realization of the *Gates* in three-dimensional form. That they emerged essentially from Rodin's imagination, based only distantly on his reading of Dante soon proved problematic for the sculptor as he later reflected: 'At the end of the year, I saw that while my drawings rendered my vision of Dante, they were not close enough to reality. And I began all over again, after nature, working with my models . . . I had abandoned my drawings.'

Before Rodin could embark on the next stage of his giant commission, he needed an architectural framework, which was devised in his year of drawing in 1881. The sketched structure began loosely to mirror that of Ghiberti's *Gates of Paradise*, although Rodin proposed to include eight panels rather than the ten that his Florentine predecessor had devised. Rodin also incorporated a further eight narrow flanking panels in the frame around the doors. By the end of 1881, both in drawings and

in the last of three small architectural maquettes, he had discarded the notion of using separate panels and already the dramatic, cascading mass of human form which came to characterize the reliefs within the doors had emerged. If he had ever entertained the idea of a narrative context – and the signs are that he had not – it disappeared emphatically as the panelling was discarded. Instead he used his own disjointed 'vision of Dante' as a vehicle for exploring the teeming morass of humanity as he perceived it. 'There is no method of subject' he said 'I followed my imagination.' Emphatically contradicting academic tradition, Rodin's subject matter in the *Gates of Hell* raised many more questions than it answered.

Certainly figures from Dante can be identified, not least the lovers Paolo and Francesca, together with Ugolino. Centaurs and Sirens abound from classical mythology but content is not presented in a systematic manner in the *Gates*. Even though certain commentators have perceived that Rodin uses elements from the Last Judgment, their relationship to the final form of the gates is so atavistic as to be at best confusing and at worst, meaningless. Both iconographically and spiritually, the *Gates* are unresolved, and a description that Rodin once gave to Michelangelo's sculpture could equally be applied to his own: 'His sculpture expressed restless energy, the will to act without the hope of success – in fine, the martyrdom of the creature tormented by unrealizable aspirations.'

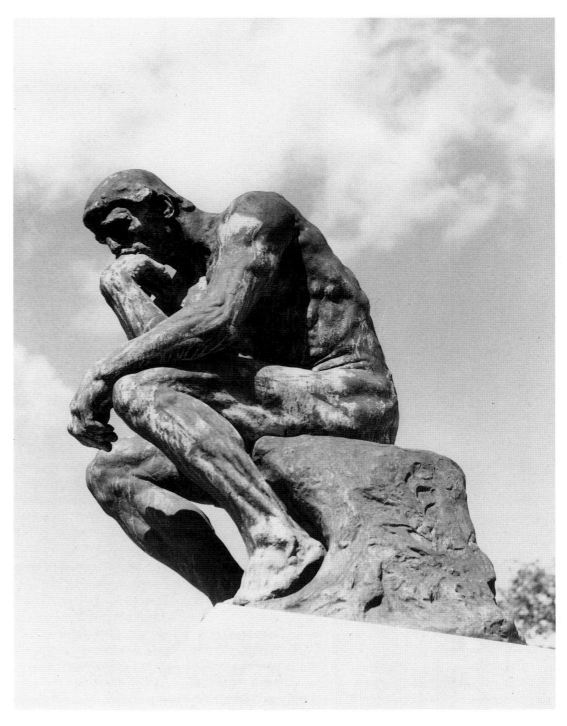

Analysis of Rodin's working sculptural practice for the *Gates* is crucial to any understanding of the uniqueness and significance of his later work. For four years he worked almost demonically with his hands to fill the new studios, made available by the government at the Dépot des Marbres.

By 1885 the writer Octave Mirbeau could report having seen '300 figures, each portraying a different attitude or feeling' stacked on shelves or spread out on the floor, an arrangement which another critic, Gustave Geffroy, described as presenting 'a vista as of some phantasmagoric cemetery, peopled by a mute yet eloquent crowd, each unit of which we feel impelled to examine.'

These figures, made from both clay and plaster, were then juxtaposed, up-ended, sawn-off, or tilted. Figure combinations or individual postures which were not structurally possible were realized initially through the medium of photography with the forms photographed at various angles and then assembled in a manner loosely akin to collage. It could justifiably be claimed that Rodin was the first artist to utilize the recently developed medium of photography in the service of avant-garde art. Likewise in both his methods and in the finished gates, Rodin could also be seen to foreshadow Synthetic Cubist collage together with the multi-perspectival viewpoint developed by the Cubist painters.

A whole host of individual figure sculptures emerged from the workshop which were both incorporated into the pulsating surface of the *Gates* and exhibited separately well before the first effective synthesis of the project in 1900 when it was exhibited in a plaster-cast form. These pieces included the *Prodigal Son*, the *Crouching Woman, Fugitive Love, I am Beautiful*, and the serene *The Kiss*. In these works the major themes of the *Gates* were given a heightened and more focused meaning. Sexual love, angst and despair, parenthood and death, intellectual activity and creation were all explored and Rodin's radical depictions of female sexuality were given their fullest expression to date.

In addition, there were four larger sculptures associated with the *Gates, Adam, Eve, The Three Shades*, and *The Thinker*, all of which were directly inspired by Michelangelo's art. 'Accepting Michelangelo's postures, with variations,' Albert Elsen wrote, 'Rodin chose both from his predecessor's paintings and sculpture, at times drawing from both sources in a single figure.' *Adam* and *Eve* were modeled initially to flank the portals but eventually were omitted. They recall vividly the figures of Adam and Eve in the Sistine chapel and Adam's left arm, as Leo Steinberg has observed, is derived from that of Michelangelo's *Pietà* in the Duomo in Florence. *The Three Shades* crowned the tympanum and were a threefold variation on the figure of Adam. They stand in a rhythmical configuration at the apex of the gates and their stump-like hands thrust the attention of the viewer down towards vibrant activity below.

Although it is positioned less prominently underneath *The Three Shades* and is noticeably smaller, *The Thinker* is the dominant figure in the *Gates of Hell*. It was realized in its present form probably as early as the beginning of 1881 and was subsequently enlarged and reproduced in marble for the headstone to Rodin's tomb. In its isolated and enlarged form it served both as a poignant monument to its creator and as a timeless, indeed universal, symbol. Yet above the *Gates*, gazing down in quiet contemplation at the self-inflicted agonies of humanity, it takes on a more forceful meaning: '*The Thinker*, in his austere nudity, in his pensive face, is at the same time a wild Adam, implacable Dante and merciful Virgil. . . .' wrote Octave Mirbeau 'but he is still above all The Ancestor, the first man, naive and without conscience, bending over that

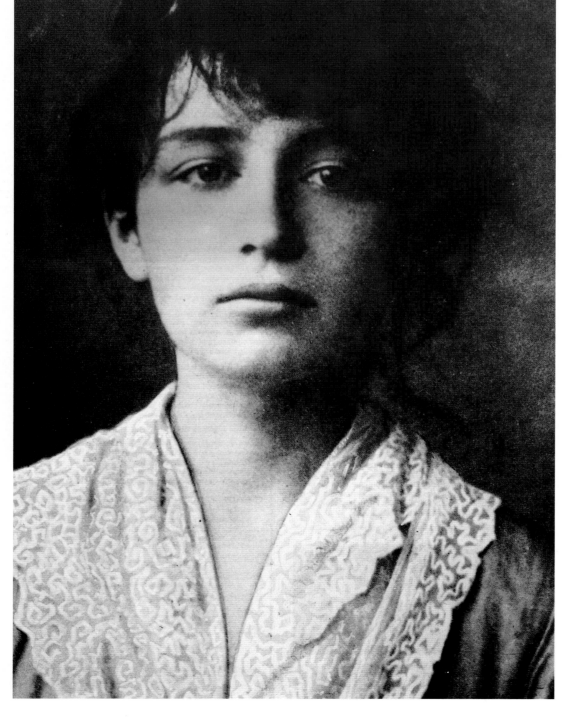

which he will engender.' Beneath *The Thinker*, another commentator has observed, might appropriately be inscribed: 'I think therefore I am . . . damned.'

The *Gates of Hell* was never erected at the Musée des Arts Décoratifs. The government's decision to install it in a wing of the Louvre gave Rodin an almost open-ended deadline for submission. In 1905, five years after its first public display in an incomplete plaster form, Rodin returned the funds which he had received for the commission. In the years up to his death he made minor changes to the *Gates* and only in 1917 was it fully assembled, under the supervision of Léance Bénédite who became the first director of the Musée Rodin. Both bronze versions were cast posthumously, the first in 1928 and the last as late as 1981. They can be found at the Musée Rodin in Paris, and in Philadelphia, Zurich, Tokyo, and San Fransisco. Although now restored to its intended status as a public monument, nonetheless it remained an essentially private work for the duration of Rodin's lifetime, his 'Noah's Ark' as he called it, in which fantasy and form were developed and from which sprung his wildest and most successful work.

Although Rodin contributed decisively to the decline of public momuments in the modern period through his emphasis on expressiveness at the expense of subject matter, and pure sculptural values over those of traditional statuary, nevertheless he sought to make them throughout his career. From 1878 to 1882 he tried unsuccessfully to obtain five commissions, the most notable of which was a monument to commemorate the Franco-Prussian War for which he produced a small terracotta sketch entitled *Call to Arms* which was enlarged and cast in bronze in 1920 after his death by the Belgian government and set up as a war memorial to Verdun. In 1884, bolstered by the commission for the *Gates*, he successfully competed for a commemorative monument for the city of Calais.

The city proposed to honor six of its former burghers who, in 1347, had given themselves as hostages to the King of England in return for lifting the siege of Calais. Although the commission was for only one figure, that of Eustache de St Pierre, Rodin persuaded the committee to allow him to make a group which included the other five heroic men. Taking the fourteenth-century chronicles of Jean Froissart as his point of departure, Rodin

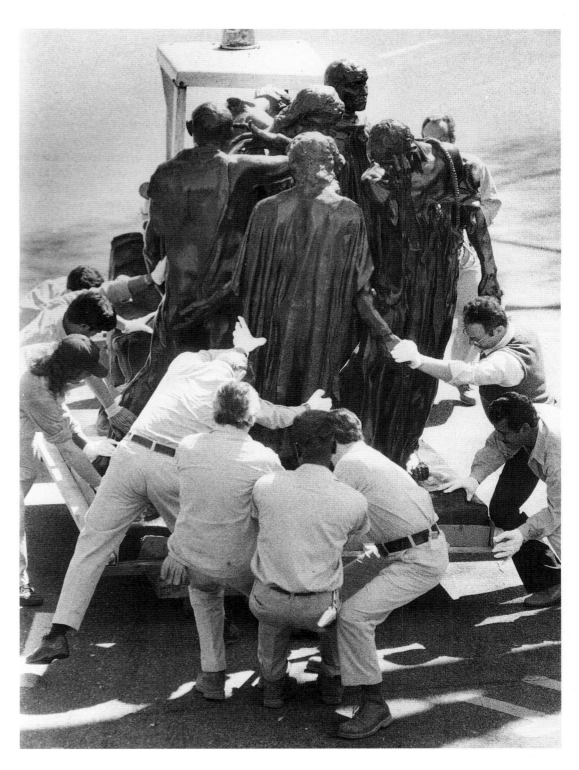

focused on a particular passage in which the six burghers are about to set off for the English camp, bound by a halter and dressed only in sackcloth. Of his first maquette, Rodin explained that 'the grouping of the six figures sacrificing themselves has an expression and an emotion which can readily be shared. The pedestal is triumphal and has the rudiments of an arch in order to carry not a quadriga, but human patriotism, abnegation, and virtue.'

The fourteenth-century saga gave Rodin the opportunity to deal with subject matter which he felt was both medieval and timeless, in a style which could allude strongly to Gothic art. The sackcloth robes in which the *Burghers* were depicted are abstractions of Gothic carved draperies and they add what one commentator has described as 'mystery, cadence, and unity to the dense grouping of his monument.'

Over one hundred three-dimensional studies were made for the *Burghers* together with thousands of drawings in his ubiquitous sketchbooks. Physical and even anthropological accuracy was central to his conception: 'I intend to make expressive studies of heads for Eustache de St Pierre and his companions' he informed the mayor of Calais, Omer Dewavrin, 'by making portraits of people from the area.' He began by asking a painter-friend, Jean-

19

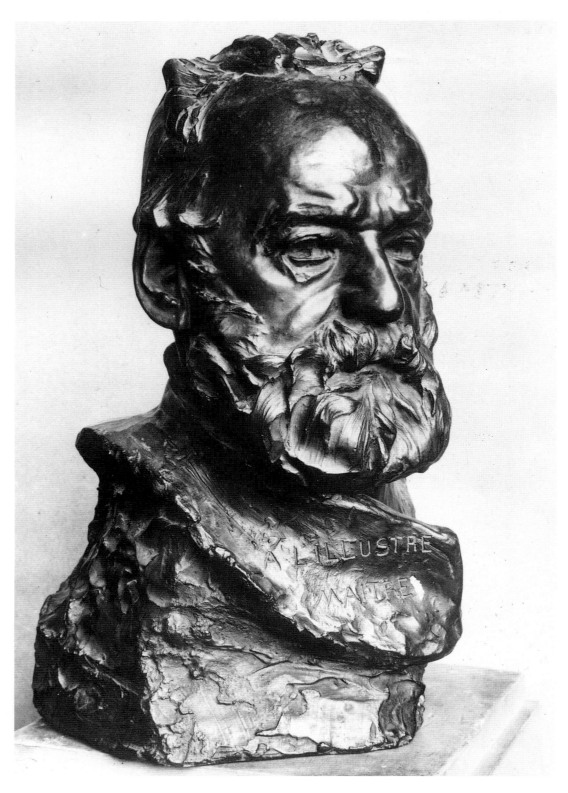

sponse by exhibiting them as individual works. The signs were good. 'The figures seem to have emerged from the mud of the middle ages,' one critic wrote, 'to demonstrate conscious suffering, the admirable expression of human sacrifice.' Another critic, Gustave Geffroy, felt that they represented 'man's ephemeral existence and his sorrows. They bear the mark of sadness,' he added 'which is the unavoidable characteristic of all great works.'

The completed plaster group was unveiled at the Galerie Georges Petit in 1889 as part of a joint exhibition between Rodin and Monet. This exhibition, coinciding with the Exposition Universelle in which he also took part, established Rodin's reputation on a wider, more international scale. Subsequently, after the *Burghers of Calais* were installed in their home town in 1894, the monument was sought after on a wider international scale. In Rodin's lifetime, casts were made for London, Brussels, and Copenhagen. Today there are eleven casts of the *Burghers* of Calais worldwide.

There were two more major commissions for Rodin, both in the 1890s when he was at the height of his creative power. They honored two great men of nineteenth-century French literature, Victor Hugo and Honoré de Balzac.

The plan to design a large statue of Victor Hugo was part of a grandiose state scheme to produce over 100 sculptures to promote the secular ideas of the Third Republic. Victor Hugo was a perfect choice: popular, self-professed voice of the people, he had remained in exile for 10 years in protest against the government of Napoleon III.

Rodin's suitability for the commission was enhanced by the fact that he had made a bust of Victor Hugo back in 1883, albeit in taxing circumstances when the 81 year-old writer refused to sit. Rodin was obliged to locate his modeling studio on the veranda above the room in which the writer worked, occasionally dashing downstairs to make fleeting pencil and ink sketches.

Instead of producing a single image of Victor Hugo as the commissioners had requested, Rodin produced a series of plaster configurations in which the writer appeared naked and surrounded by his nubile, erotically charged muses, his hand outstretched toward the viewer, his eyes gazing off into space beyond. Hugo was presented as the lonely genius, both dreamer and creative artist who could reach out and communicate with a wider

Charles Cazin, who lived near Boulogne, to pose for the central figure. Cazin accepted with alacrity: 'I am ready to pose for your figure of Eustache de St Pierre with a halter around my neck and with bare feet and arms.' Other appropriate models were chosen mainly for their facial characteristics. It seems that the bodies were created independently of the heads, using the figures of professional models holding a series of twisted poses which help to convey both a sense of anticipation and withdrawal verging on paralytic fear.

Rodin had a series of disputes with the commissioning municipal authorities over both the interpretation and location of the monument. In 1885 he prepared to place the six *Burghers* on the paving stones of the square in front of the town hall 'so that the group would look more at home and that would do more to make the public enter the spirit of misery and sacrifice.' His patrons were not happy with this proposal. For a time the project looked to be in jeopardy, though mainly because a local banking firm responsible for municipal funds went bust. The ensuing period of uncertainty, from 1886 to 1888, gave Rodin the opportunity to work further on the figures and to solicit a more public re-

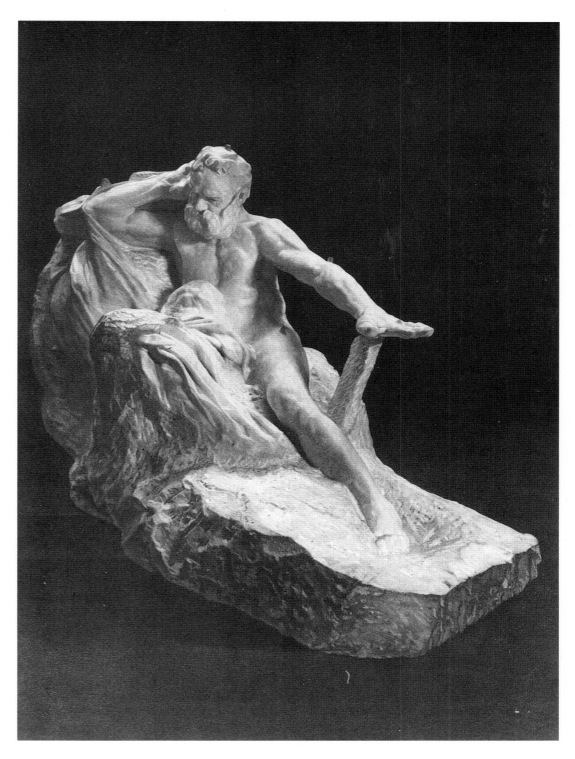

public. Increasingly Rodin came to identify himself thus, as an artist who felt a strong sense of alienation while experiencing widespread idolization. Rodin's monument to Victor Hugo was rejected as being unsuitable for the Pantheon, but eventually found a home at the end of the avenue Victor Hugo and a marble version of the monument, stripped of its muses, was erected in the gardens of the Palais Royal in 1909.

The monument to Balzac, begun in 1891, more than realized Rodin's ambition 'to do something out of the ordinary' which he declared when he was invited to produce the sculpture. His preparation verged on the obsessive: he read and re-read all the novels; spent a month in Touraine to familiarize himself with the writer's native province and even visited Balzac's old tailor to determine his exact shape and size, in spite of the fact that Balzac had died over forty years earlier. It was not so much obtaining a physical resemblance which fascinated Rodin: 'I think of his intense labor, of the difficulty of his life of his incessant battles and of his great courage. I would express all that.'

Balzac's huge physique needed no setting, or so it would seem, for Rodin began to produce studies of the writer clothed and then naked, depicted as a fighter, strong and steadfast. His patrons were angered by the giant nude figure and the Société des Gens de Lettres deemed his work to be 'artistically insufficient' and called one of the sketches 'a giant foetus.' Accounts of bitter quarrelling between the patrons and Balzac reached the press who began to hound the sculptor. In 1894, Rodin rented a house at Meudon, just outside Paris, as a refuge and new sanctuary of work away from the city. Four years later, in 1898, Rodin finished the monument to Balzac. The figure was clad in a huge robe, an imitation of Balzac's famous dressing-gown or 'monk's robe' which covered the earlier offending nudity. From the side, most markedly, it became clear that sexuality was not to be covered up, for under the robe, Balzac clutches his erect penis. The correlation between sexual and creative energies was well established in artistic circles in the late nineteenth century. Rodin, an artist obsessed with the primordial life-force seems to be paying tribute to Balzac's potency as man, artist, and creator.

When it was exhibited, the sponsoring committee refused to acknowledge that it was finished, dismissing it instead as a sketch which was said to depict Balzac variously as 'a penguin, a snowman, a sack of coal, a menhir, a phantom and a shapeless larva,' according to Albert Elson. In response, in a letter to the Paris Journal, which appeared on 12 May 1898, signed X, Rodin made one of his most eloquent statements of explanation and intent:

Without doubt the decision of the Société is a material disaster for me, but my work as an artist remains my supreme satisfaction. I am anxious to recover the peace and tranquility of which I have need. I sought in *Balzac*, as in *Victor Hugo* to render in sculpture what was not photographic. One can find errors in my *Balzac*; the artist does not always realize his dream; but I believe in the truth of my principle; and *Balzac* rejected or not, is none the less in the line of demarcation between commercial sculpture and the art of sculpture that we no longer have in Europe. My principle is to imitate not only form but also life. I search in nature for this life and amplify it by exaggerating the holes and lumps, to gain thereby more light, after which I search for a synthesis of the whole. I am now too old to defend my art which has sincerity as its defense. The task of the public has been tainted by the habit of making casts after the model to which it has grown accustomed.

If Rodin felt too old to defend his art as he approached his 60th birthday, he still felt young enough to continue to produce

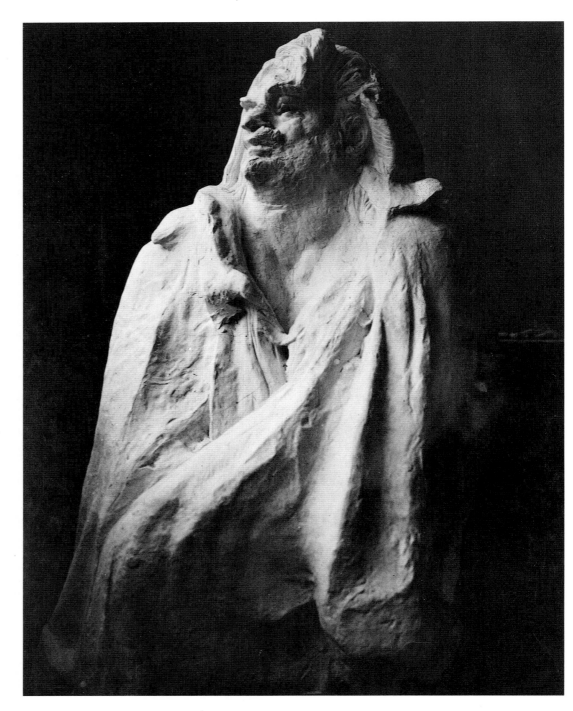

it, although his greatest works had essentially been realized by 1898. In the same year his relationship with the sculptor Camille Claudel finally ended after fifteen years of intensity, argument, and inspiration. As a young student in 1883, Camille had become a studio assistant and subsequently both mistress and model for Rodin. She inspired a number of pieces of sculpture but two stand out above all others: the beautiful, haunting and slightly vulnerable *Meditation* from 1884, together with an enlarged and fragmented version which was subsequently called *Inner Voice*. Camille inspired in Rodin work of a sensitivity and a mystery that seems to have been addictive for the older man and it stands in marked contrast to the more physical, essentially sexual force which Rodin sought and realized in sculptures focused on other models. In the now celebrated, but still notorious *Muses* which originated from the Victor Hugo monument, and particularly in *Iris, Messenger of the Gods*, Rodin centred his attention literally and metaphorically on the woman's sex. Her splayed legs and gaping vagina still have a power to shock, but their real power lies in the celebration of female sexuality, with the figure wrapped as she is in the throes of orgasm. This is a theme explored in later works, particularly in the drawings and gouaches after 1900, which art historians have compared to the erotic work of Félicien Rops, Gustav Klimt, and Egon Schiele. In Rodin's work however, as Catherine Lampert has pointed out, there is none of the shame or tension attached to the depiction of carnal relationships in the Northern European tradition. Nor is there a hint of the cyn-

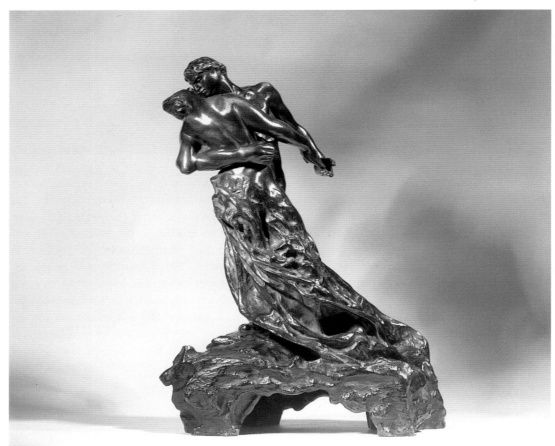

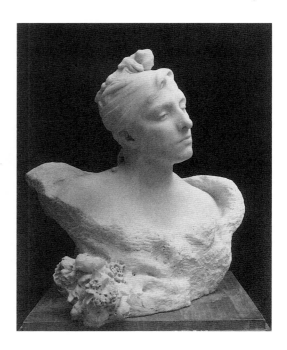

Left: Definitive study of the *Monument to Balzac* finished in 1898.

Below: *The Rising Sun*, circa 1900-05. This balletic watercolor is one of many studies of the female nude, often overlaid with cosmic significance from their title.

Below: Rodin in his studio at Meudon circa 1906-07. His hand rests on a bronze bust of George Bernard Shaw of whom he had recently made a series of portraits.

Bottom: *Seated Girl on Knees*, a pencil and watercolor image first exhibited in 1908.

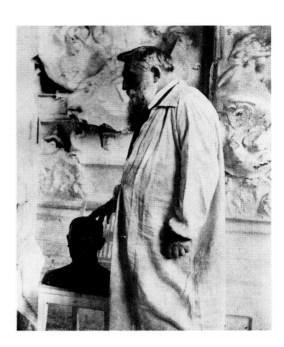

born Duchesse de Choiseul. Accounts of the affair state that Rodin was infatuated with her and became alienated from many of his friends. Whatever the case, it is an illustration of the attention which Rodin solicited from the aristocracy, not to mention certain monarchs who visited the celebrated artist's studio, often in search of a portrait. Rodin's *Bust of the Duchesse de Choiseul* is one of a series of late portrait busts which he made of society figures; it was this series which was described by the German poet Rilke as being dexterous 'classical cameos.'

In the last years of his life, Rodin continued to make portraits of 'great men,' as he had done from the 1880s: artists like Puvis de Chavannes, musicians like Mahler, whose secretary he used as a

icism so prominent in the work of the artists mentioned above. Indeed Rodin seems fascinated by the otherness of women, attempting to empathize, with what ultimately he can never understand, from within the body of a woman. Visitors to his studio were struck by the physical proximity of artist and model, so close that he could feel their body heat and smell their fleshy odors, almost but not quite realized in the resulting drawings and sculptures. 'People say I think too much about women' he once remarked, 'yet, after all what is there more important to think about?' Plenty of anecdotes exist about his sexual engagement with his models and the women who visited the studio. Gwen John tells of how she and the Finnish sculptor Hilda Maria Flodin shared a bed together with Rodin in his studio. But even as an ageing man, Rodin never bragged or even let on what went on behind studio doors. It remained his sacred place of work and exploration; his sanctuary.

Rodin has often been blamed for, or at least implicated in, the tragic demise of Camille Claudel which may or may not be the case. Suffice it to say that during and after their relationship he remained sincere in his advocacy of her work and its own originality. 'I showed her where to find gold' he once said, 'but the gold she found was her own.' Camille's bust of Rodin, executed in 1888, is an early testament to her ability as a sculptor.

In 1907 Rodin became embroiled in a difficult relationship with the American-

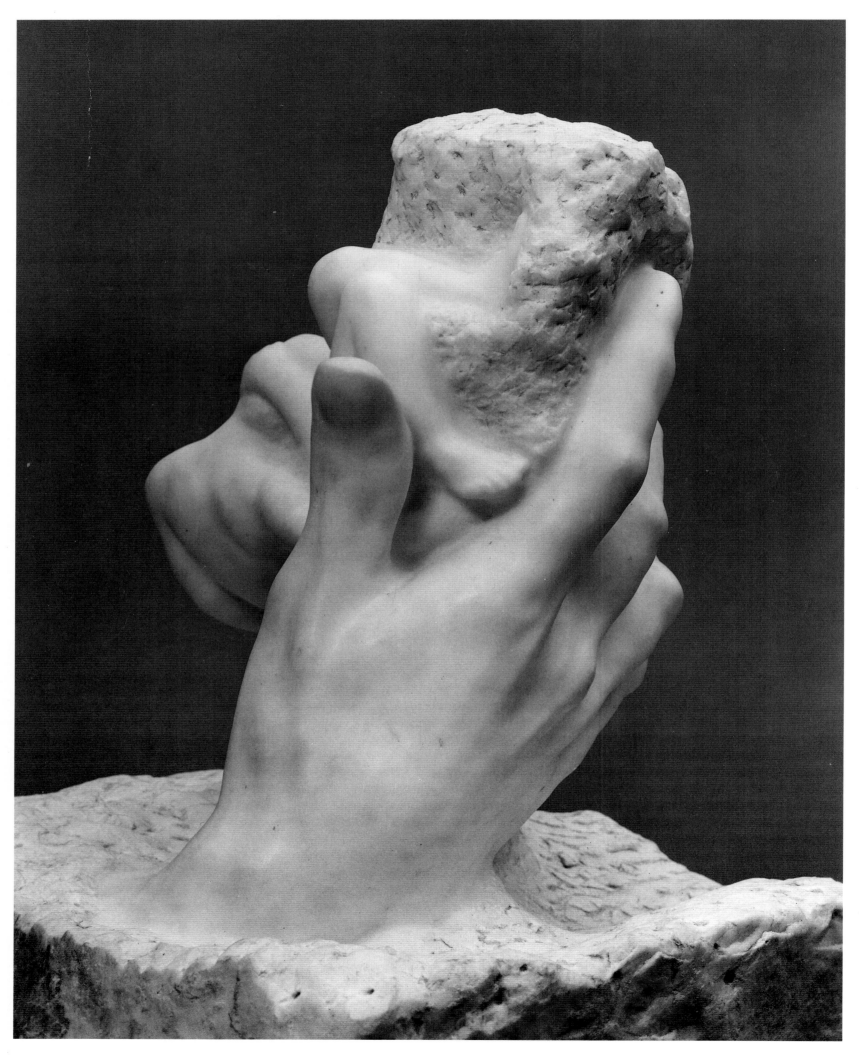

model, and men of letters including the Irish writer George Bernard Shaw.

The series of busts of George Bernard Shaw executed in 1906 was particularly powerful and delighted the sitter: 'look at my bust and you will see no resemblance to that brilliant fiction known as George Bernard Shaw . . . Moreover it is a frightening resemblance. The hand of Rodin worked, not as the hand of a sculptor works but as the work of "Elan Vital" . . . the Hand of God is his own hand . . .'

The *Hand of God* was, in fact the most finished and most widely accepted sculpture from a general series of late fragmentary pieces. Hands, legs, and torsoes were realized and cast in dislocated extremity after 1900. This aspect of his work, wherein the part is substituted for, and becomes essentially, the whole, had the strongest influence on a whole host of younger sculptors from Matisse and Maillol to Brancusi, Lipchitz, and Archipenki. While in Rome in 1915 admiring the ancient sculptural remains, Rodin remarked: 'Beauty is like God; a fragment of beauty is complete.'

Early in 1903, Rilke (who became Rodin's secretary for a time in 1905) had written: 'Rodin, knowing through the education which he has given himself that the entire body consists of scenes from life, of a life that may become in every detail individual and great, has a power to give to any part of this vibrating surface the independence of a whole.'

In a sense, Rodin's greatest work challenges the notion of Gestalt, a quality central to the traditional perception of successful sculpture whereby the sense of

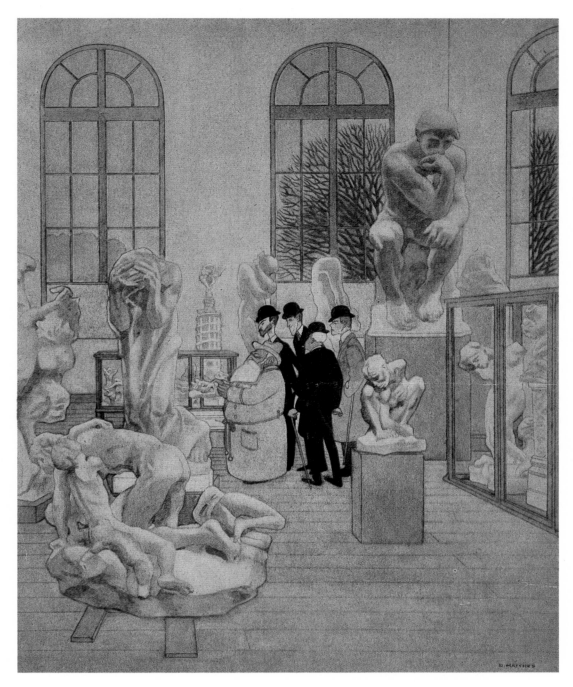

wholeness is greater than the sum of its parts. In Rodin's work a sense of wholeness often exists but it is frequently transcended by the power of the individual parts, wrestling with each other and affirming their own independence and value.

Here again is the final glimpse, but never a full view, of Rodin the Modern. Albert Elsen summarised thus:

Rodin was the Moses of modern sculpture, leading it out of the wilderness of the nineteenth century Salons and academic studios. Like the biblical Moses, he lived only long enough to look on the Promised Land. Not his death, however, but his steadfast adherence to naturalism and certain of its traditions prevented Rodin from entering into the new territories that were being surveyed and colonized by younger sculptors of the twentieth century.

At the beginning of 1917 Rodin married Rose Beuret fifteen days before she died. Eight months later, with France still at war, and the state still wrangling over the details of his will, Rodin contracted pneumonia. On 17 November 1917 he died. Above the tomb which he shared with Rose at Meudon, sits the *Thinker*. 'Nature gives me my model, life, and thought; the nostrils breathe, the heart beats, the lungs inhale, the being thinks, and feels, has pains and joys, ambitions, passions and emotions. These I must express.' He said, shortly before his death, 'What makes my *Thinker* think is that he thinks not only with the brain, with his knitted brow, his distended nostrils, and compressed lips, but with every muscle of his arms, back, and legs, with his clenched fist and gripping toes.' It could be, emphatically, Rodin's alter ego.

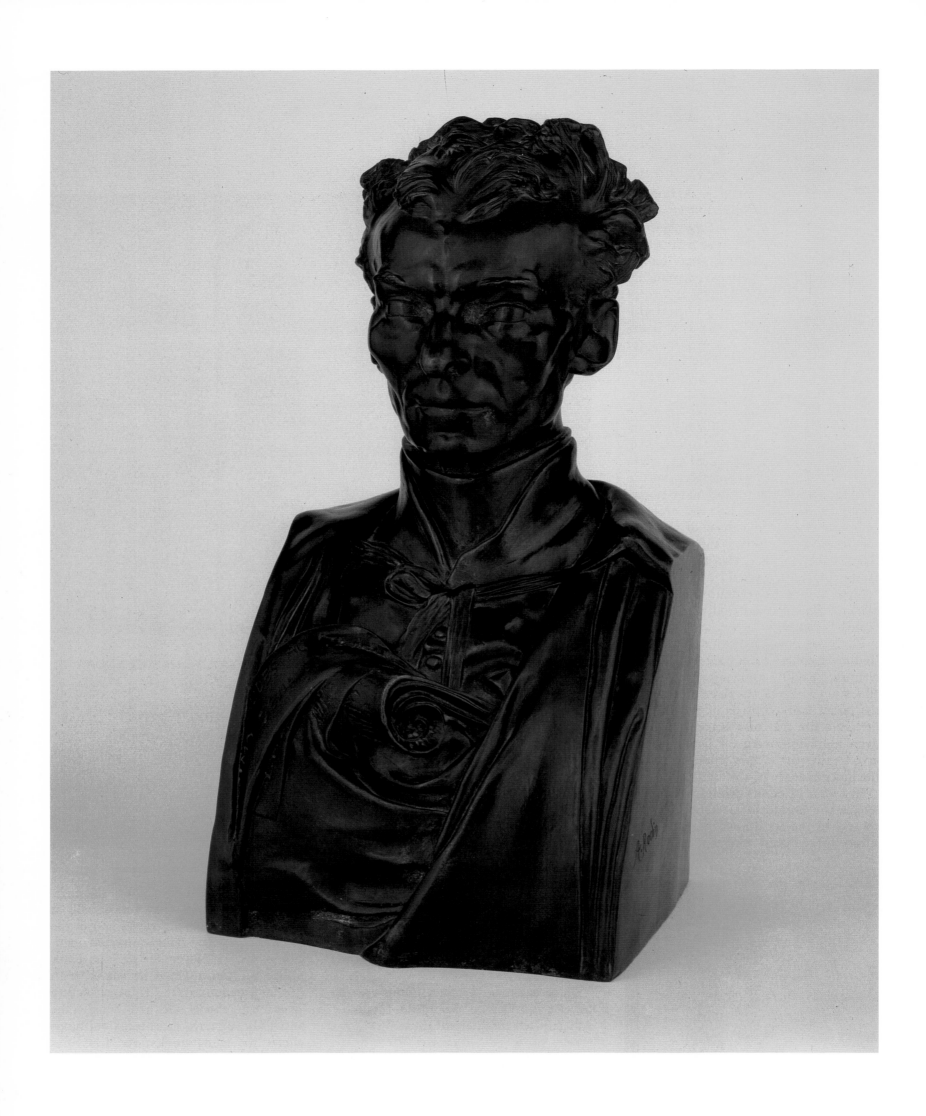

Above:
Father Eymard, 1863
Bronze
22⅞×11½×11 inches (58×29×28 cm)
Musée Rodin, Paris S 972

Right:
Man with A Broken Nose, 1864
Bronze
12½×7½×6¼ inches (31.8×18.9×16 cm)
Musée Rodin, Paris S 755

26

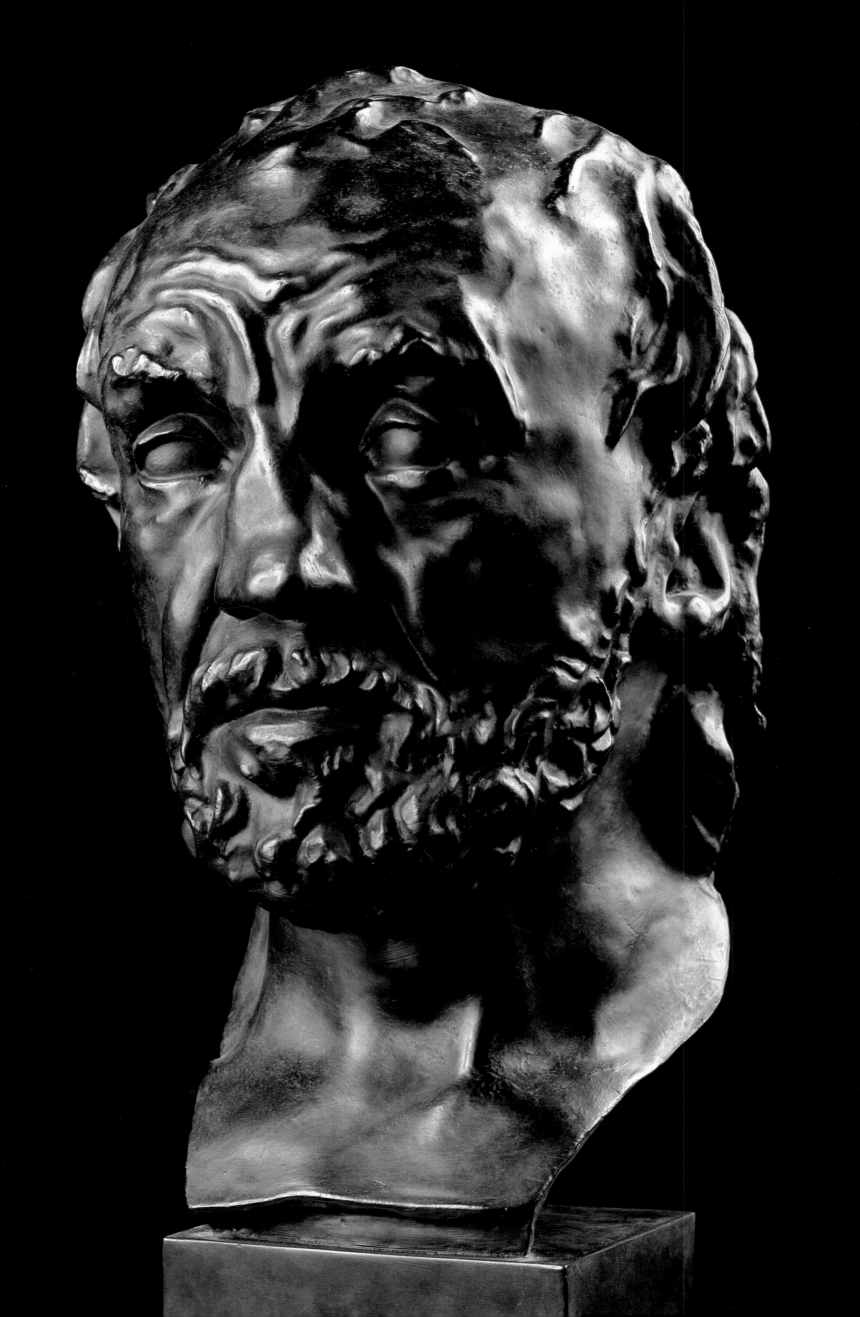

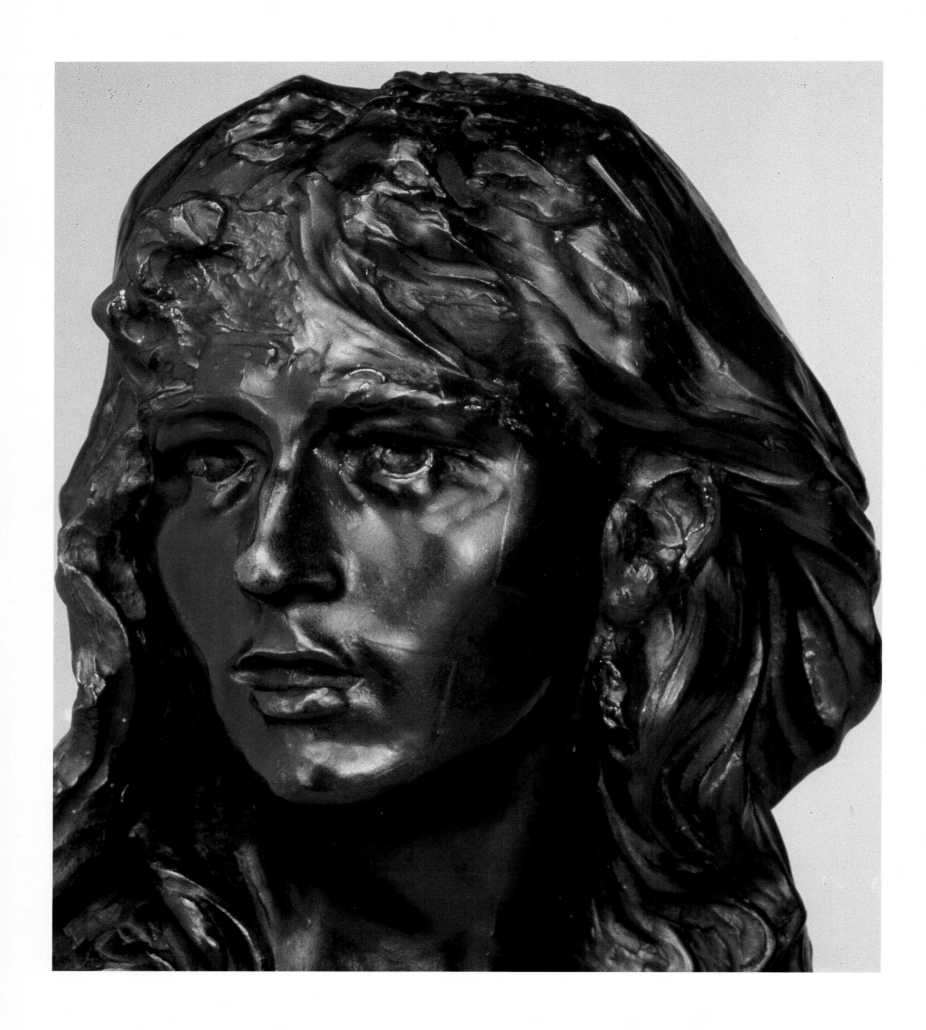

Mignon (Mme Rodin), 1867-68
Bronze
15½×12×9½ inches (39.4×30.5×24.1 cm)
The Rodin Museum, Philadelphia Museum of Art
Gift of Jules Mastbaum

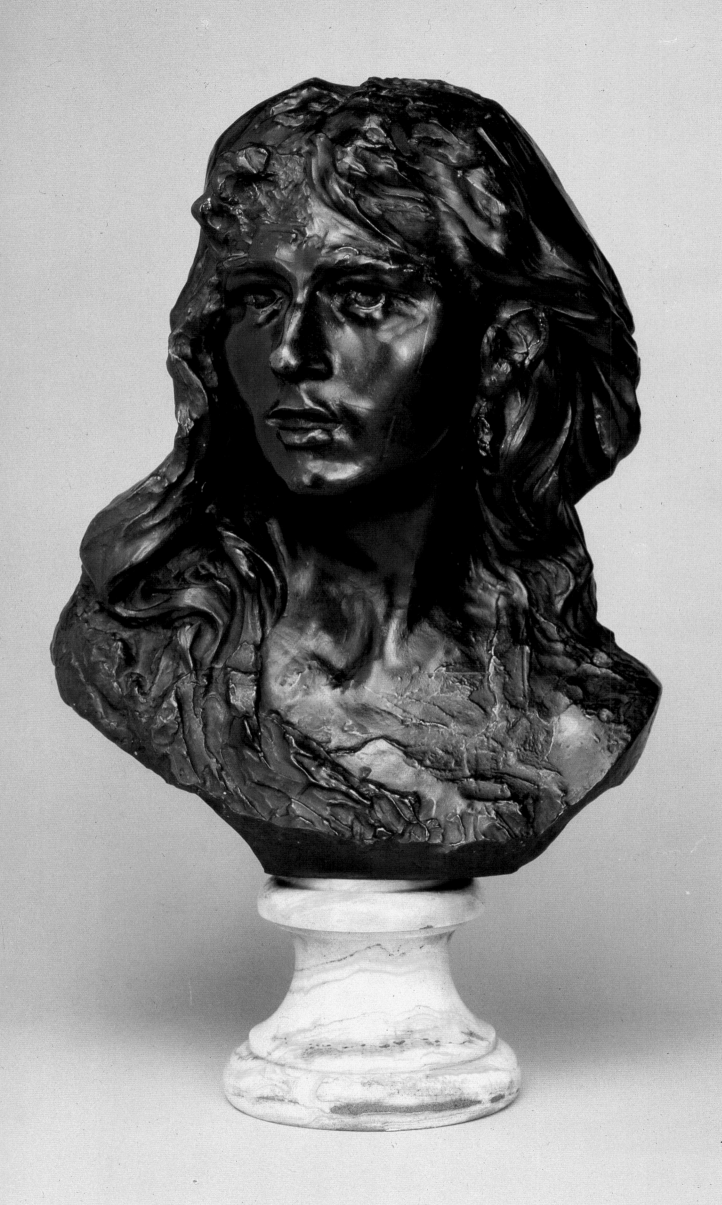

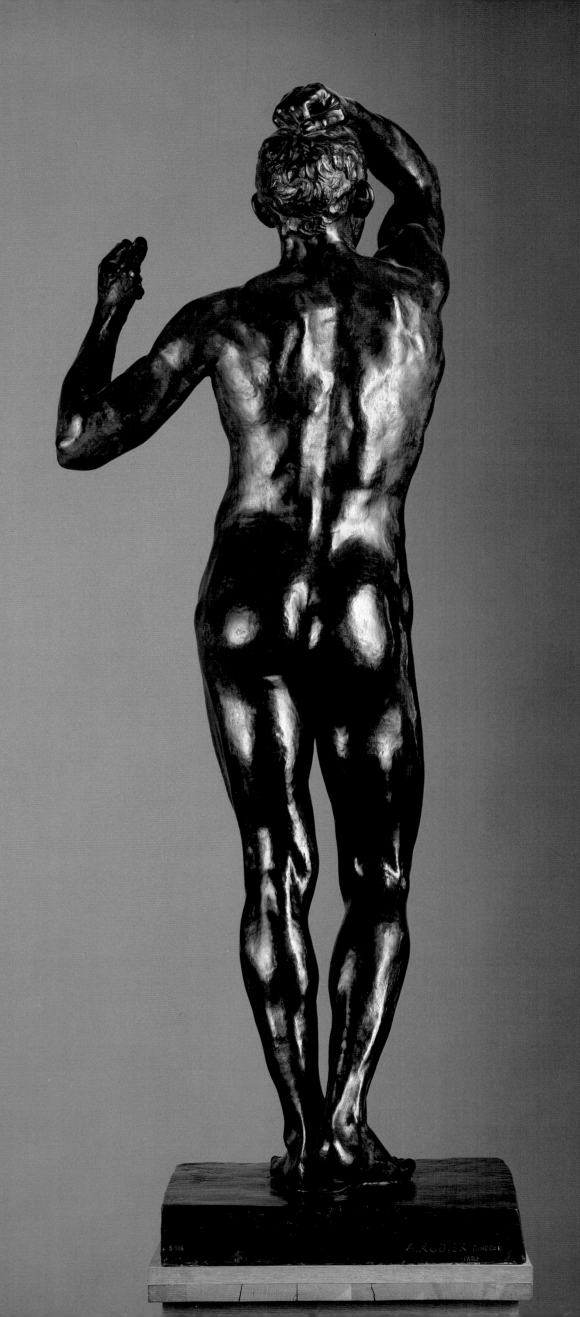

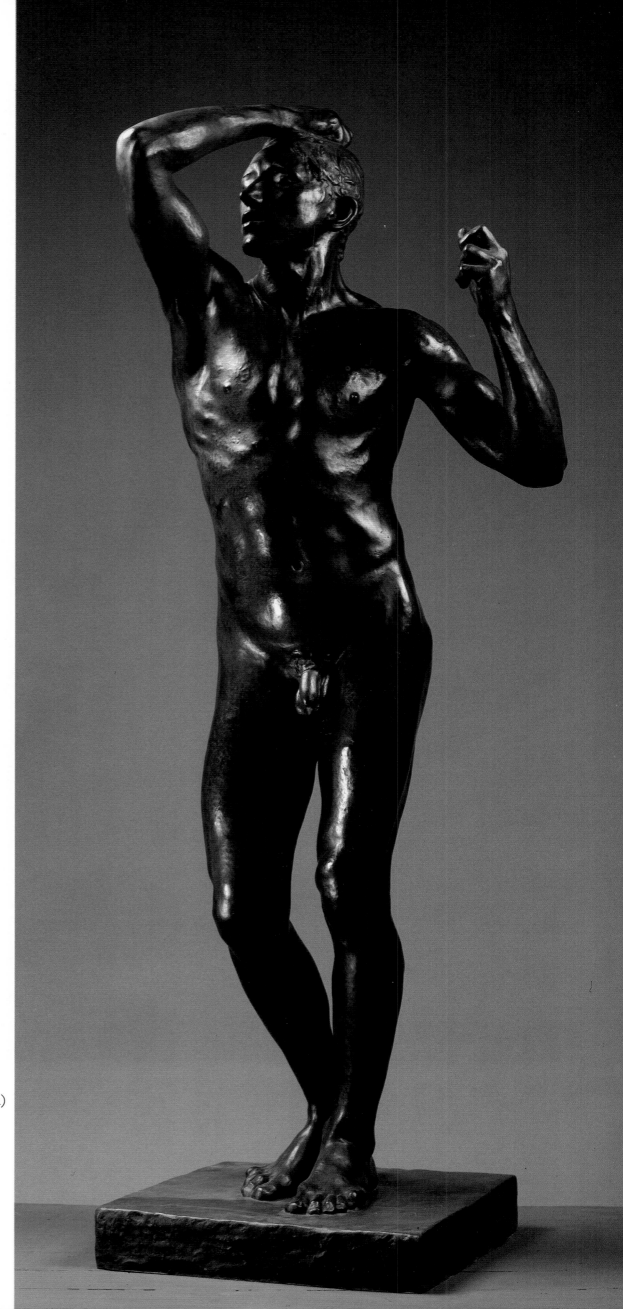

Left:
The Age of Bronze, 1875 or 1876
Bronze
69×26⅝×20⅞ inches (175.3×67.5×52.9 cm)
Musée Rodin, Paris S 986

Right:
The Age of Bronze, 1876-78
Bronze
70⅞×31½×23⅝ inches (180×80×60 cm)
Musée Rodin, Paris S 468

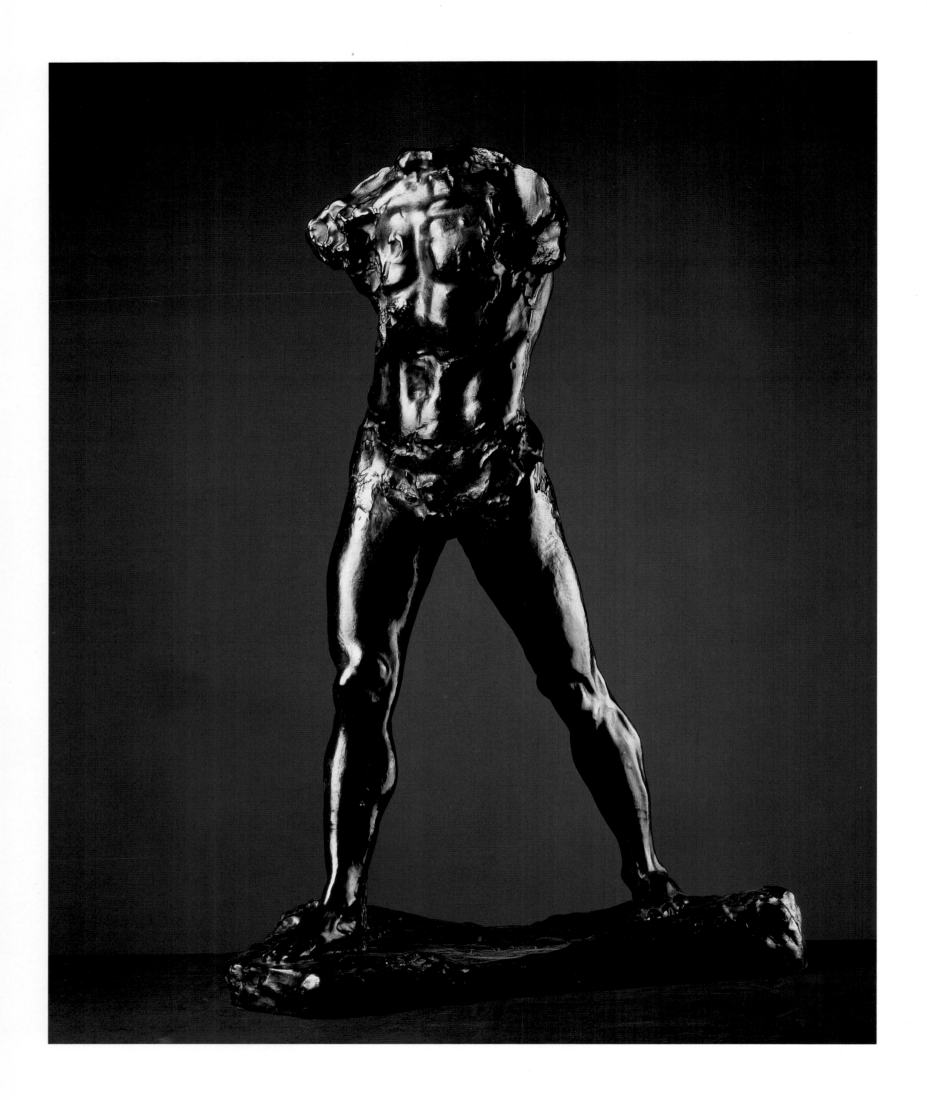

Above:
The Walking Man, 1877
Bronze
33½×11×22⅞ inches (85×28×58 cm)
Musée Rodin, Paris S 495

Right:
Saint John the Baptist, 1877
Bronze
78⅞×28⅝×43½ inches
(200.3×72.6×110.5 cm)
Musée Rodin, Paris S 999

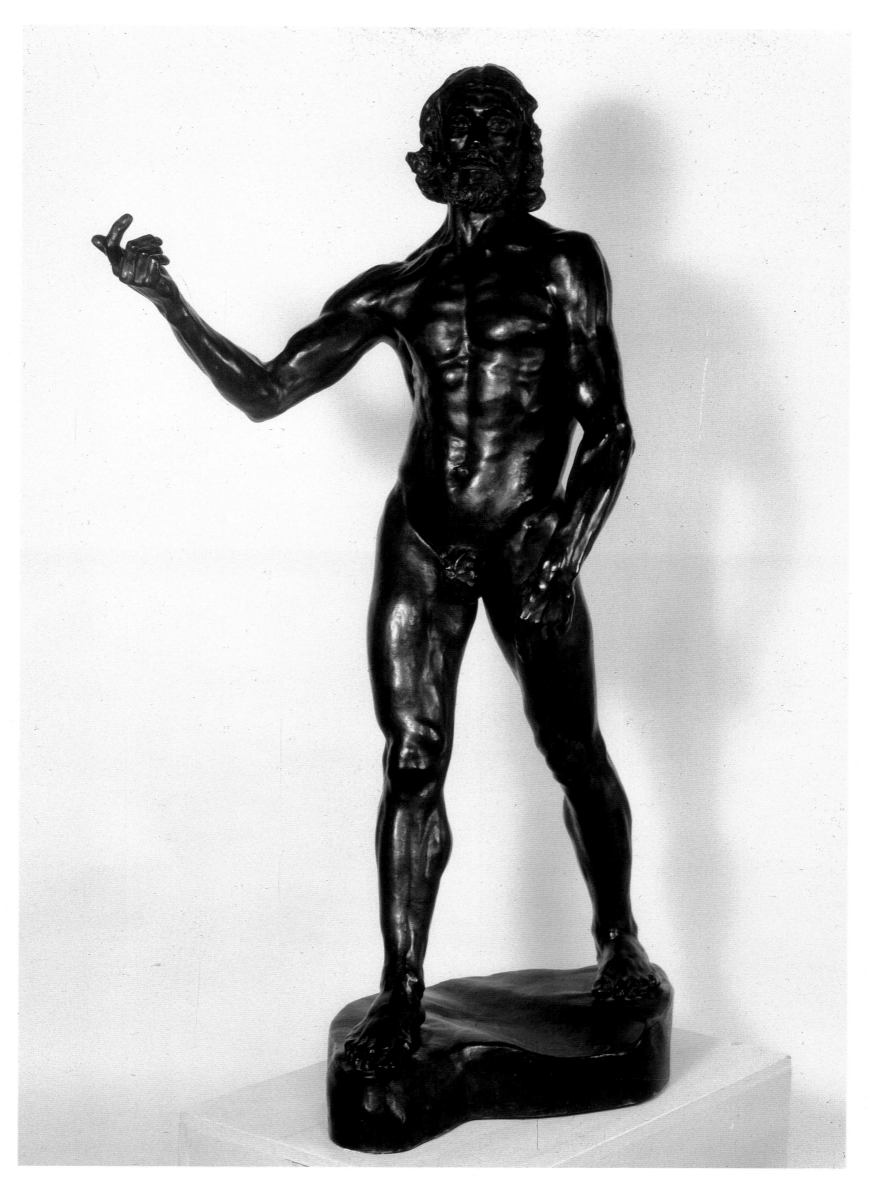

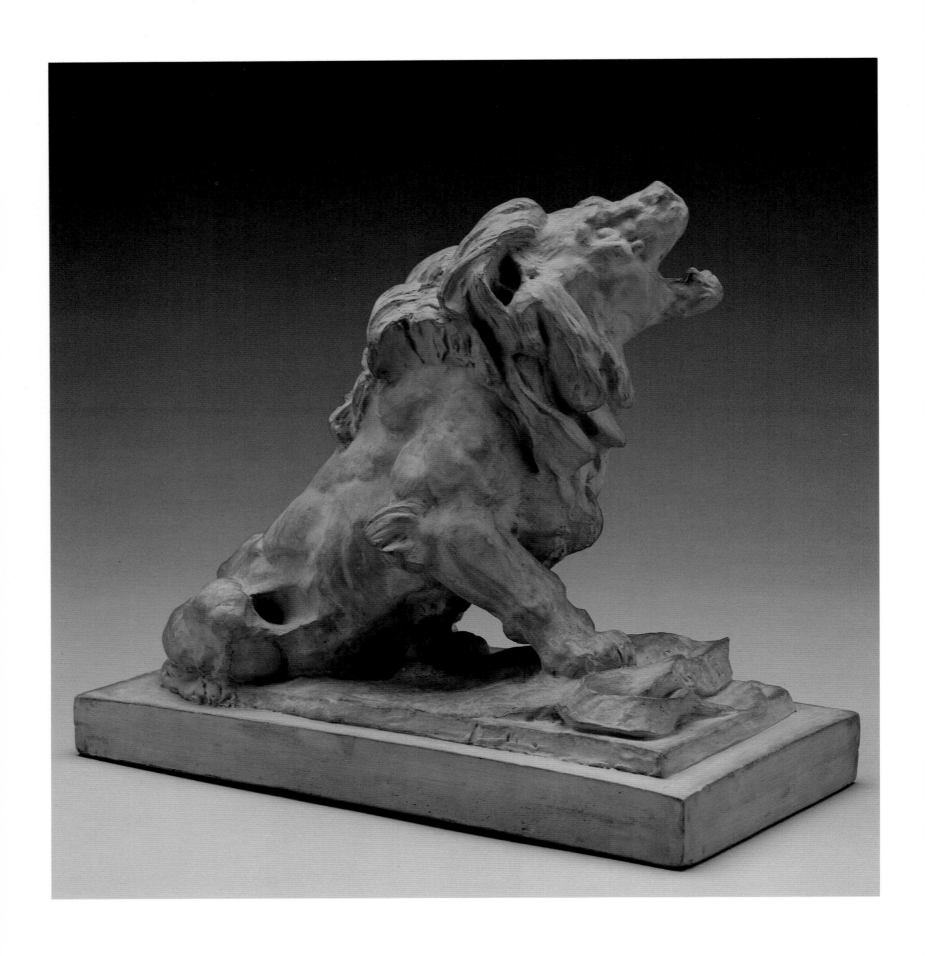

Above:
The Crying Lion, 1881
Terracotta
11⅛×13⅛×6⅛ inches (28.3×33.3×15 cm)
Maryhill Museum of Art, Goldendale, Wa
Gift of the B Gerald Cantor Foundation

Right:
The Call to Arms, c. 1879
Bronze
44×22⅞×19⅜ inches (112×58×50 cm)
Musée Rodin, Paris S 984

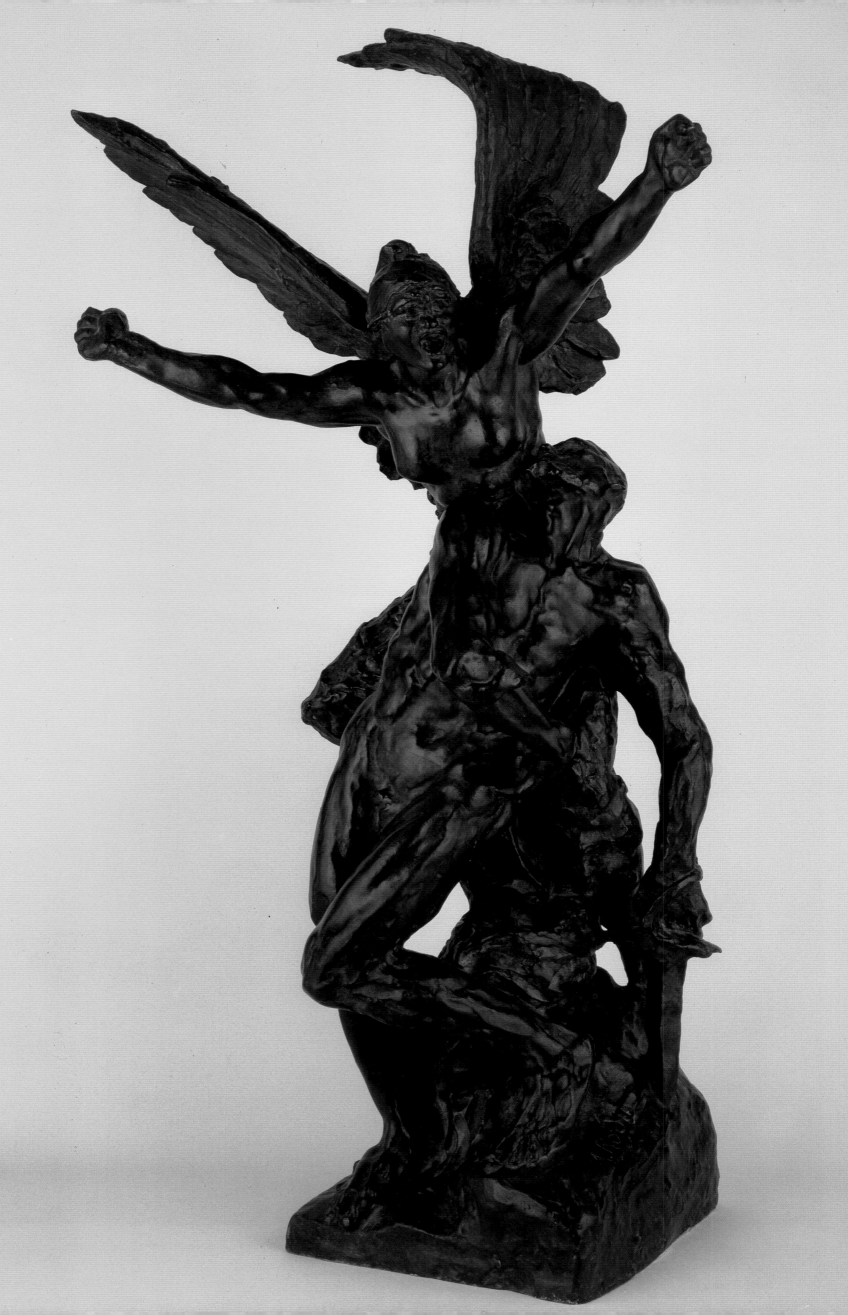

Below:
Torso of Adele, 1882
Bronze
6½×18⅞×8 inches (16.6×47.9×20.5 cm)
Musée Rodin, Paris S 6137

Right:
Torso of Adele, 1882
Terracotta
4⅛×14⅝×6½ inches (10.5×37.3×16.4 cm)
Musée Rodin, Paris S 1177

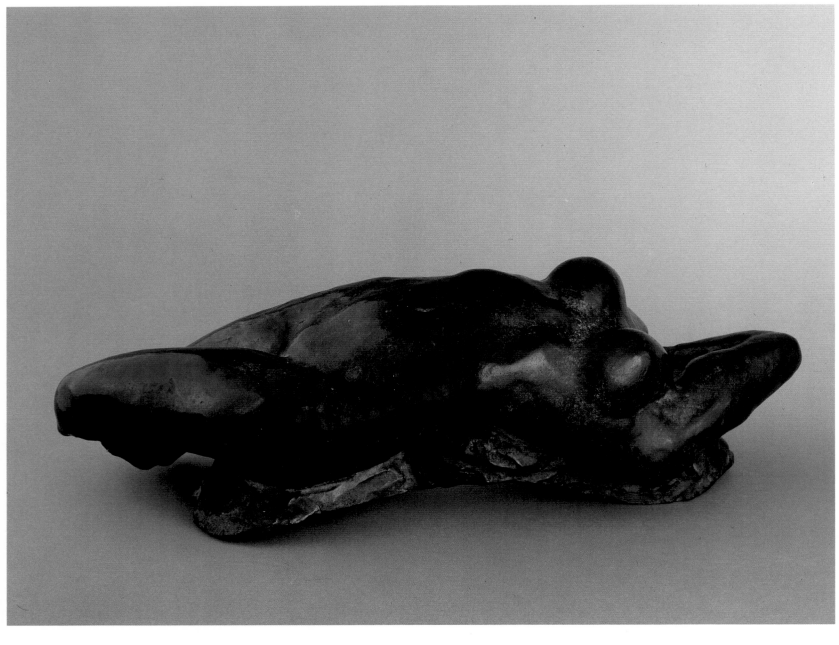

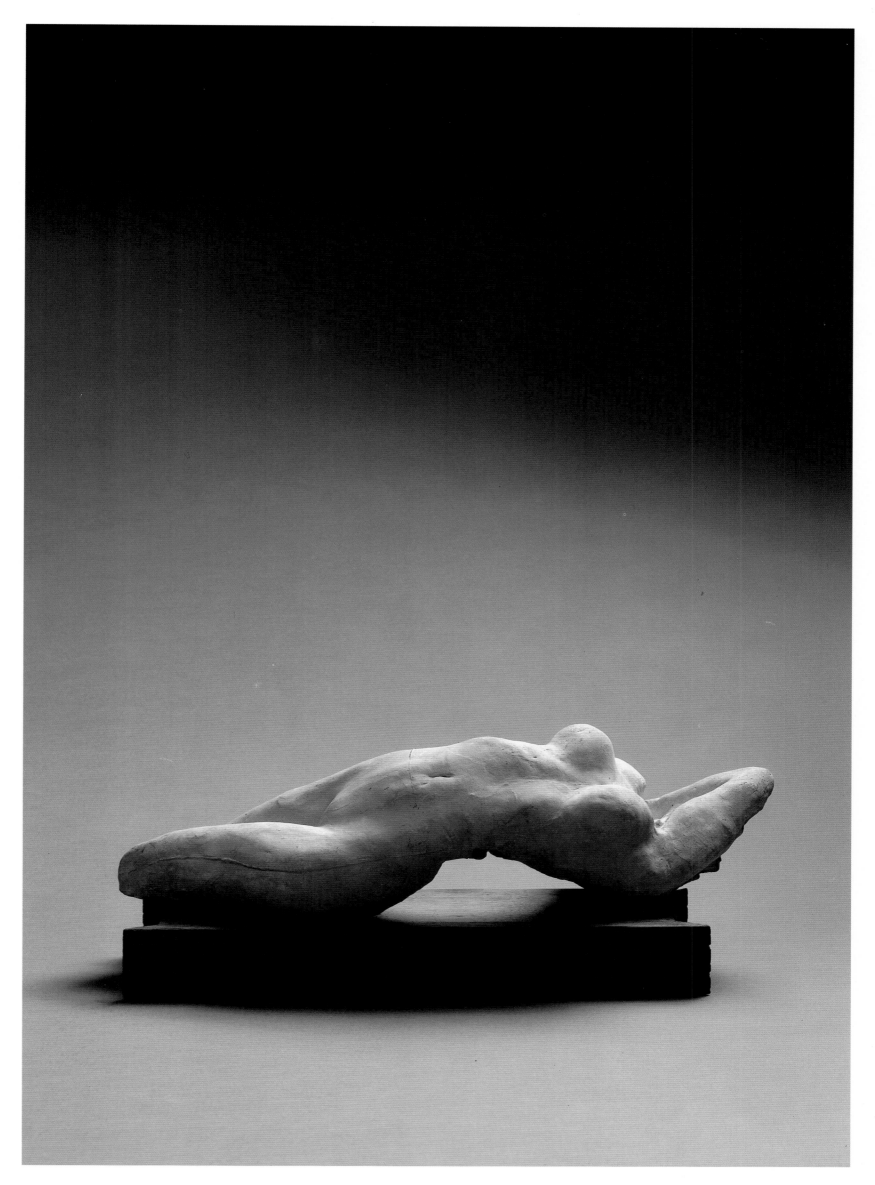

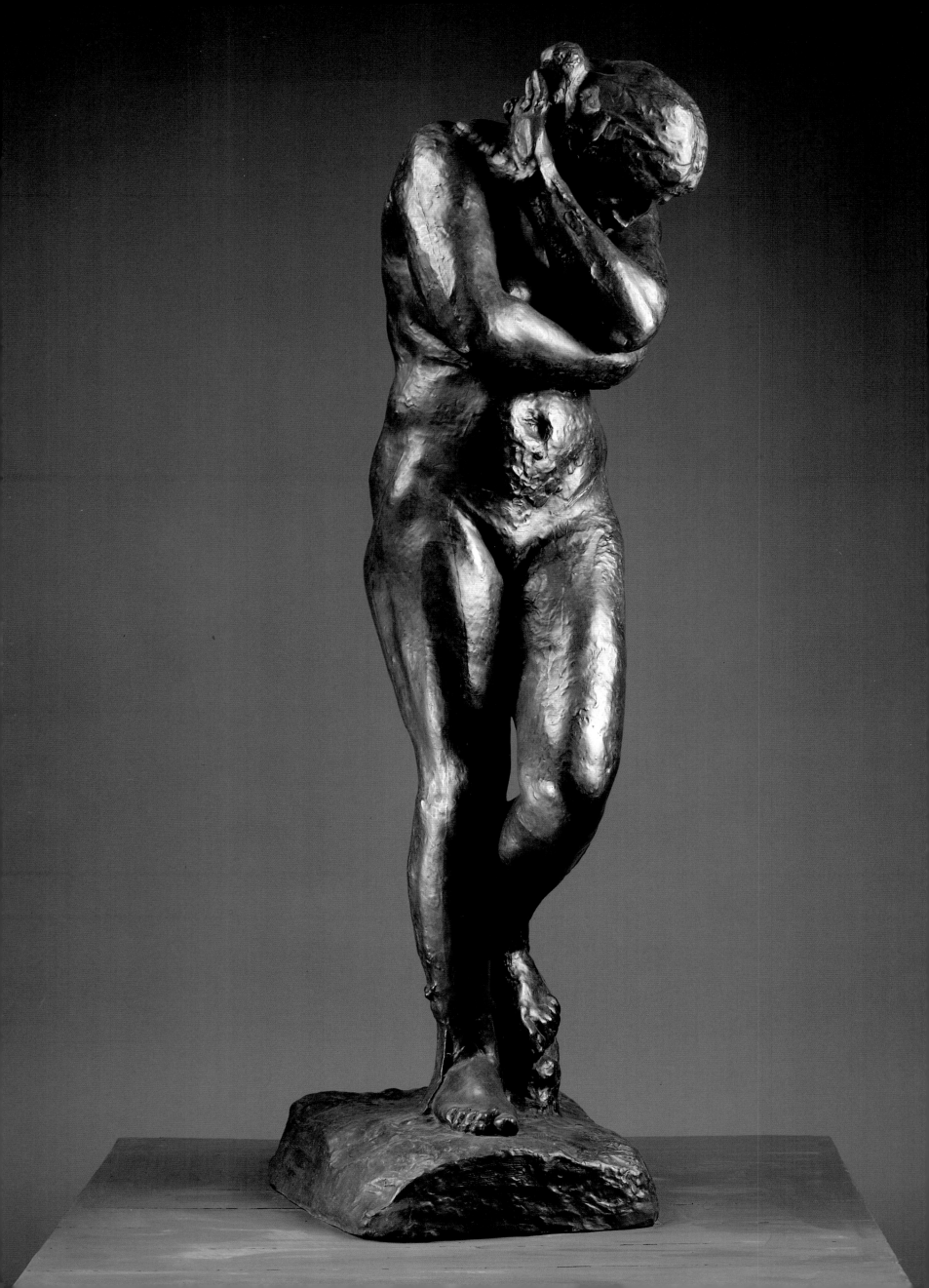

Left:
Eve, 1881
Bronze
76¾×35½×23⅝ inches (195×90×60 cm)
Musée Rodin, Paris S 484

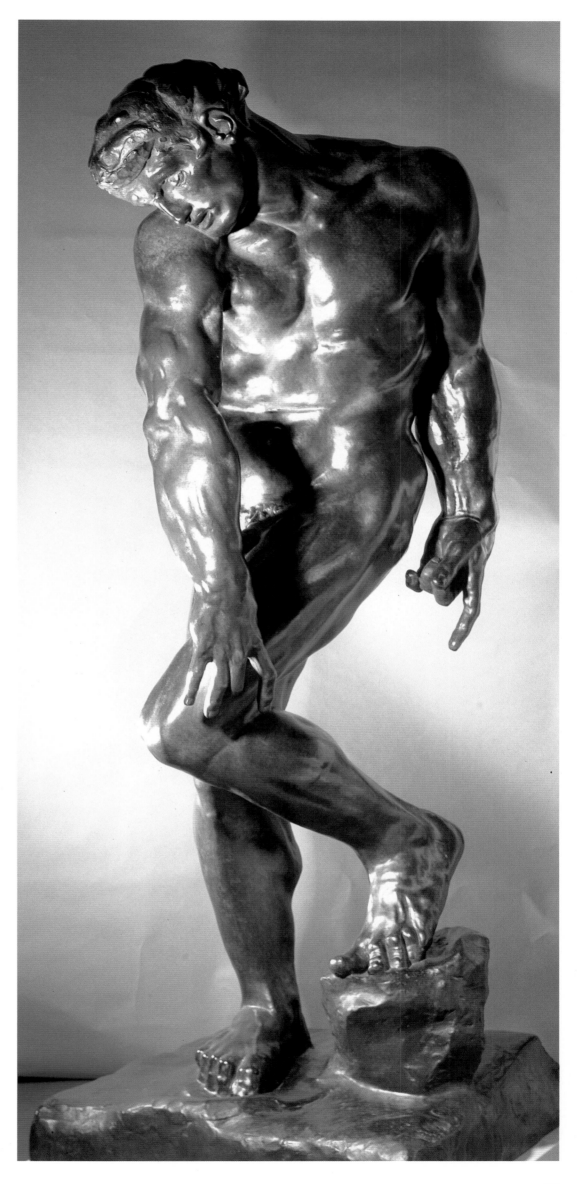

Right:
Adam, 1880
Bronze
75½×29½×29½ inches (191.8×95×75 cm)
B Gerald Cantor Collection, New York

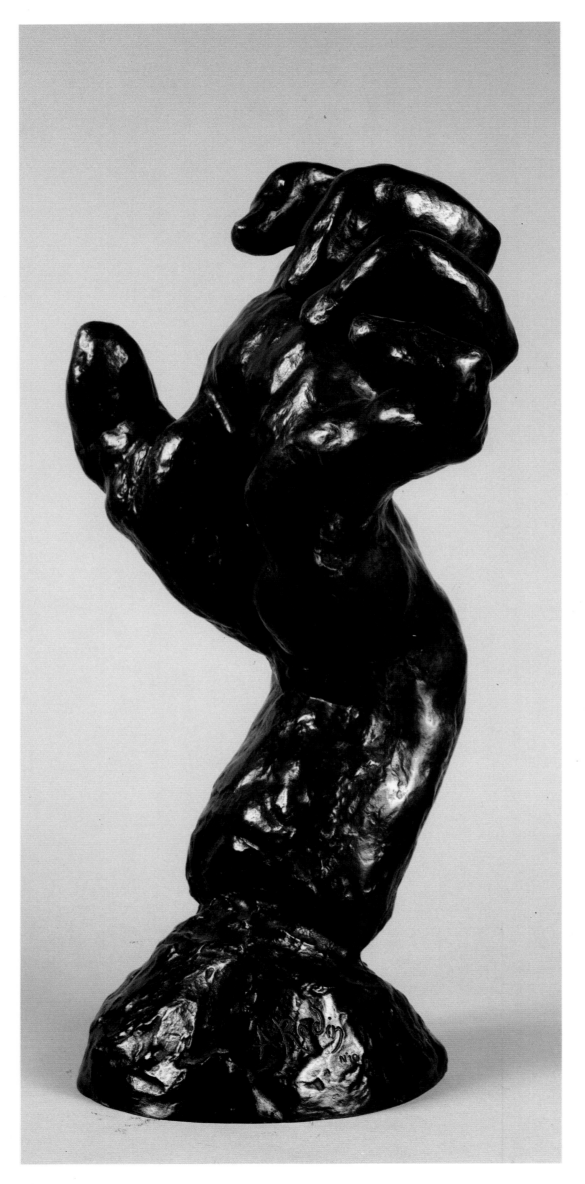

Left:
Large Clenched Left Hand, c. 1885
Bronze
18¼×10⅜ inches (46.4×26.4 cm)
The Metropolitan Museum of Art, New York
Gift of the B Gerald Cantor Foundation, 1984

Right:
The Gates of Hell, 1880-1917
Bronze
250×157½×33½ inches (635×400×85 cm)
Musée Rodin, Paris S 1304

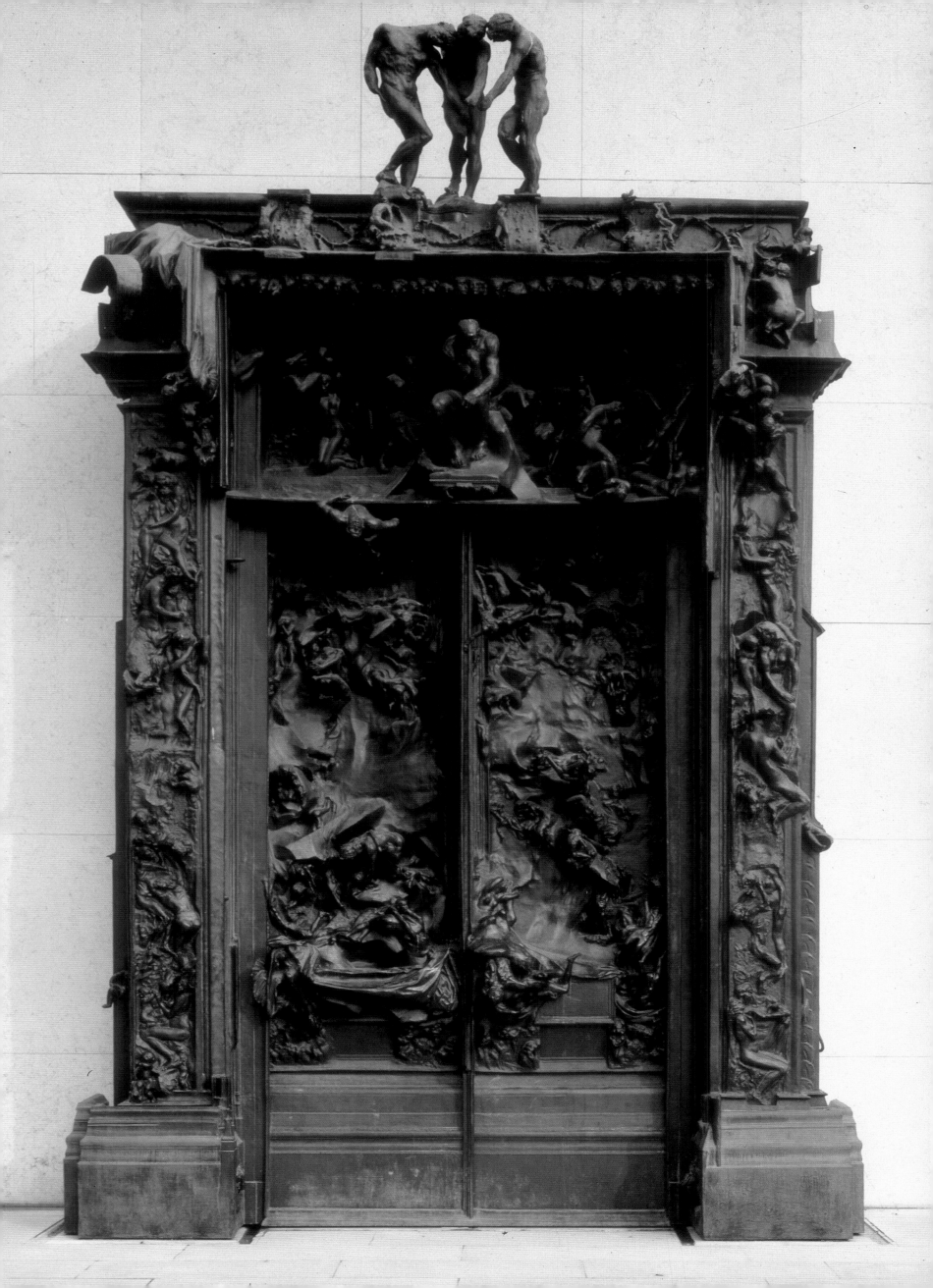

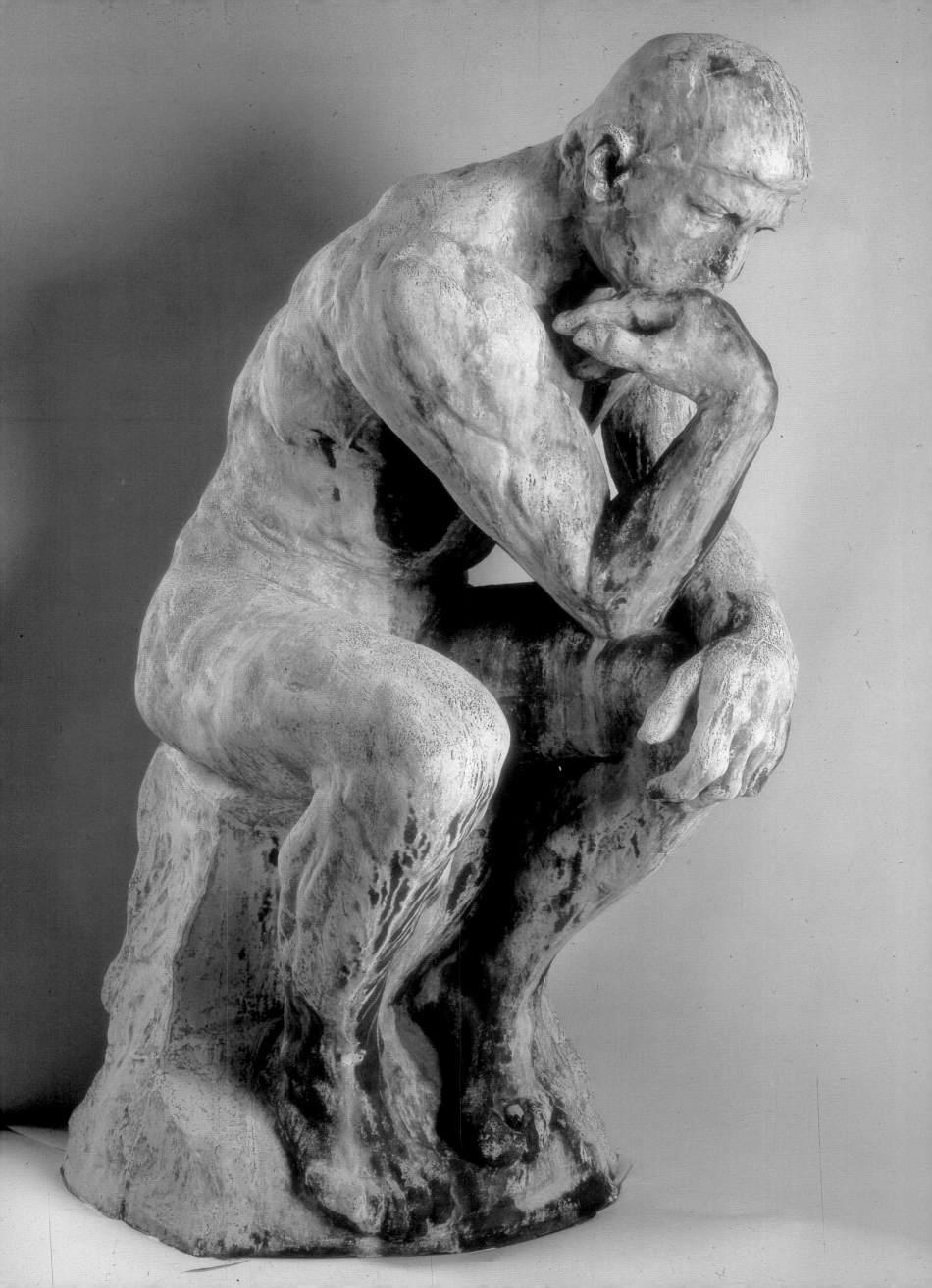

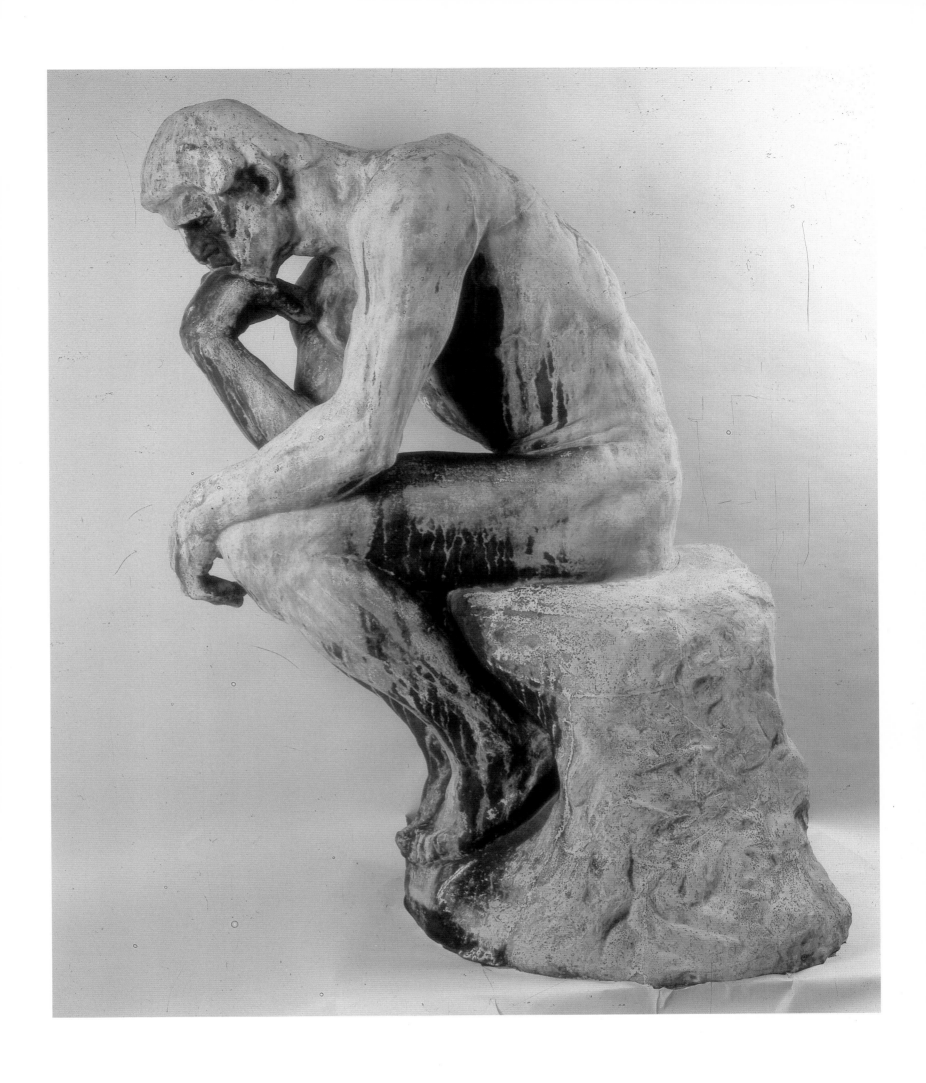

The Thinker, 1880
Bronze
70⅞×38⅝×57 inches (180×98×145 cm)
Musée Rodin, Paris S 1295

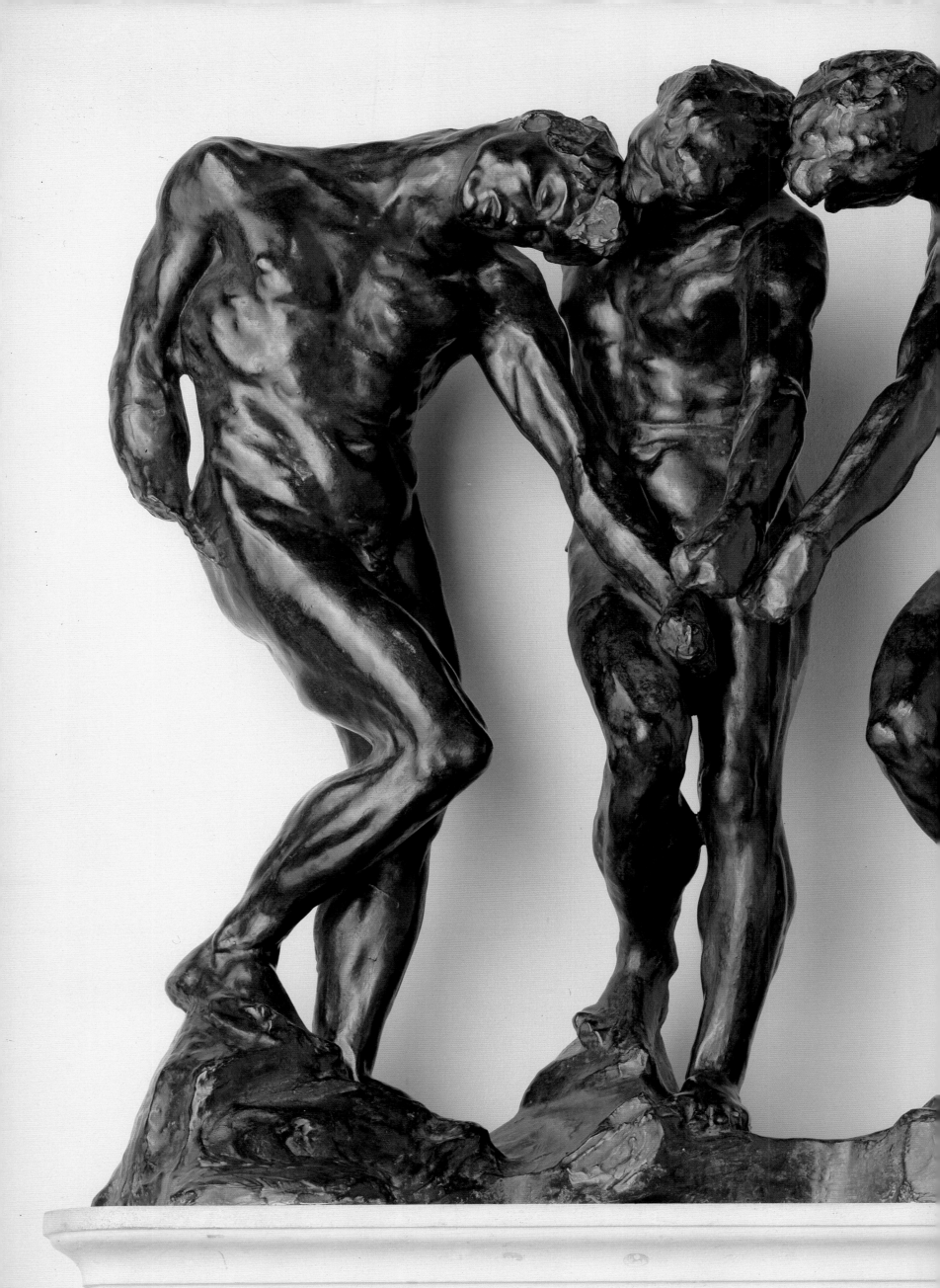

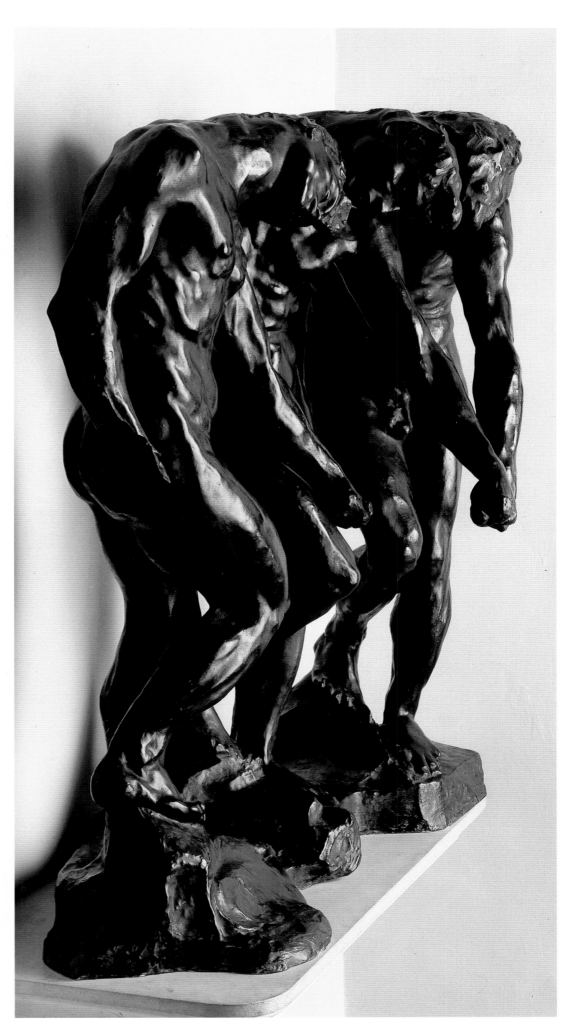

The Three Shades, 1880
Bronze
38×36¼×21¼ inches (96.6×92×54.1 cm)
Musée Rodin, Paris S 1191

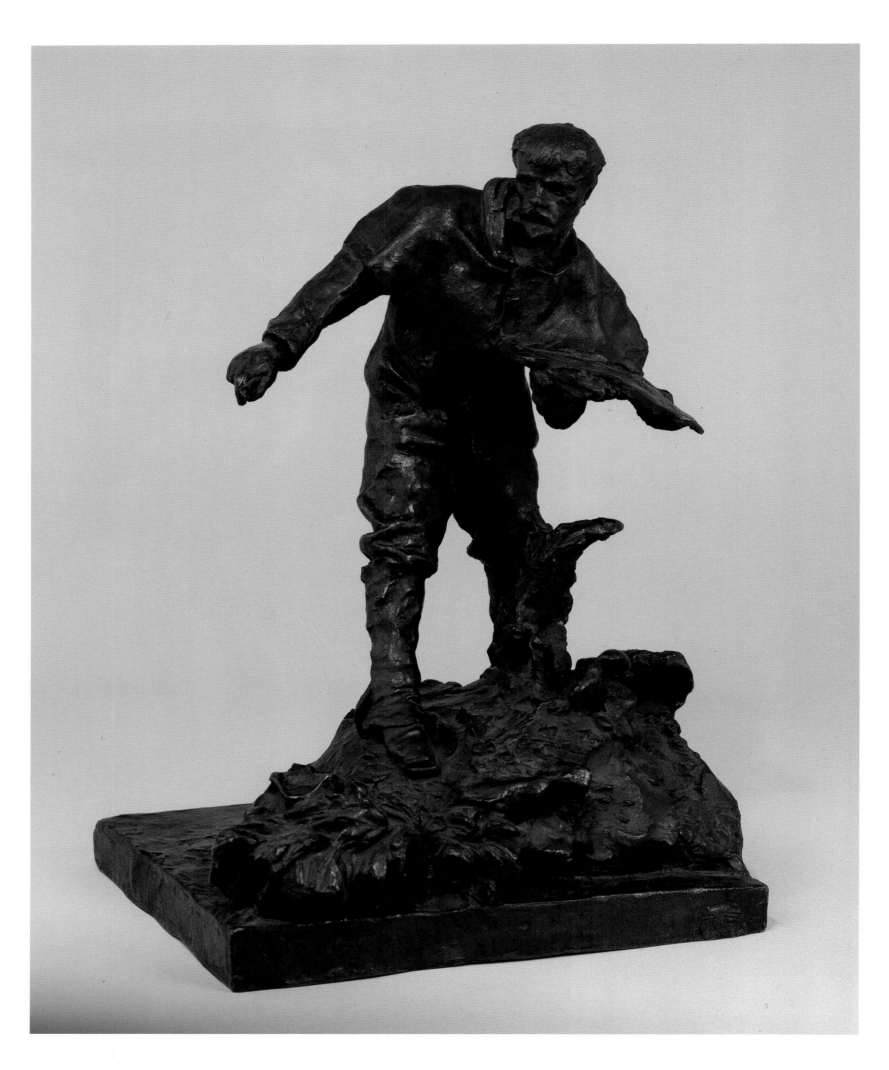

Above:
Study for a Monument to Bastien-Lepage,
c. 1887
Bronze
14½×11×9 inches (36.85×27.9×22.9 cm)
Wadsworth Atheneum, Hartford
Gift of Samuel P Avery

Right:
The Caryatid and the Stone, c. 1881
Bronze
17¼×12⅝×11¾ inches (44×32×30 cm)
Musée Rodin, Paris S 477

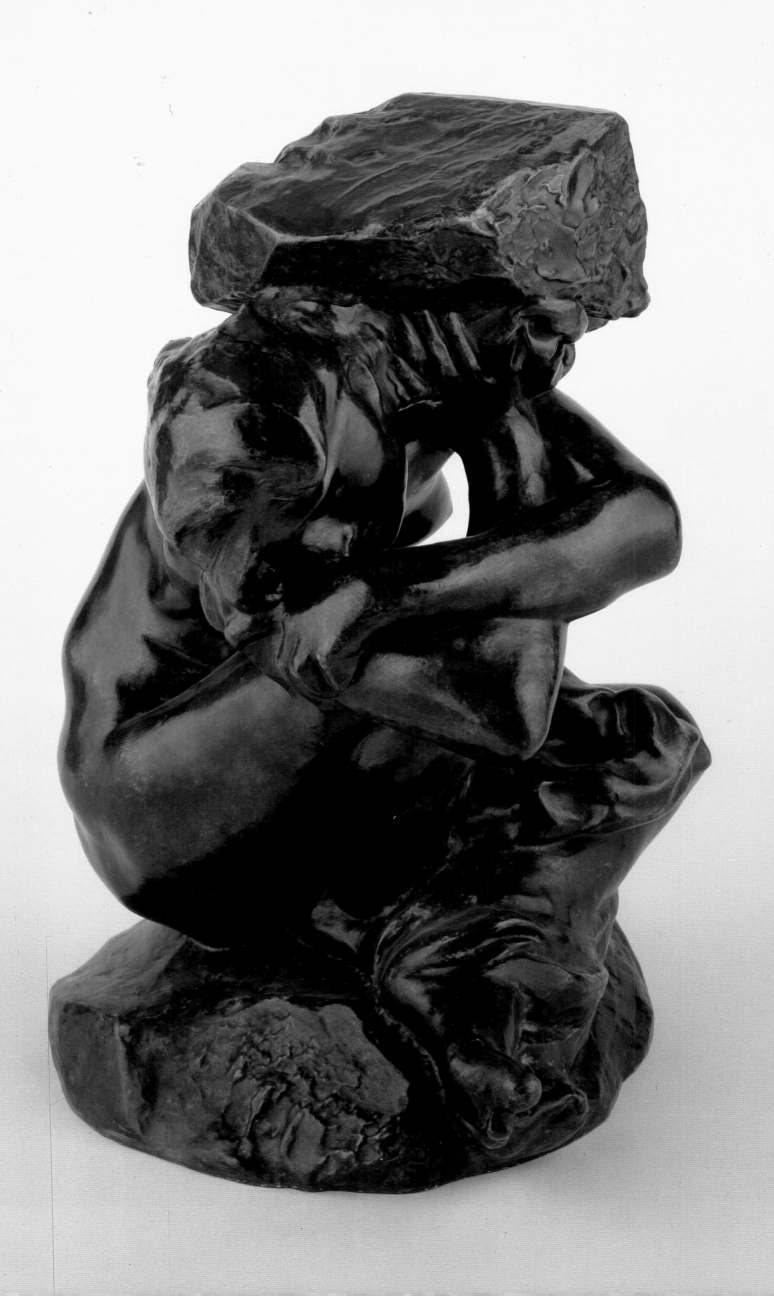

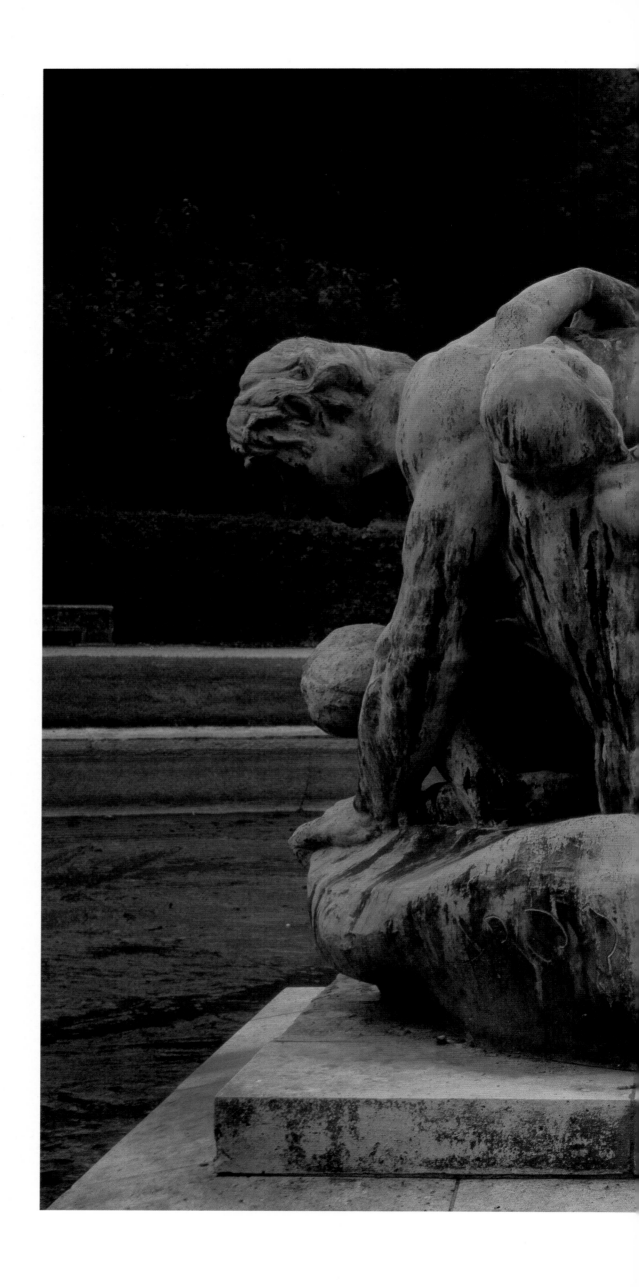

Ugolino, c. 1881
Bronze
Musée Rodin, Paris S 1427

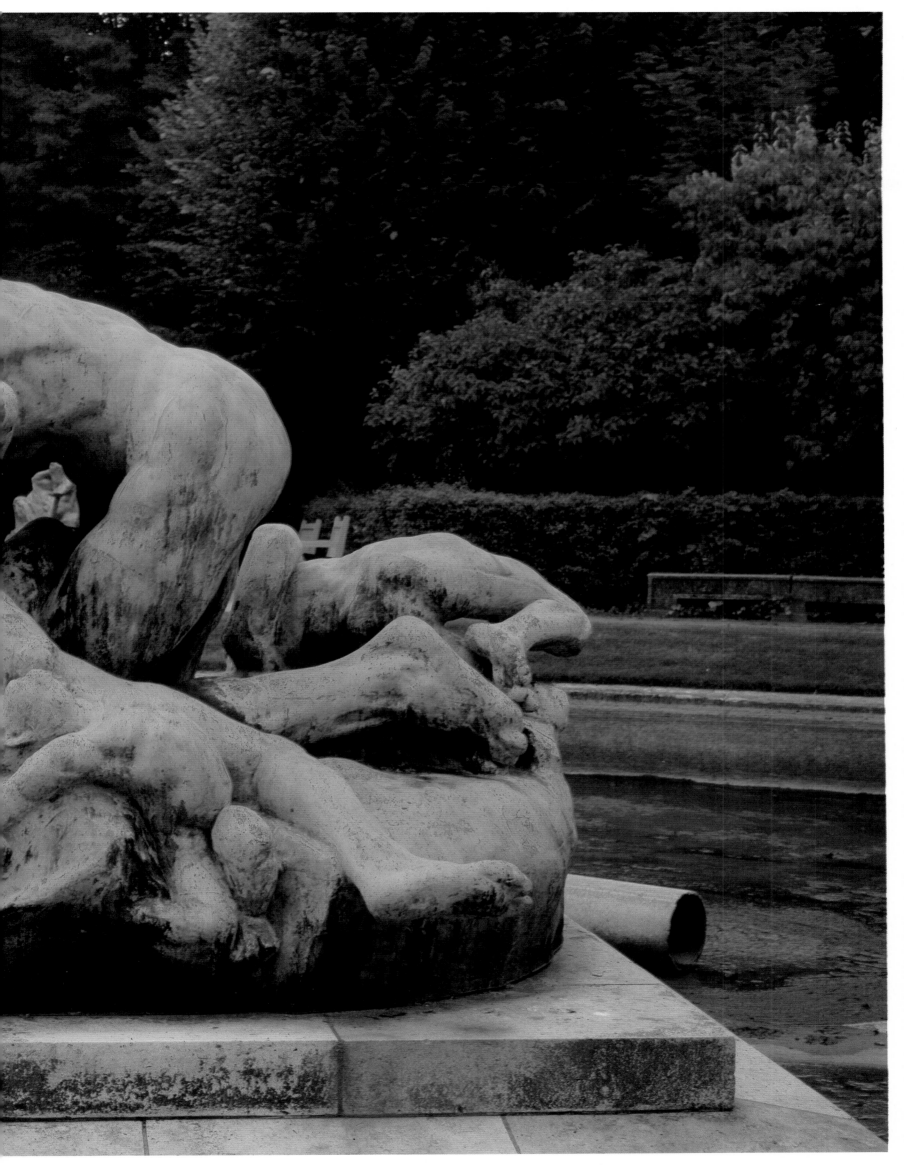

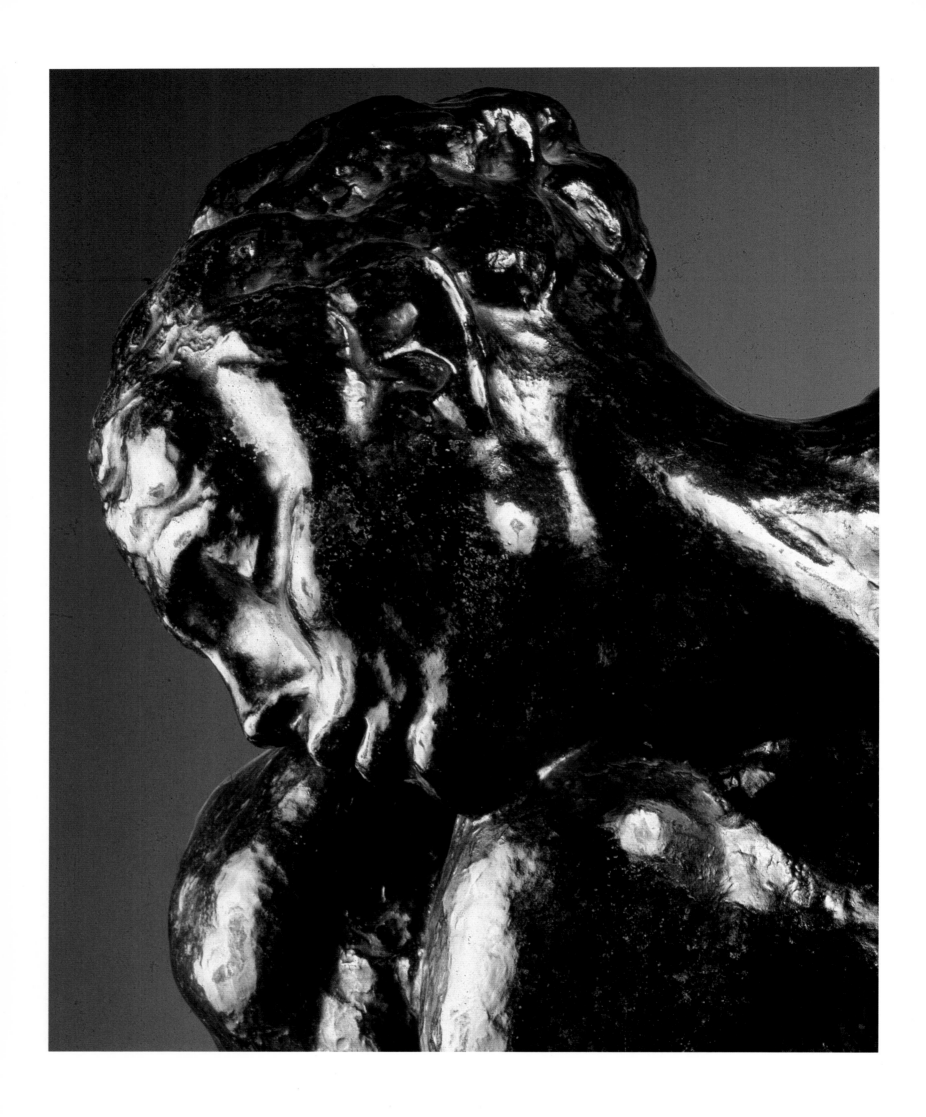

The Crouching Woman, 1882
Bronze
33¼×24¼×20¼ inches (84.4×61.5×51.5 cm)
Musée Rodin, Paris S 1156

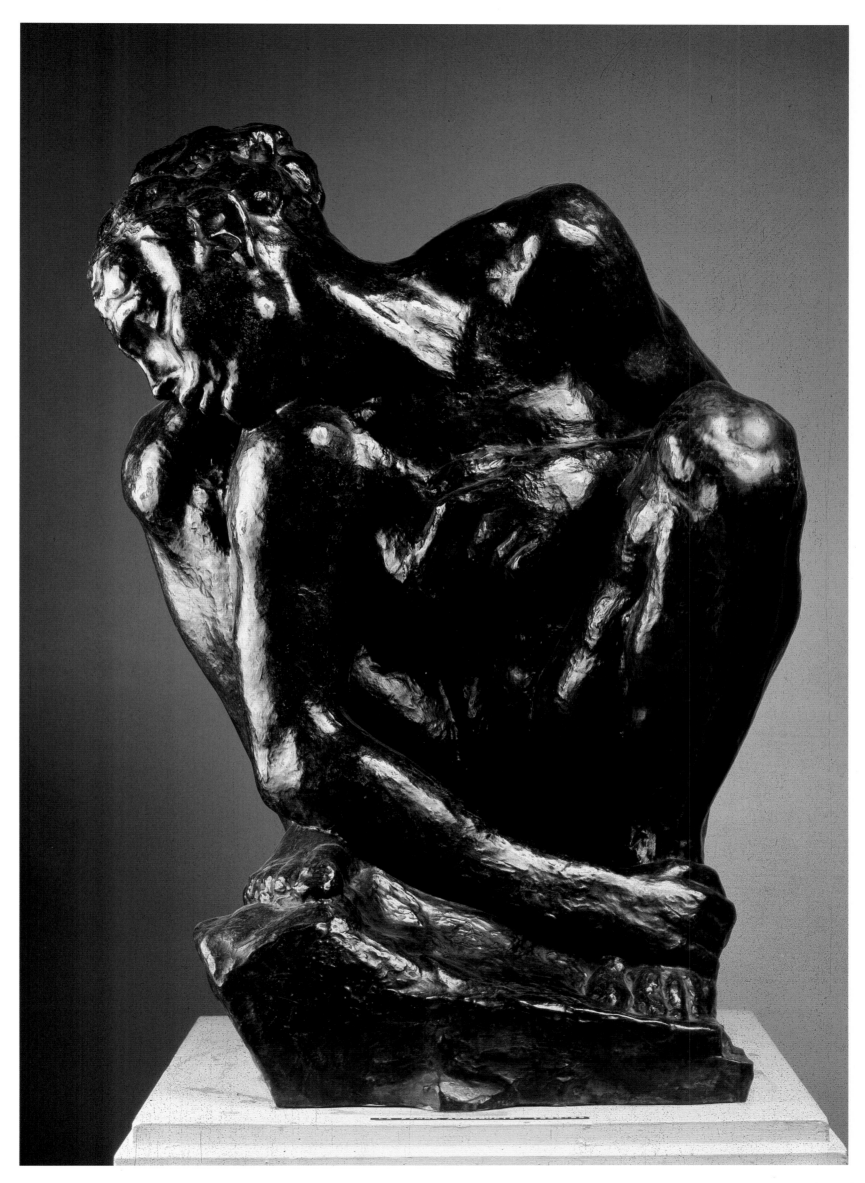

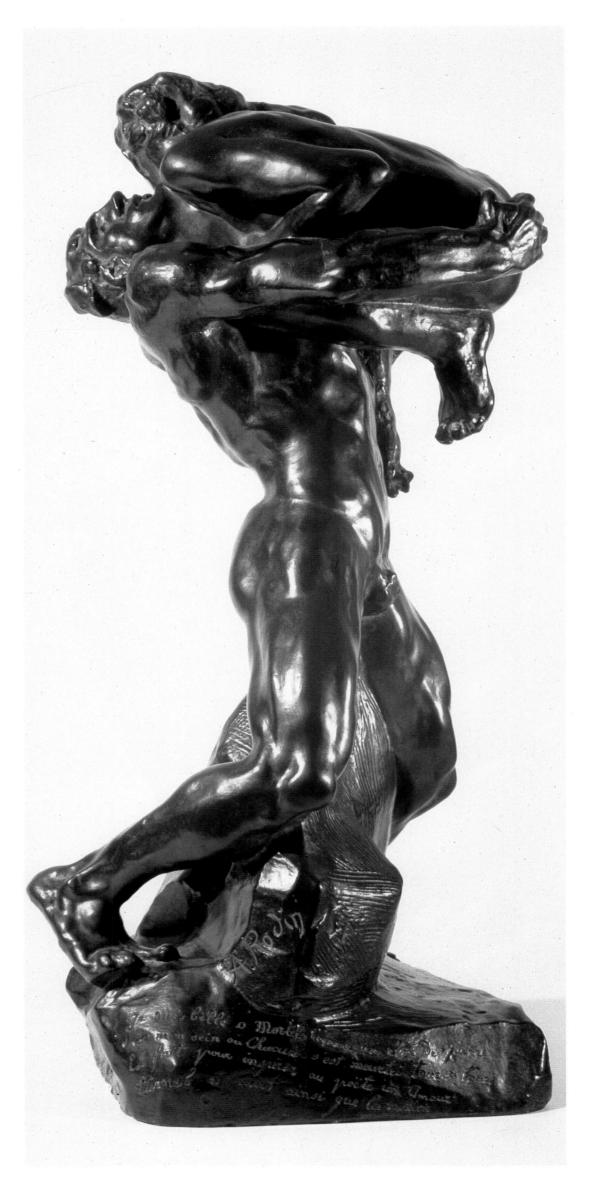

I am Beautiful, 1882
Bronze
27⅛×12⅛×12½ inches (69×30.8×31.9 cm)
Musée Rodin, Paris S 1151

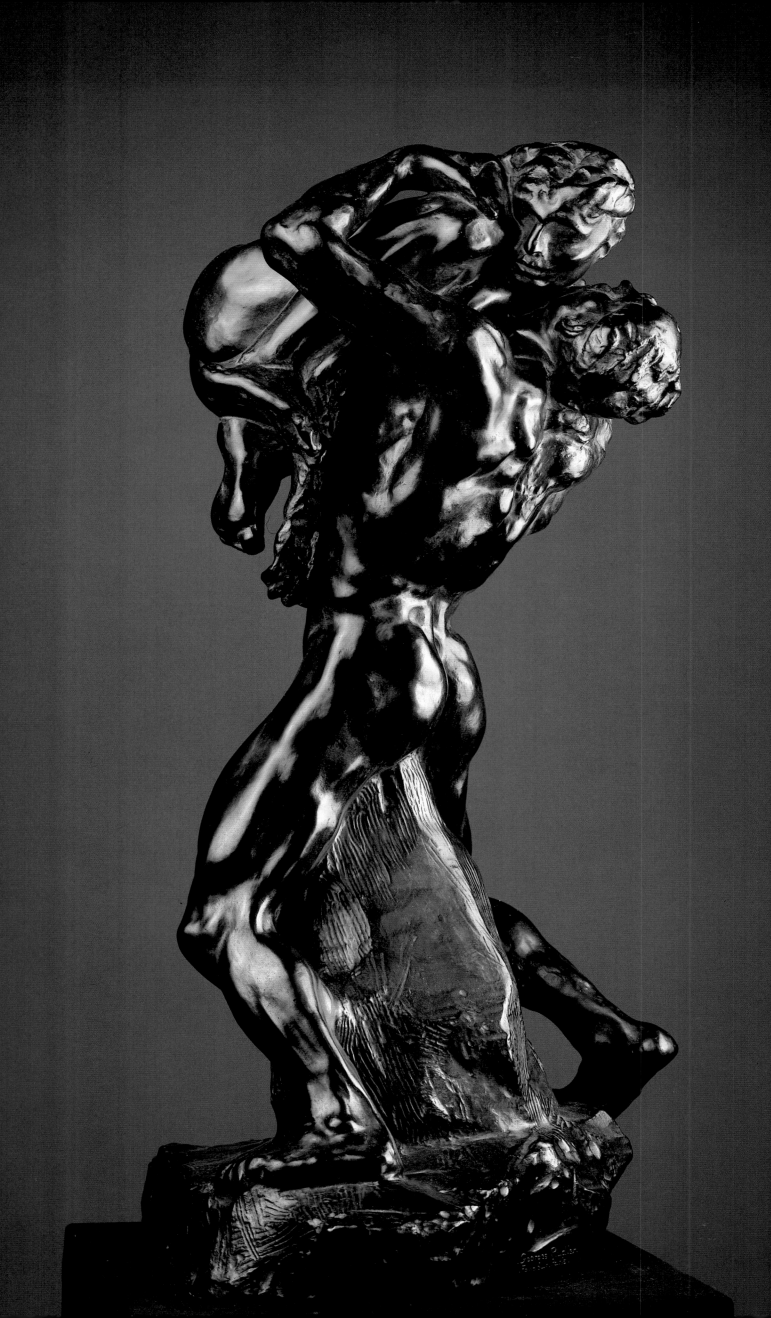

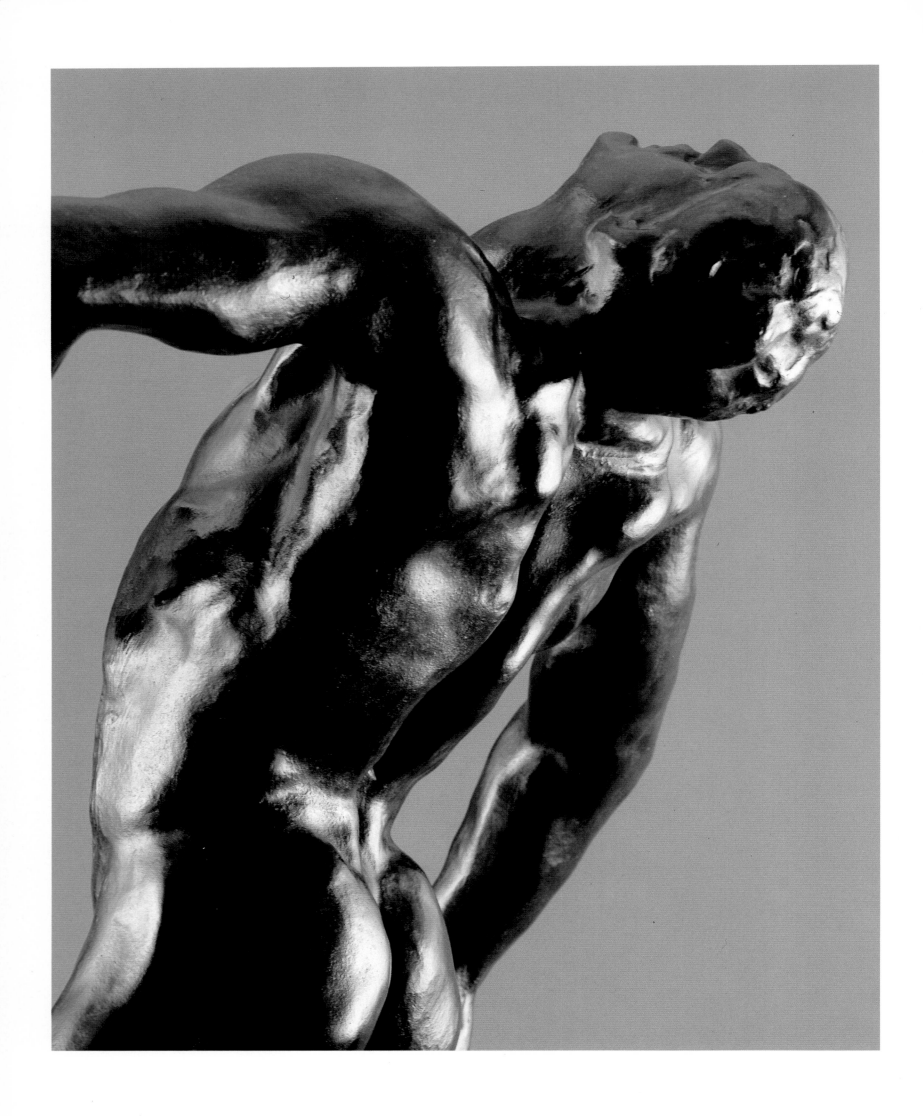

The Falling Man, 1882
Bronze
23¼×14½×11½ inches (57×37×29 cm)
Musée Rodin, Paris S 963

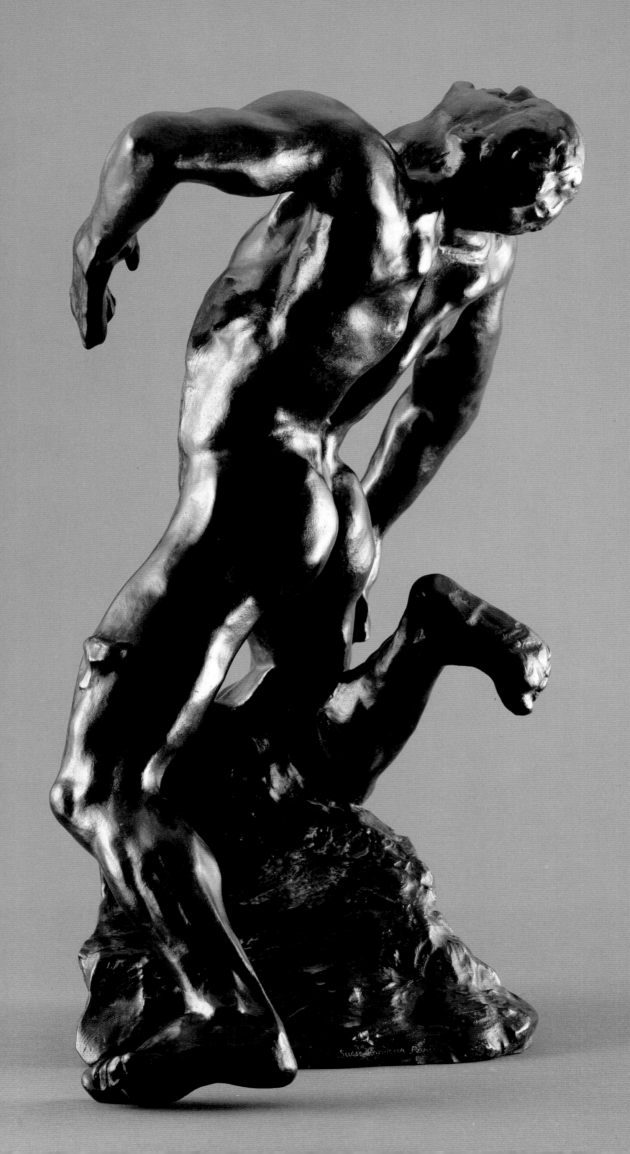

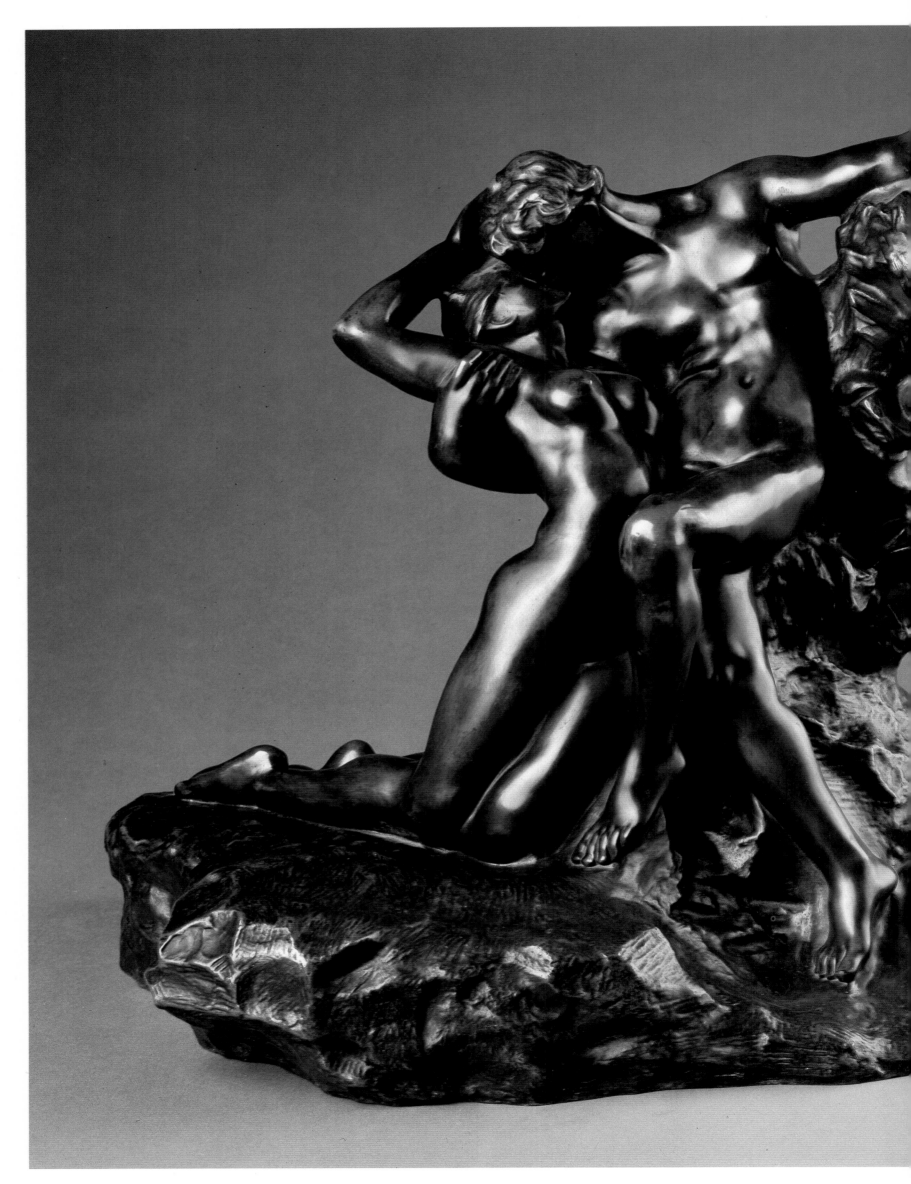

Eternal Spring, 1884
Bronze
15¾×20⅞×11¾ inches (40×53×30 cm)
Musée Rodin, Paris S 583

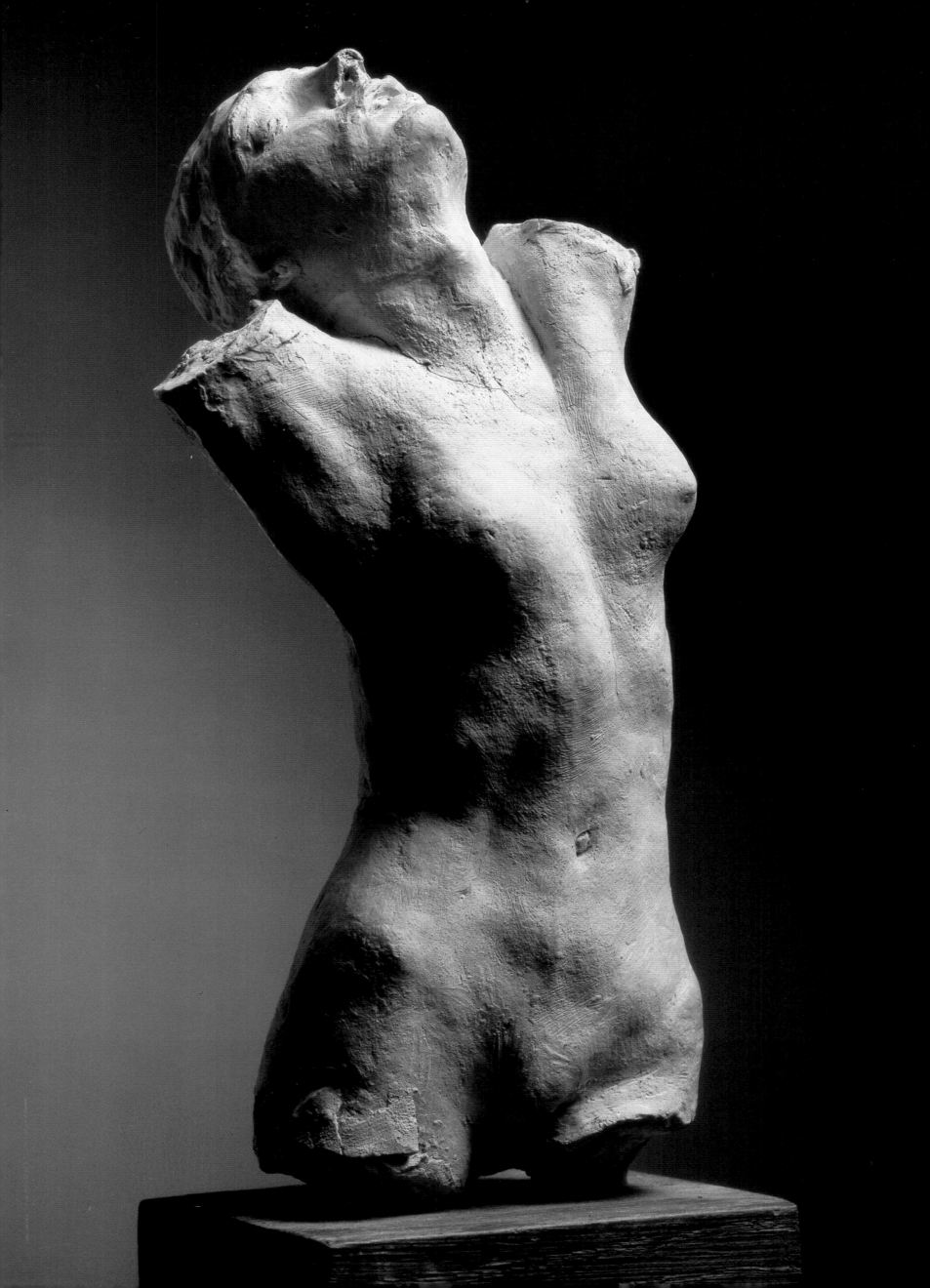

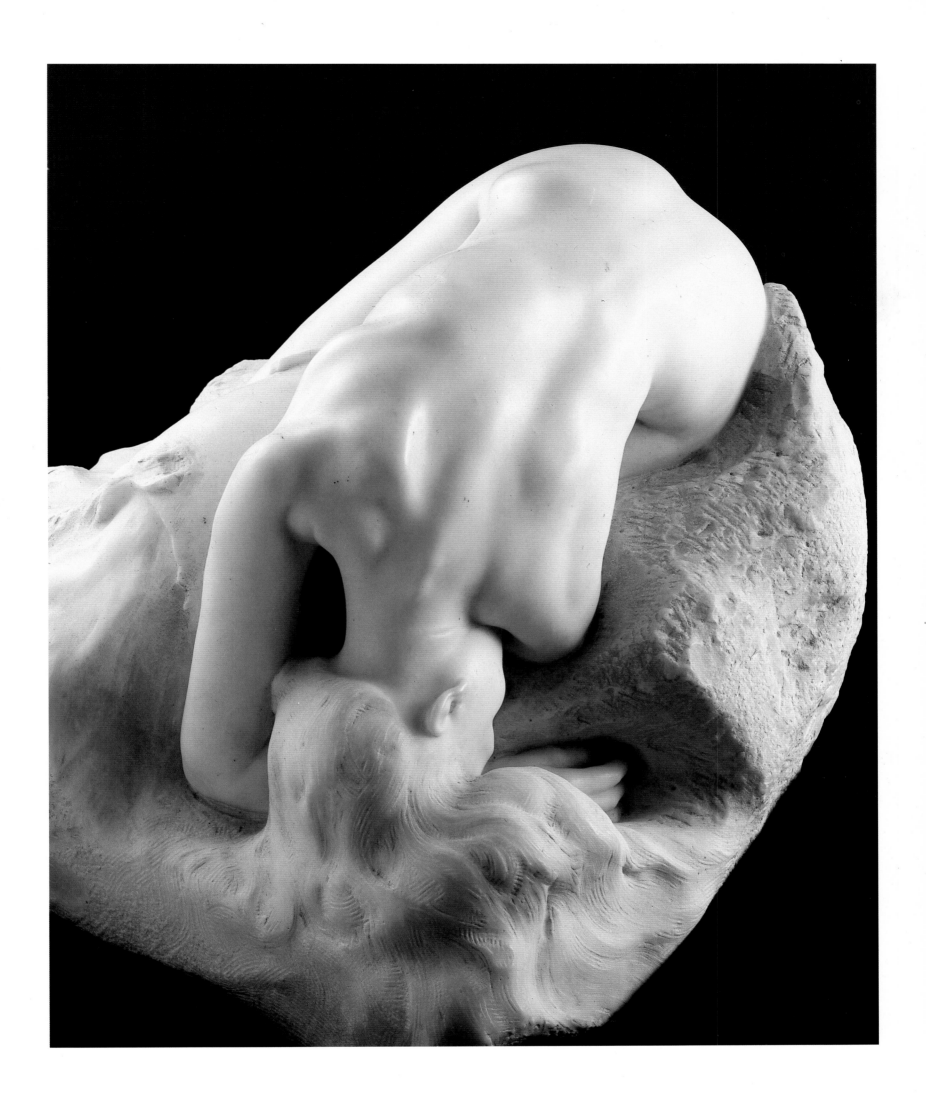

Left:
Torso of the Centauress, c. 1884
Terracotta
8½×4×3 inches (21.5×10.3×7.7 cm)
Musée Rodin, Paris S 990

Above:
Danaïde, 1885
Marble
14⅛×28×20⅞ inches (36×71×53 cm)
Musée Rodin, Paris S 1155

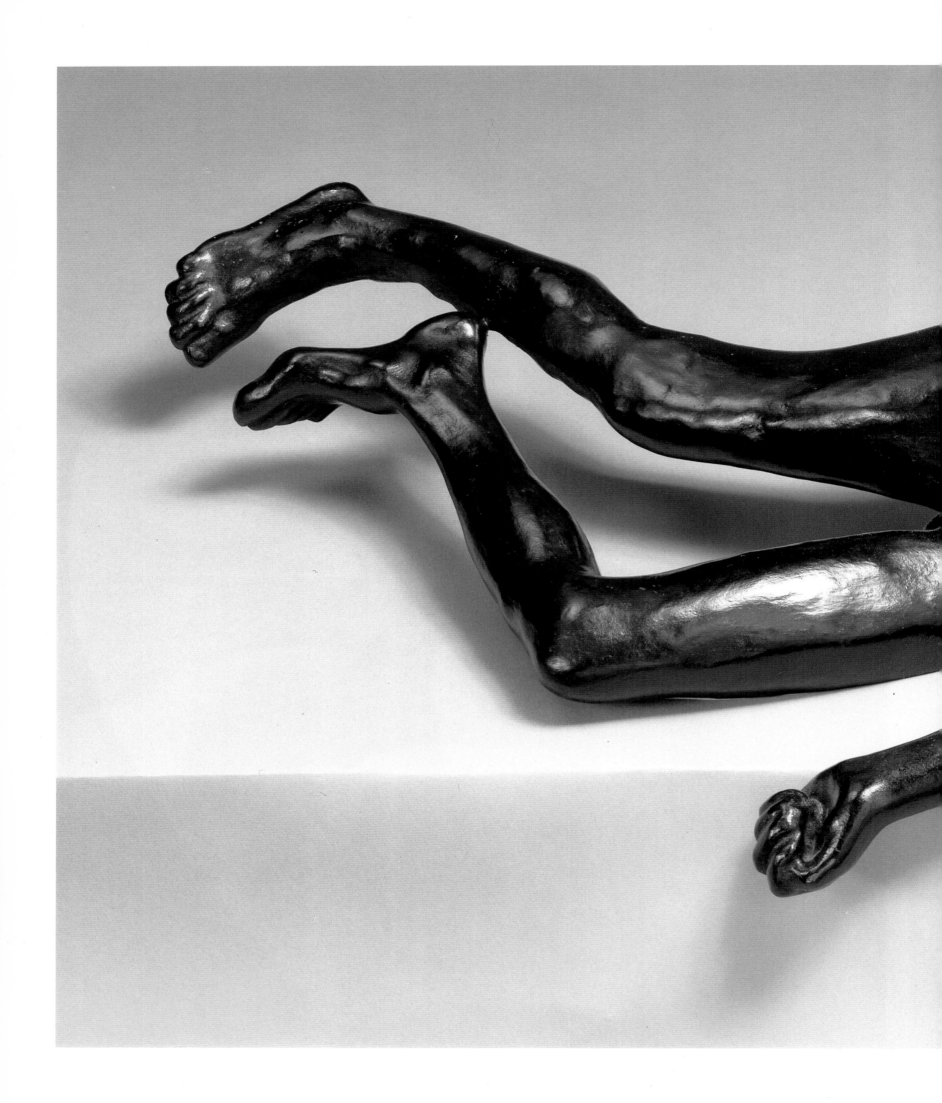

The Martyr, 1885
Bronze
Length: 23 inches (58.4 cm)
Indianapolis Museum of Art
Gift of B Gerald Cantor

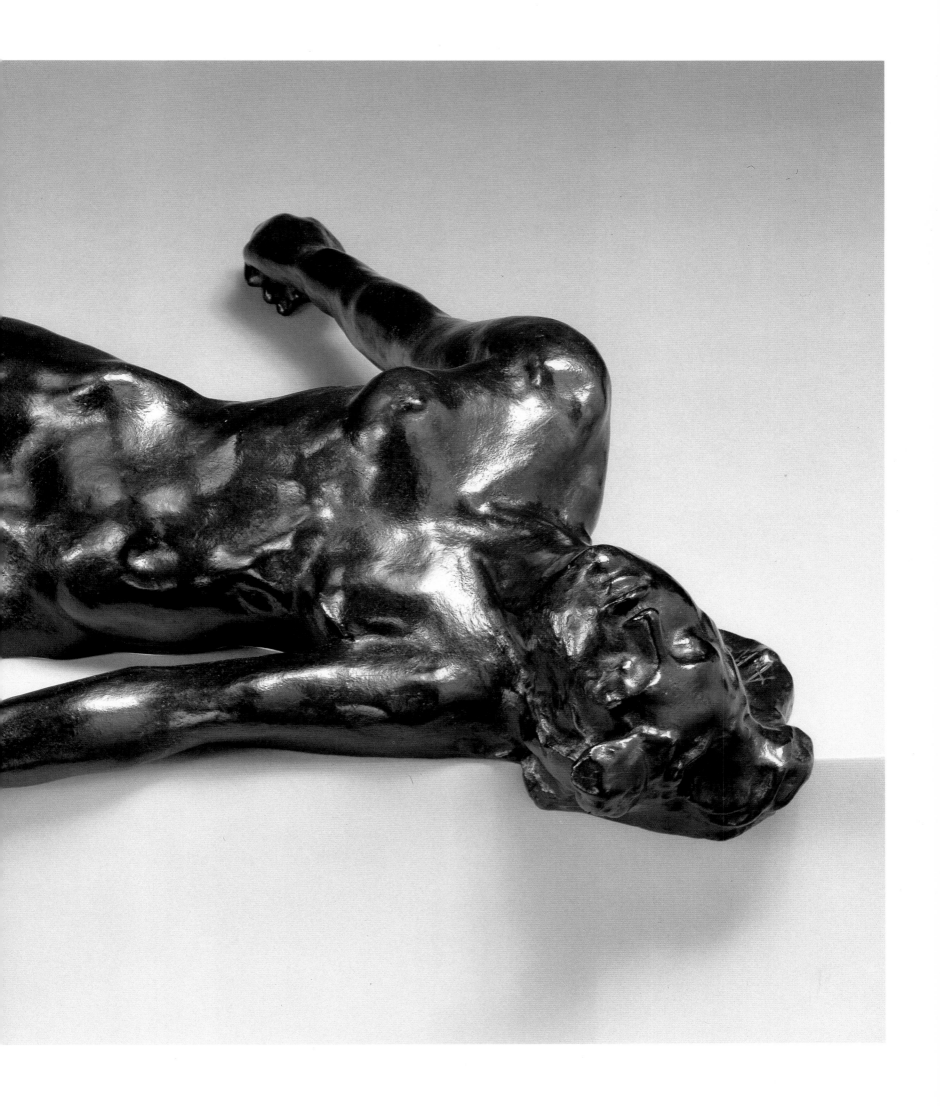

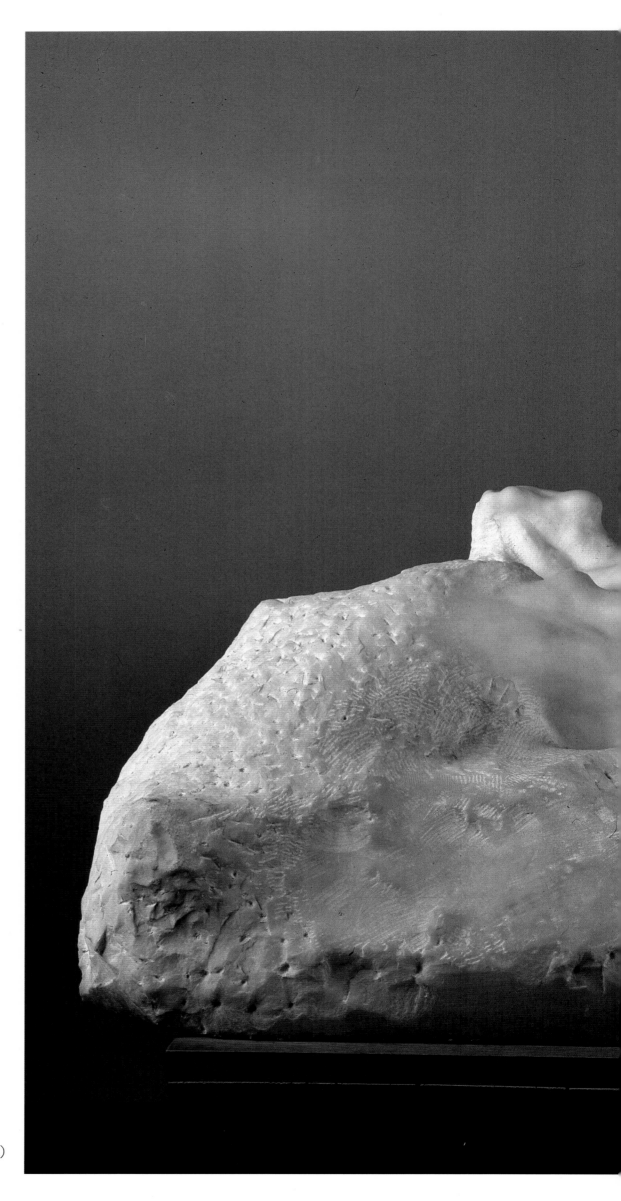

The Wave, 1887
Marble
25⅛×46⅞×24½ inches (63.3×119×62 cm)
Musée Rodin, Paris S 1025

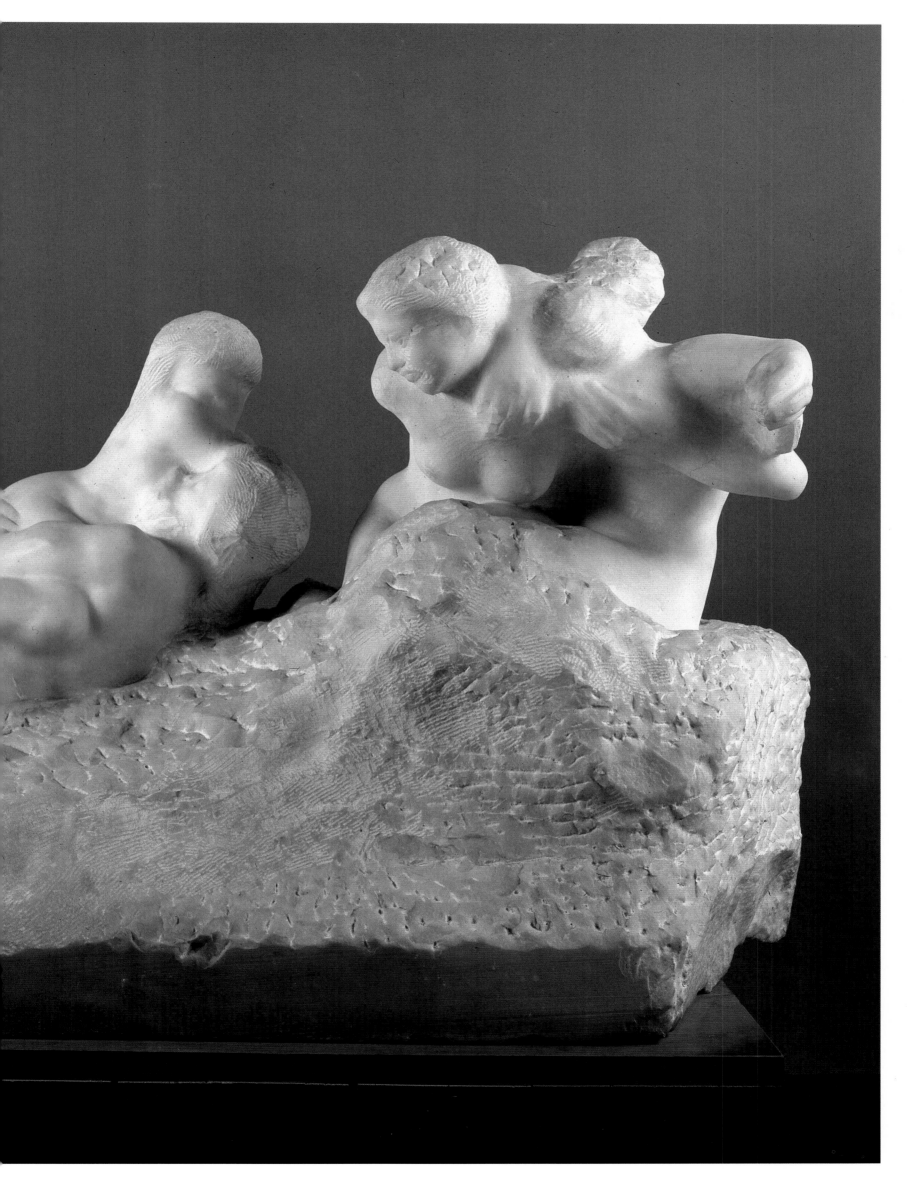

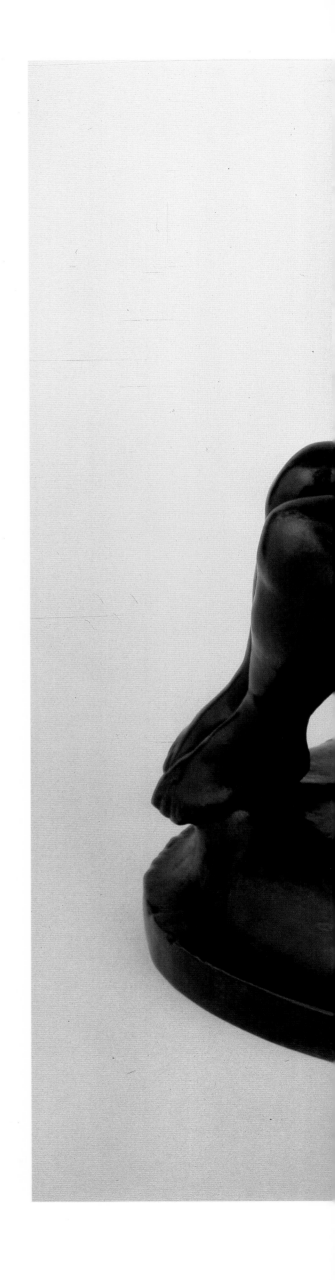

The Metamorphoses of Ovid, 1886
Bronze
12¾×15¾×10 inches (32.3×39.8×25.6 cm)
Musée Rodin, Paris S 1145

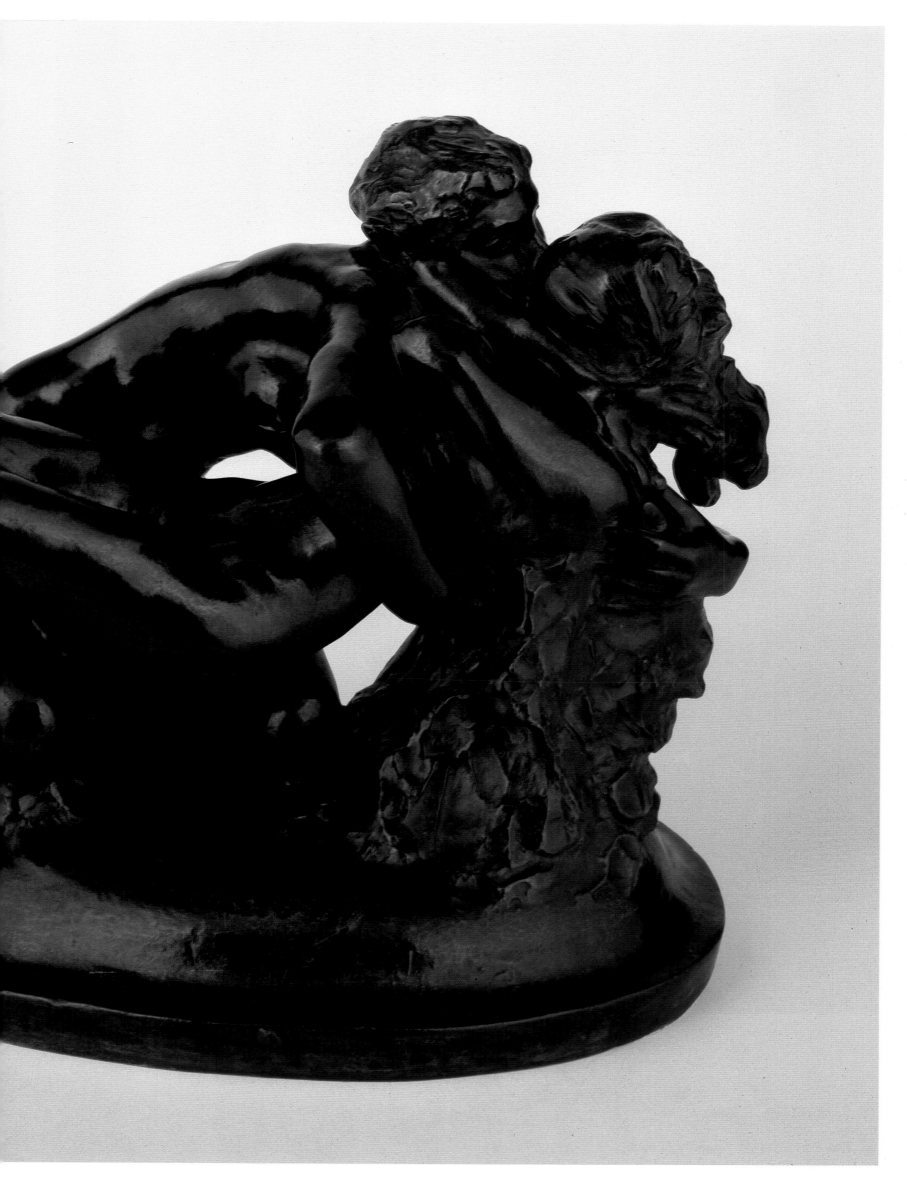

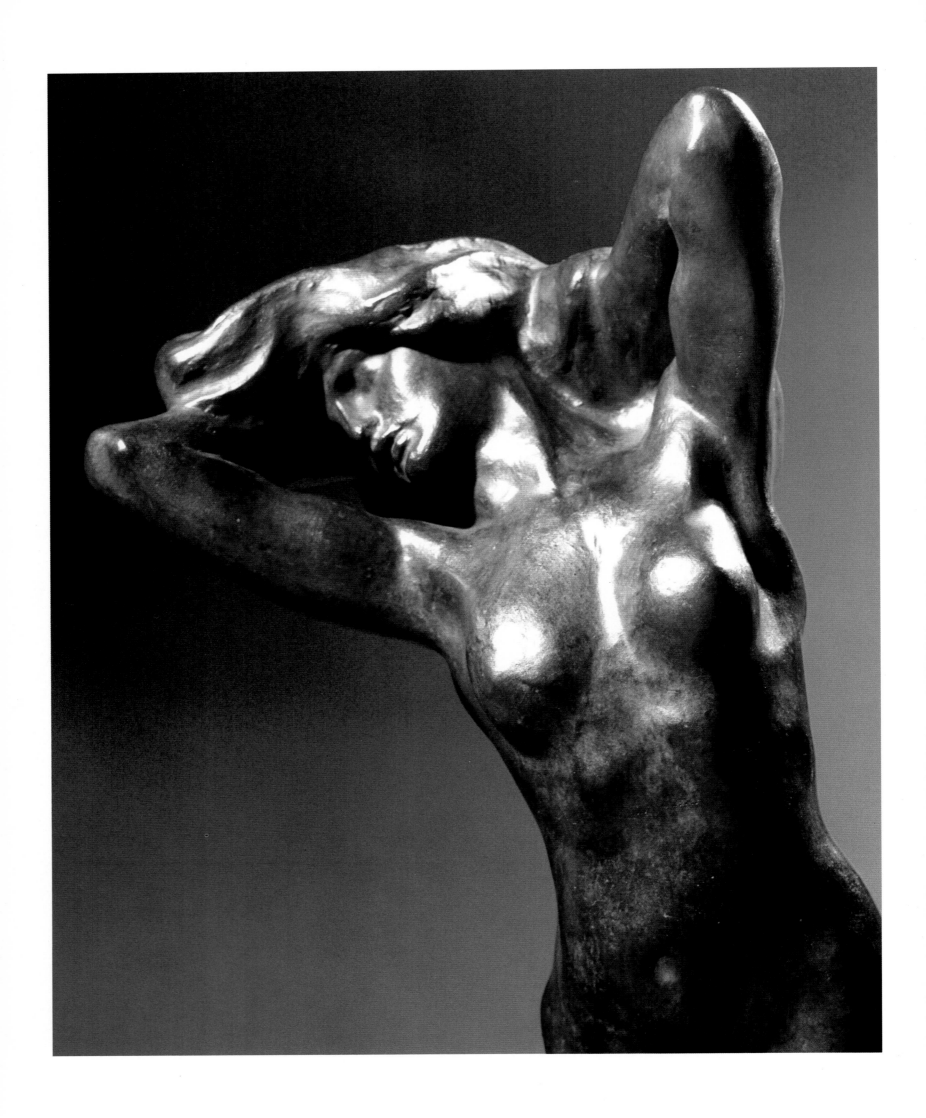

The Toilet of Venus, c. 1886
Bronze
18×9½×8½ inches (45.7×24.2×21.6 cm)
B Gerald Cantor Collection, New York

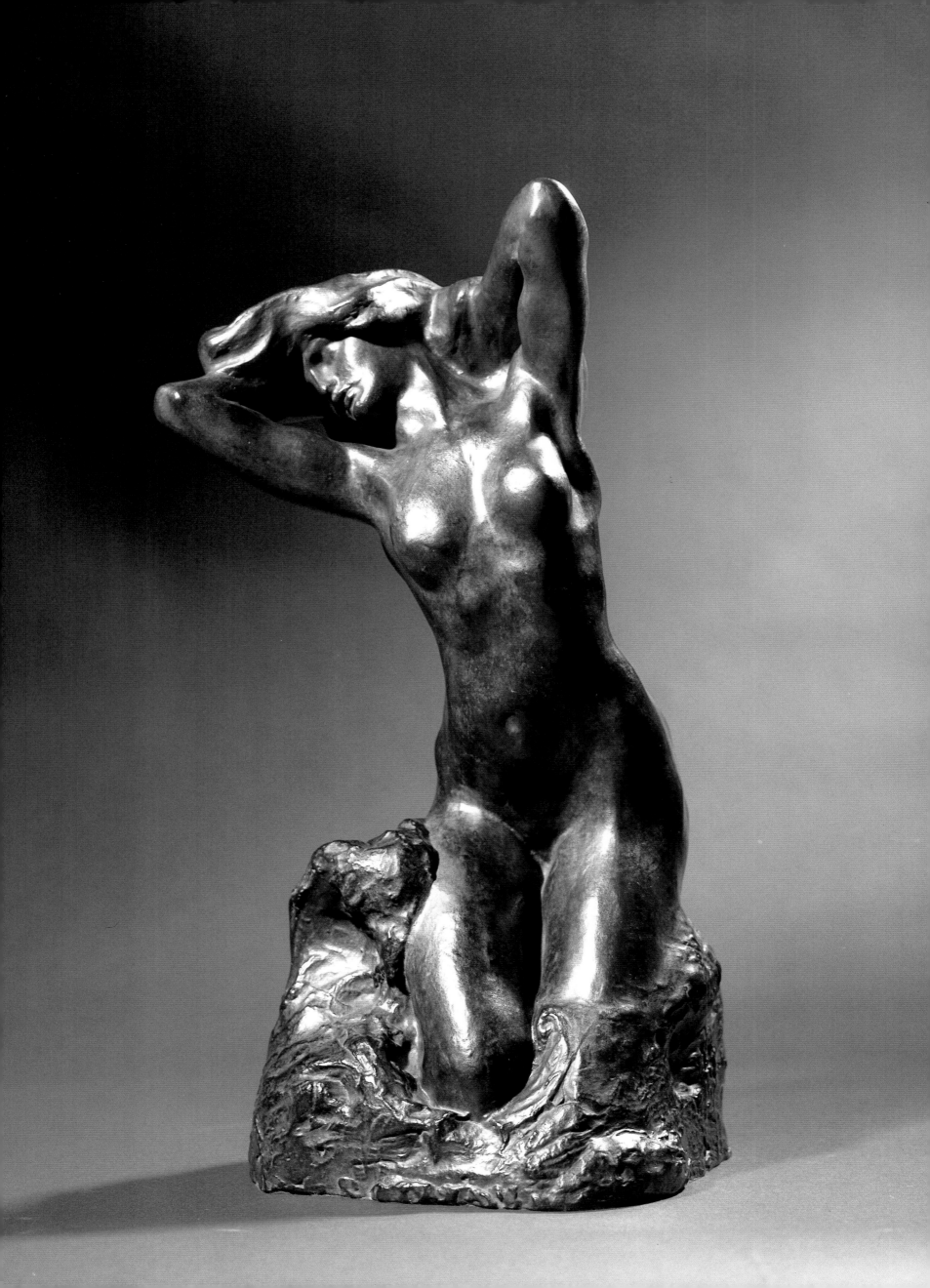

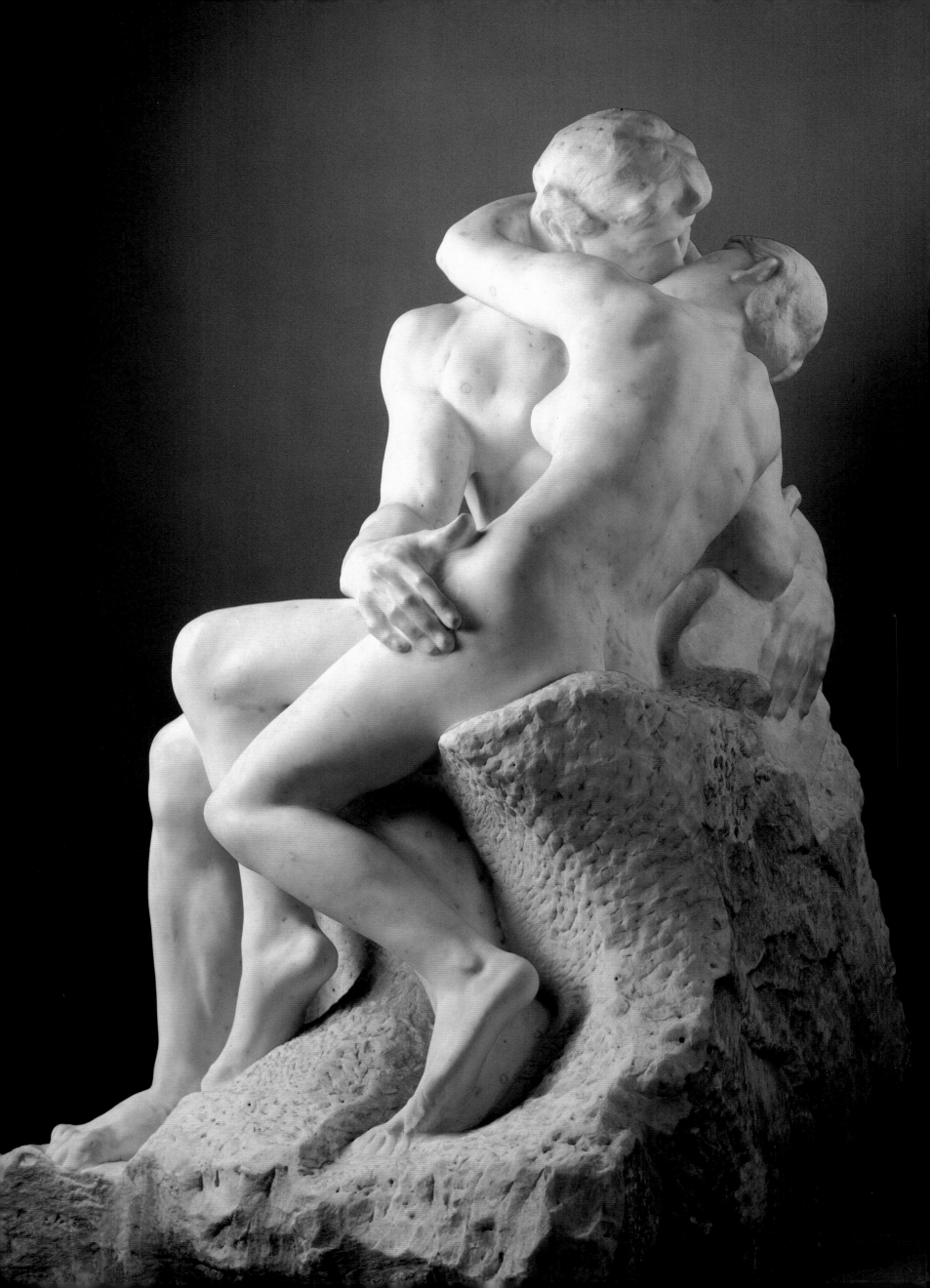

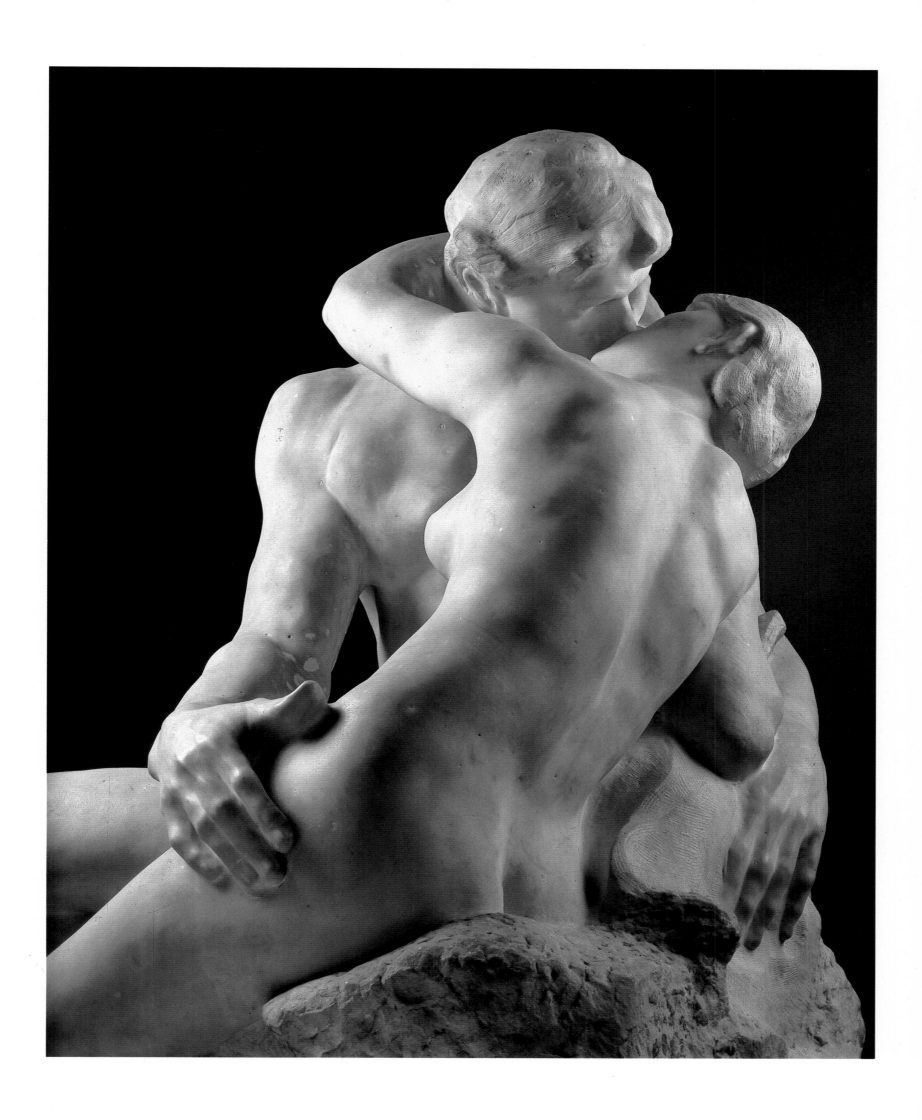

The Kiss, 1886
Marble
72¼×43½×46¾ inches
(183.6×110.5×118.6 cm)
Musée Rodin, Paris S 1002

The Burghers of Calais, 1886-88
Bronze
91×96½×79⅞ inches (231×245×203 cm)
Musée Rodin, Paris S 450

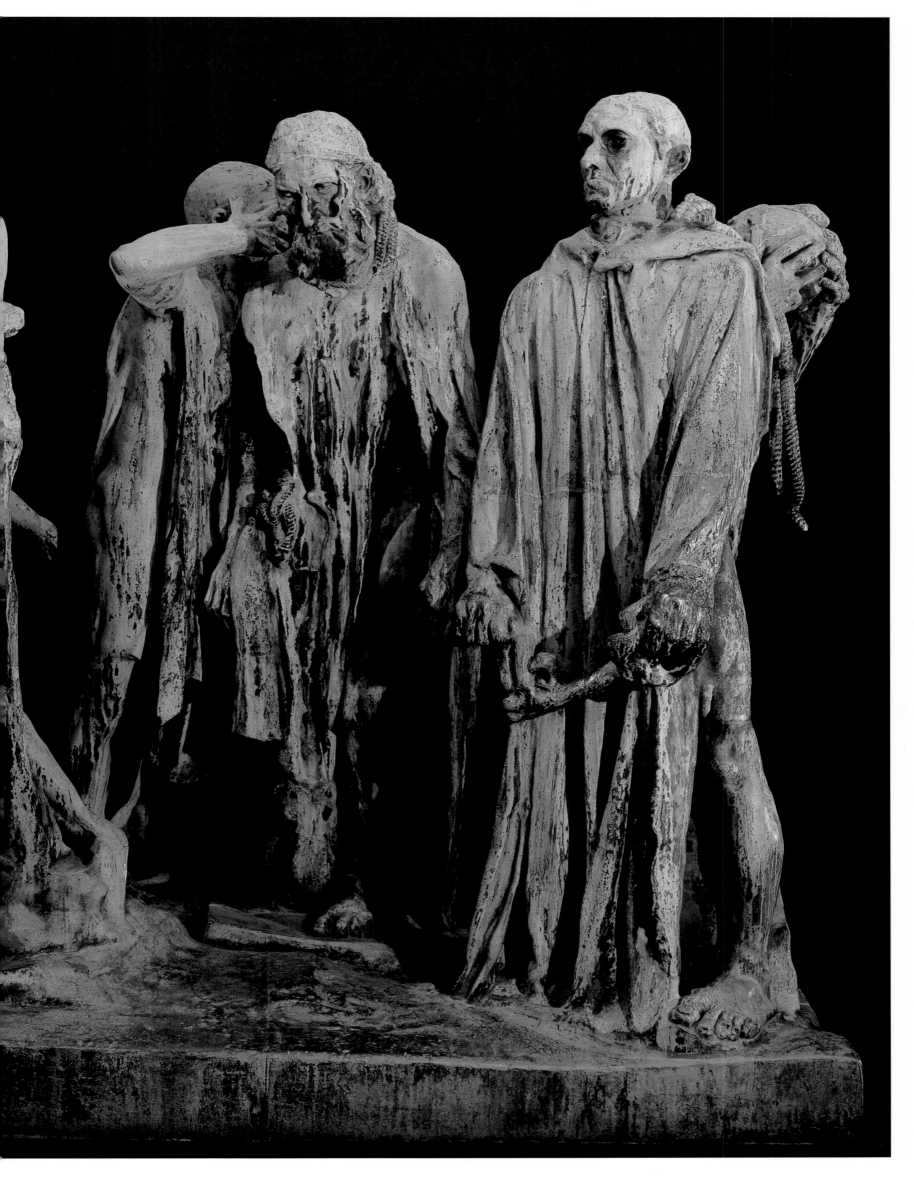

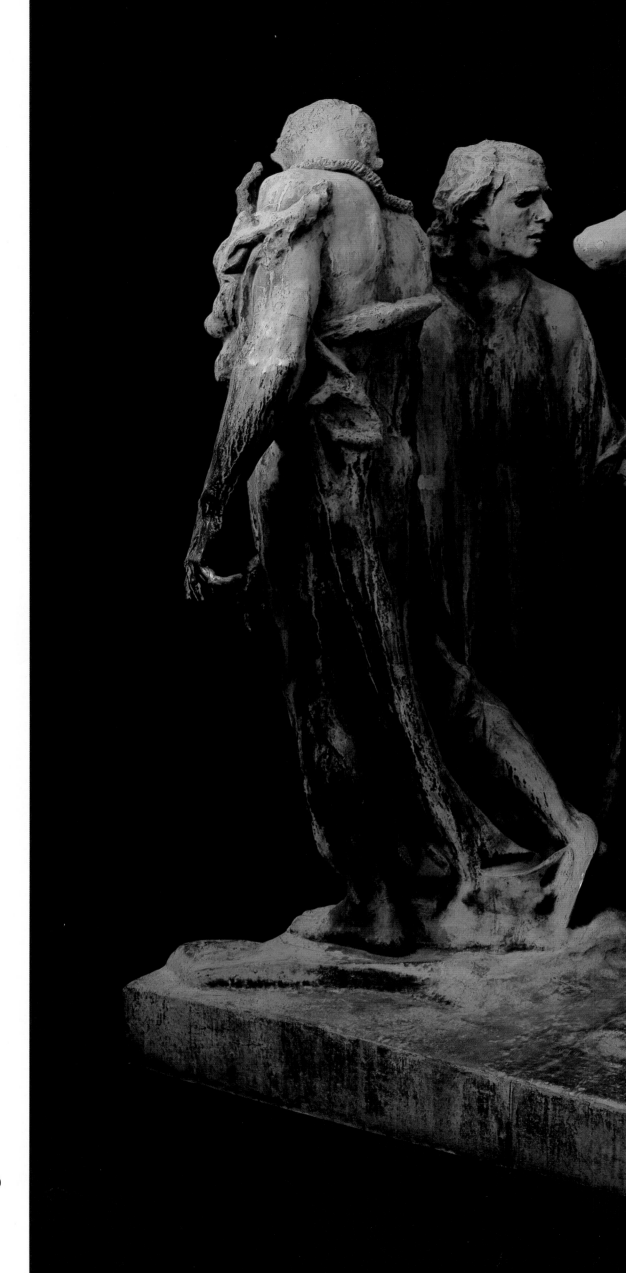

The Burghers of Calais, 1886-88
Bronze
91×96½×79⅞ inches (231×245×203 cm)
Musée Rodin, Paris S 450

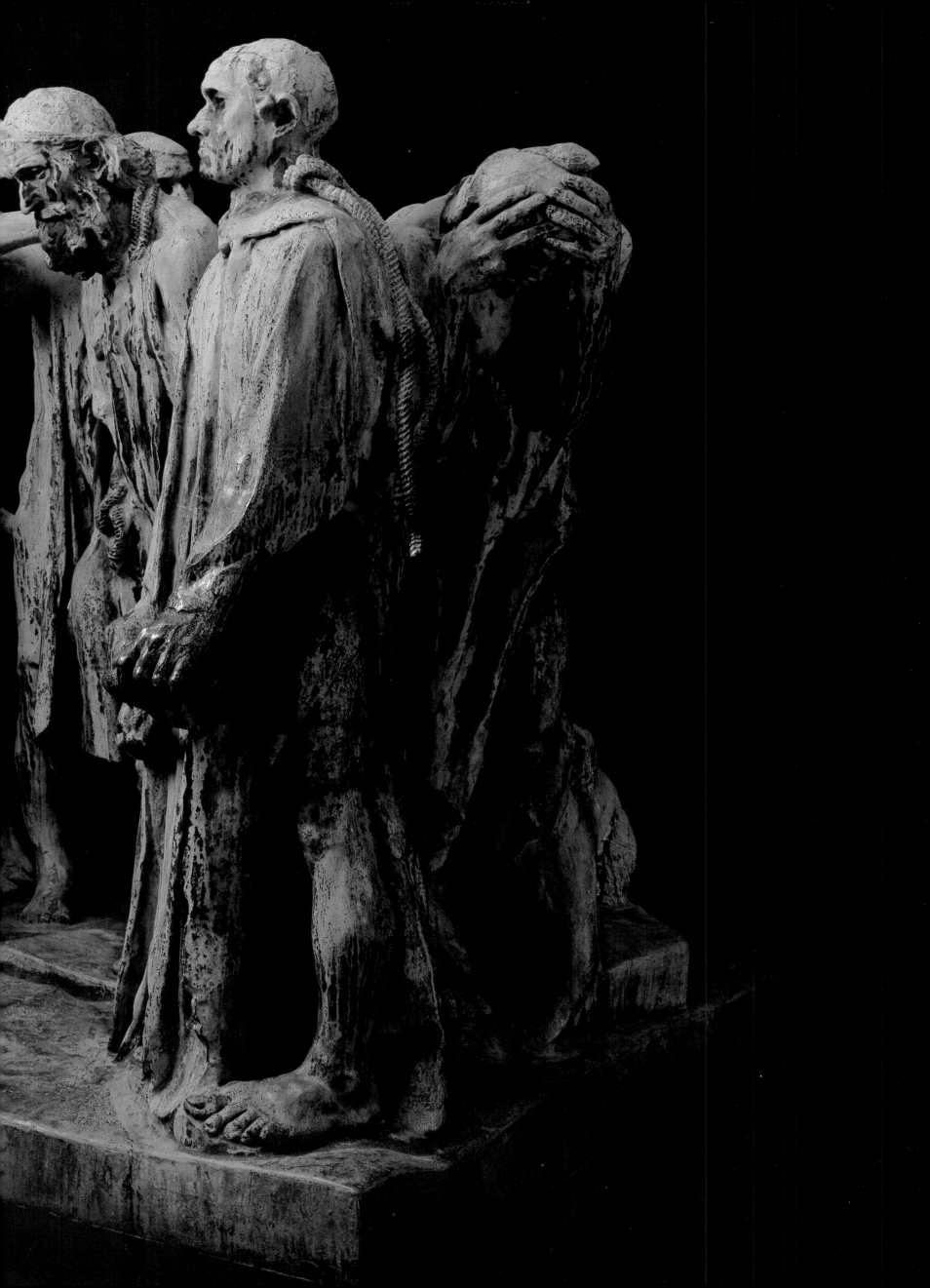

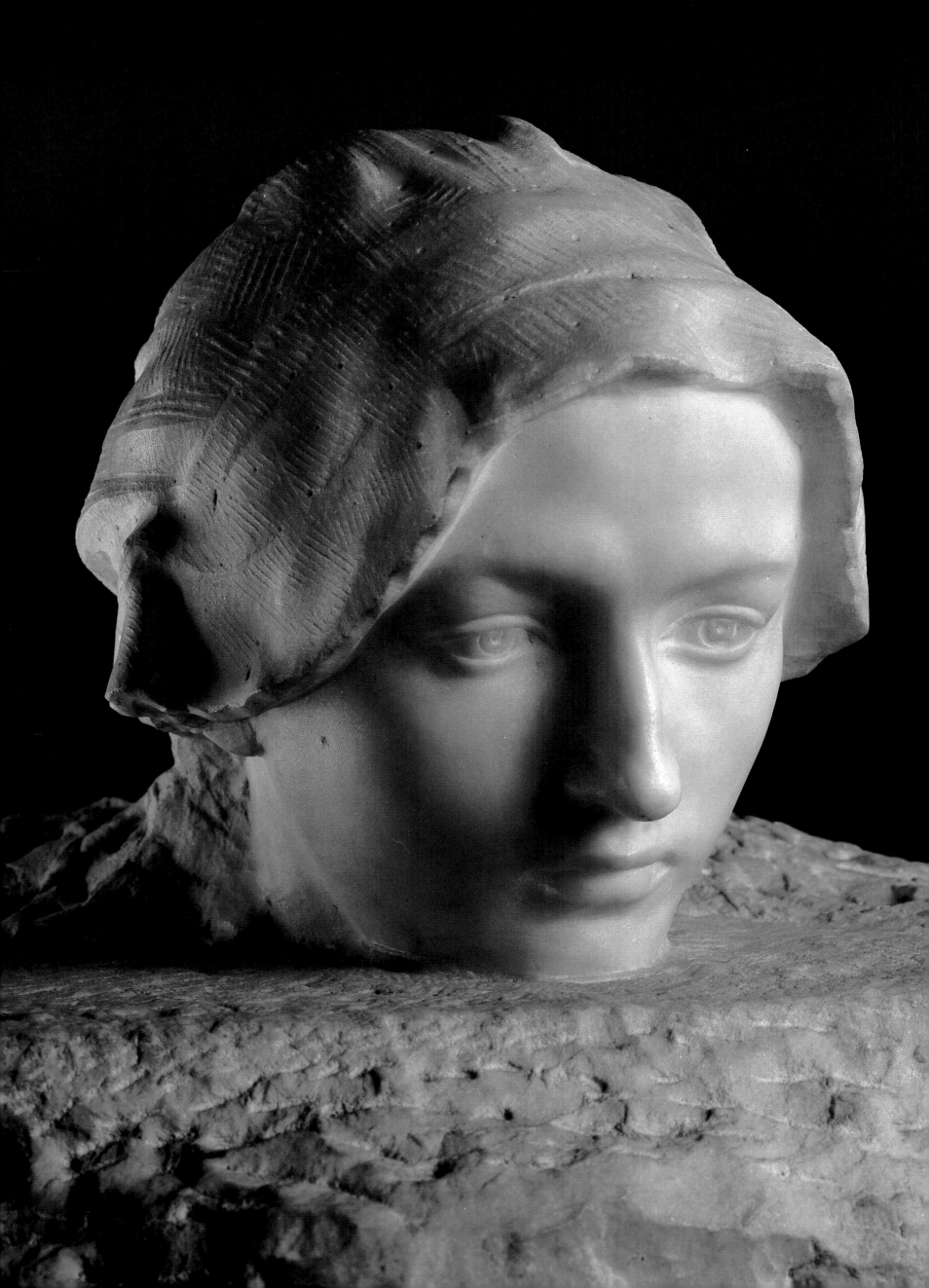

Left:
The Thought, 1886
Marble
29¼×17⅛×18⅛ inches (74.2×43.5×46.1 cm)
Musée Rodin, Paris S 1003

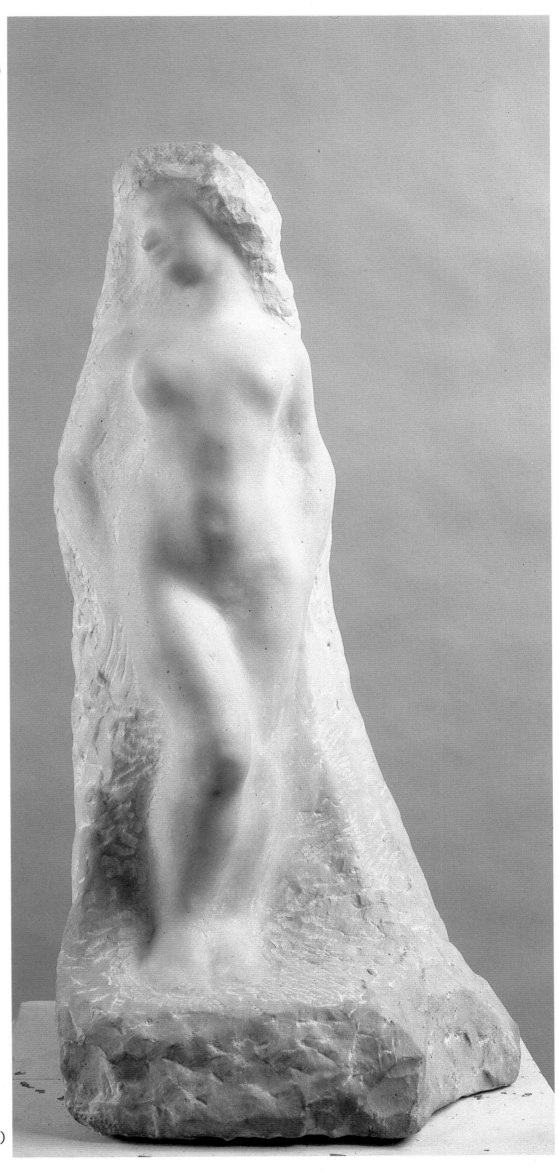

Right:
Psyche, 1886
Marble
23½×11½×10¼ inches (59.8×29.2×26.2 cm)
Musée Rodin, Paris S 1028

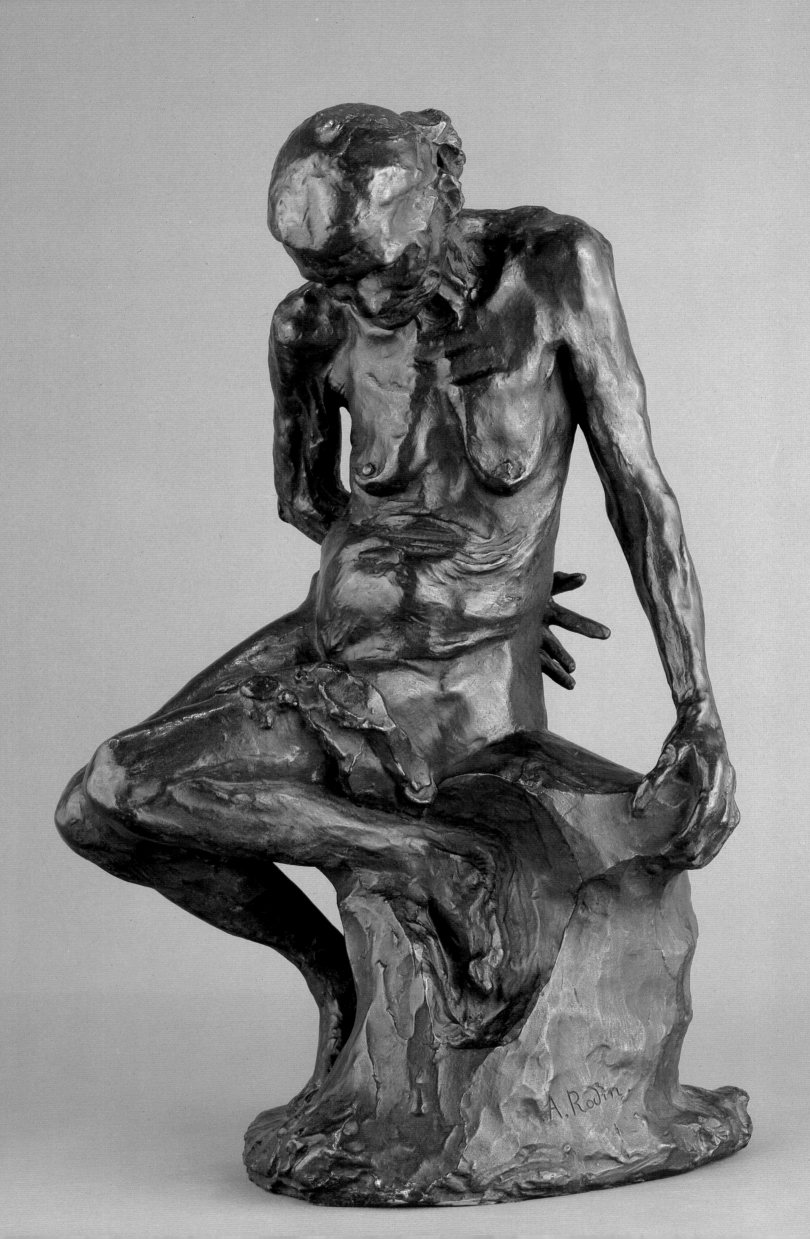

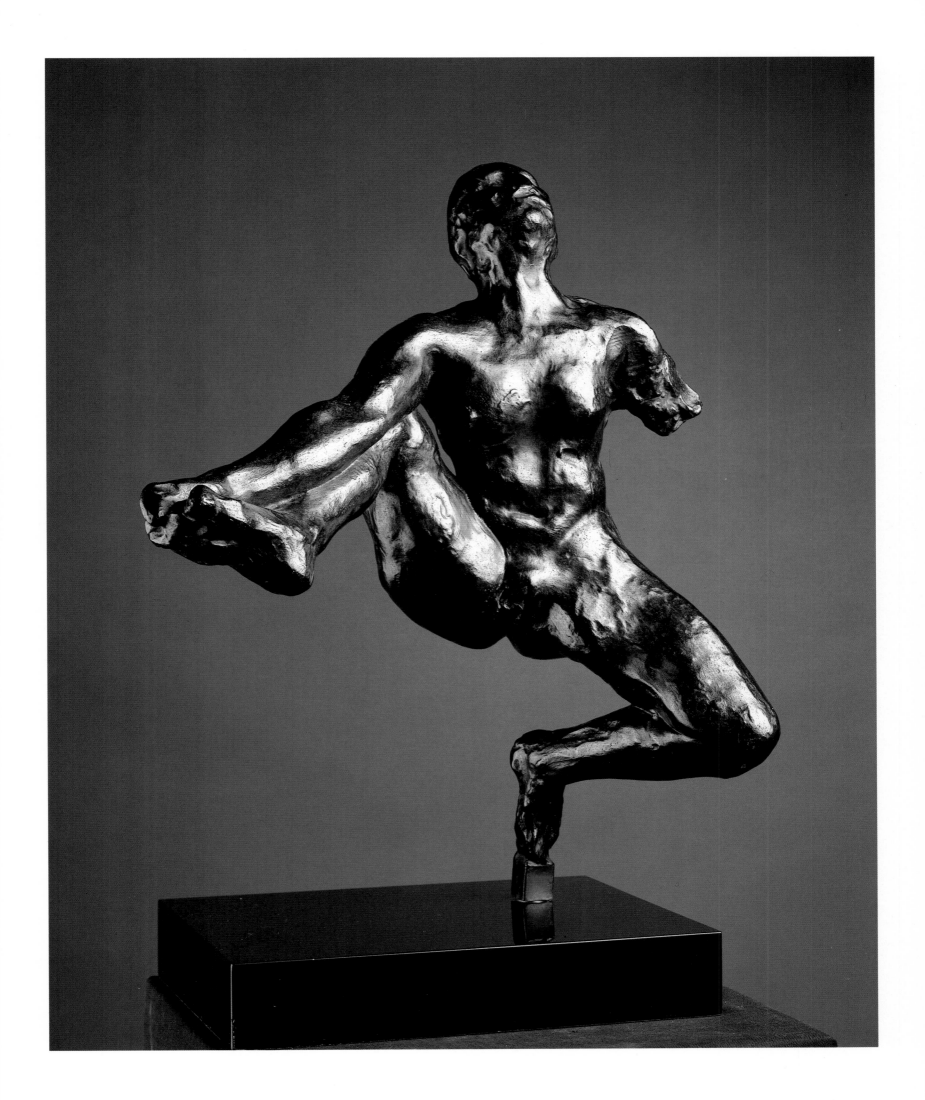

Left:
She who was the Helmetmaker's Beautiful Wife,
1888
Bronze
19⅝×11¾×10½ inches (50×30×26.5 cm)
Musée Rodin, Paris S 1148

Above:
Iris, Messenger of the Gods, 1890-91
Bronze
19×15¼×8¼ inches (48.4×38.6×21.1 cm)
Musée Rodin, Paris S 970

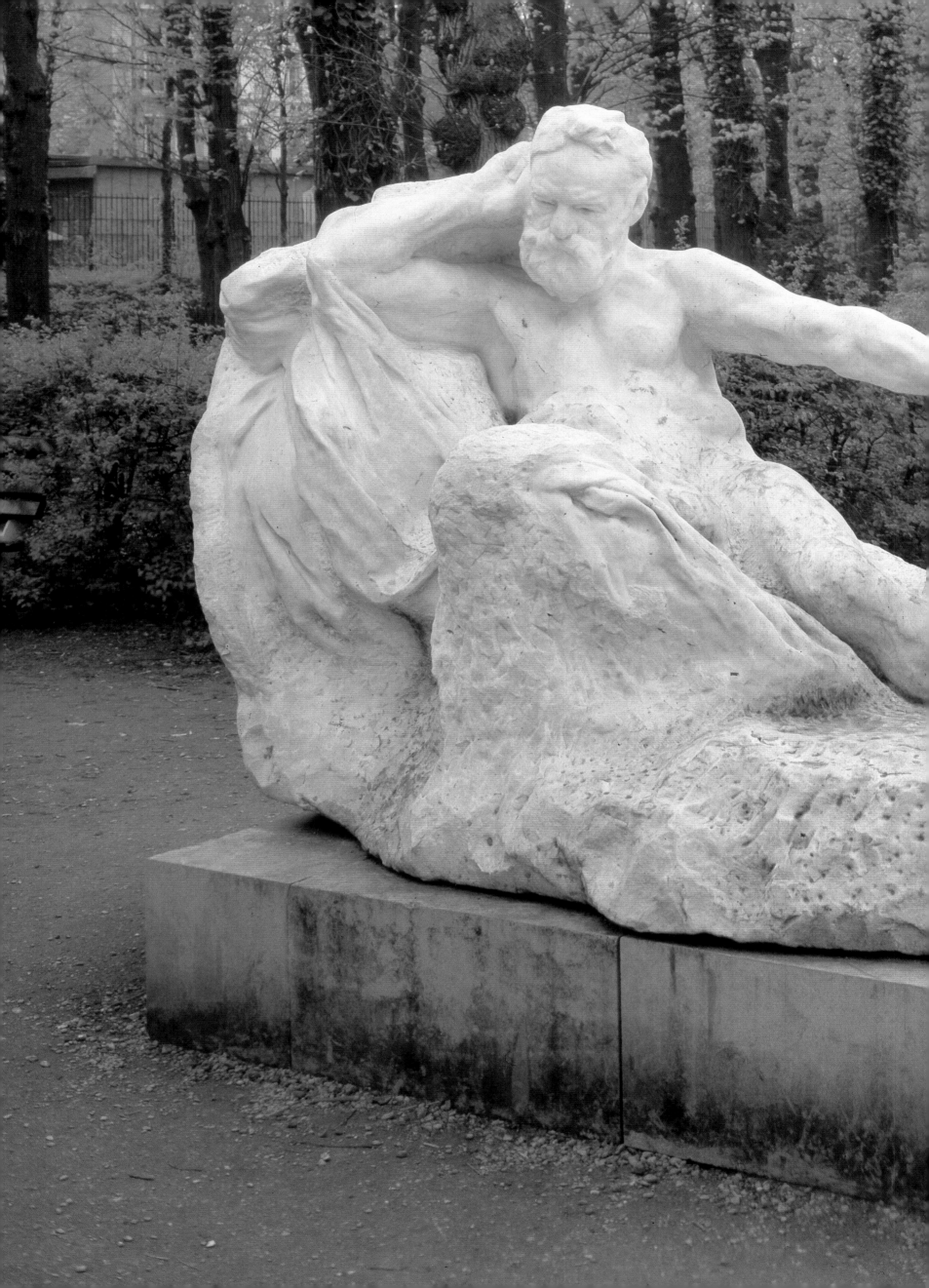

Monument to Victor Hugo, 1886-1909
Marble
Musée Rodin, Paris S 69

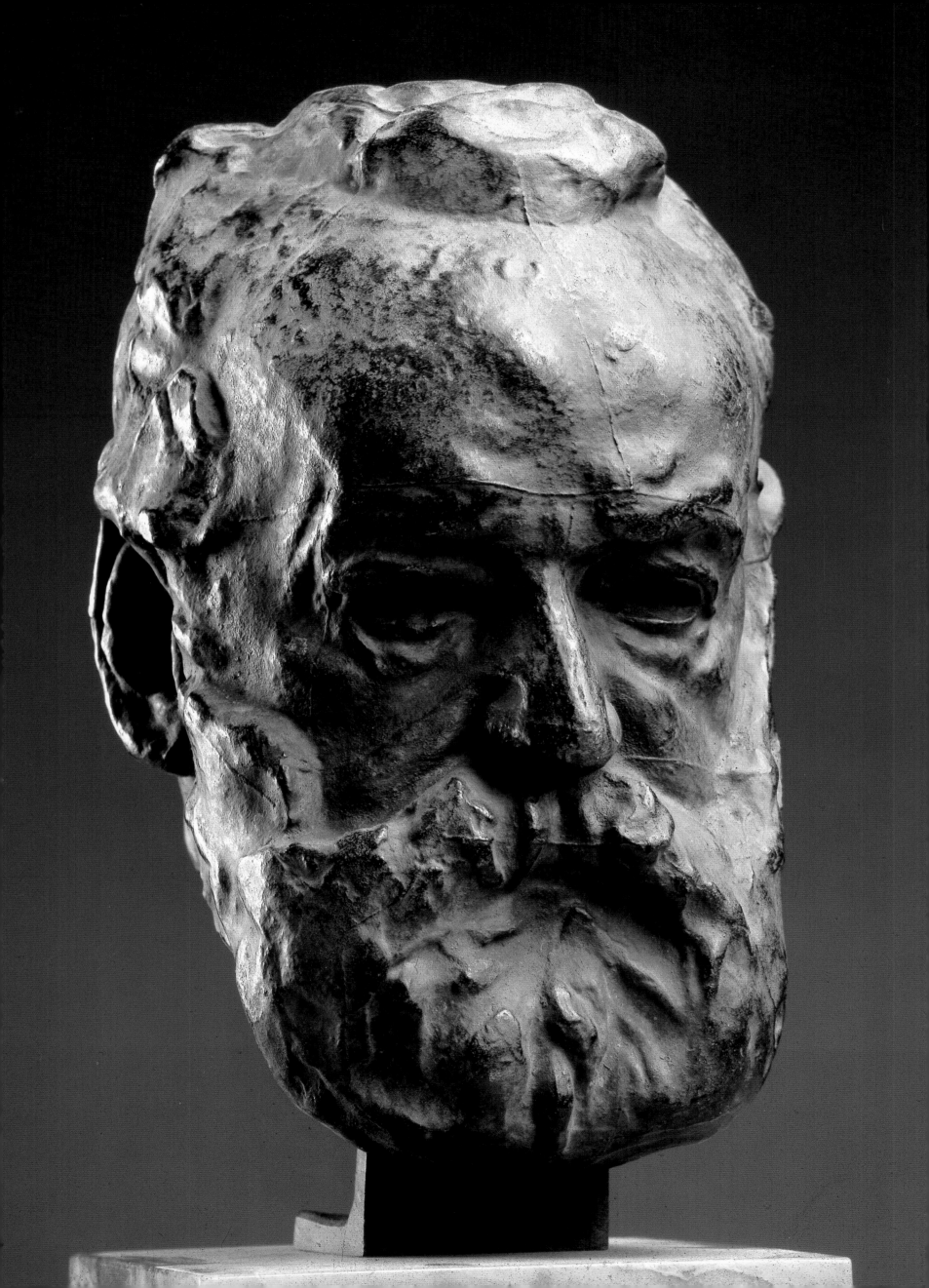

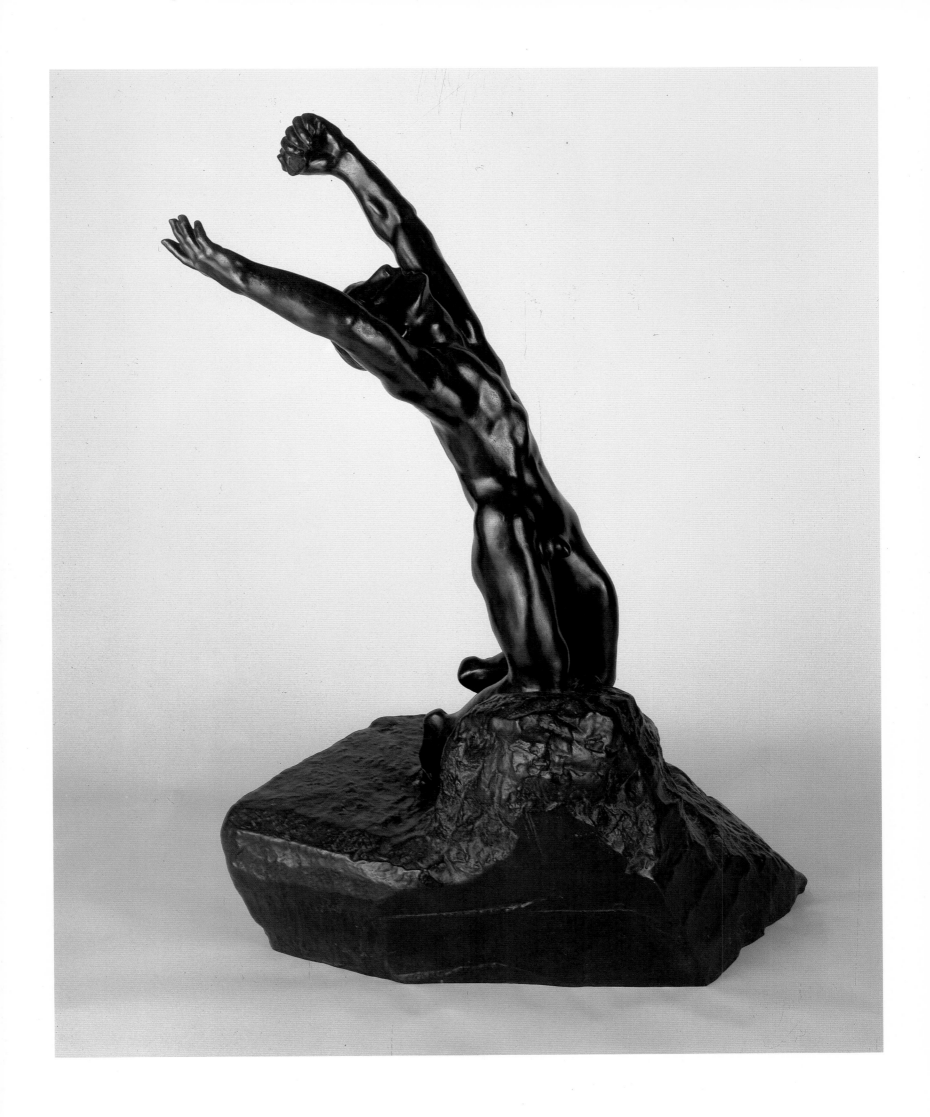

Left:
Victor Hugo, 1883-85
Bronze
7×4¾×5½ inches (18×12×14 cm)
Musée Rodin, Paris S 587

Above:
The Prodigal Son, c. 1884
Bronze
55×37⅜×25⅝ inches (140×95×65 cm)
Musée Rodin, Paris S 599

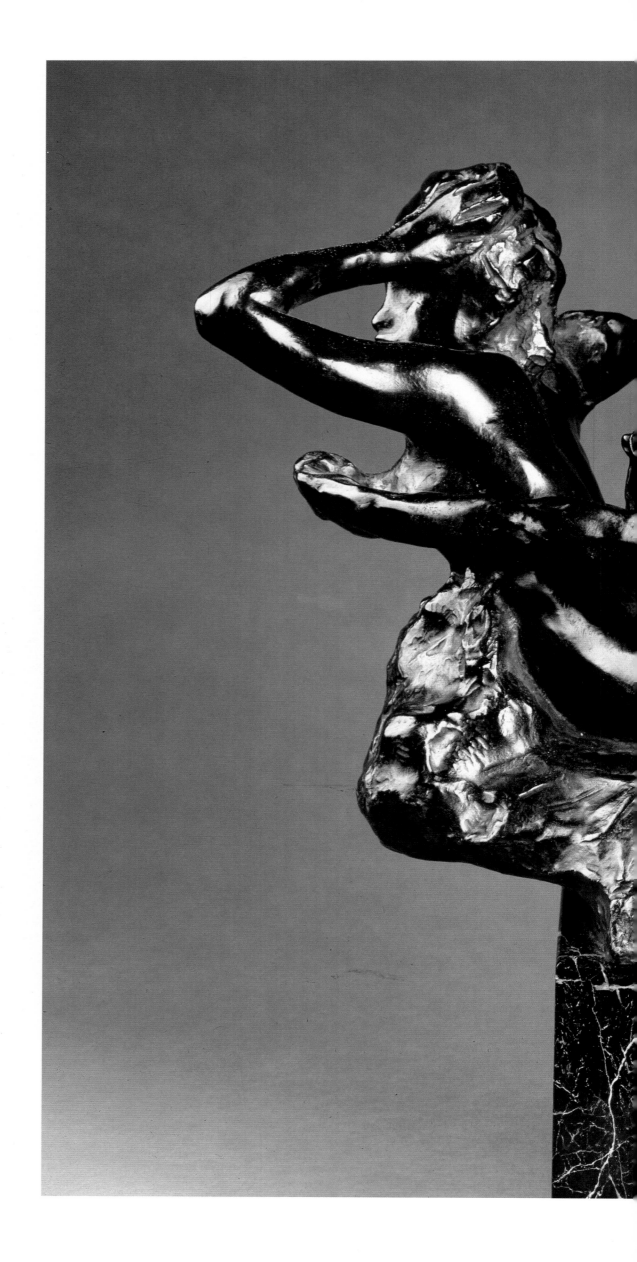

Fugit Amor, c. 1884
Bronze
15×18⅞×7⅞ inches (38×48×20 cm)
Musée Rodin, Paris S 489

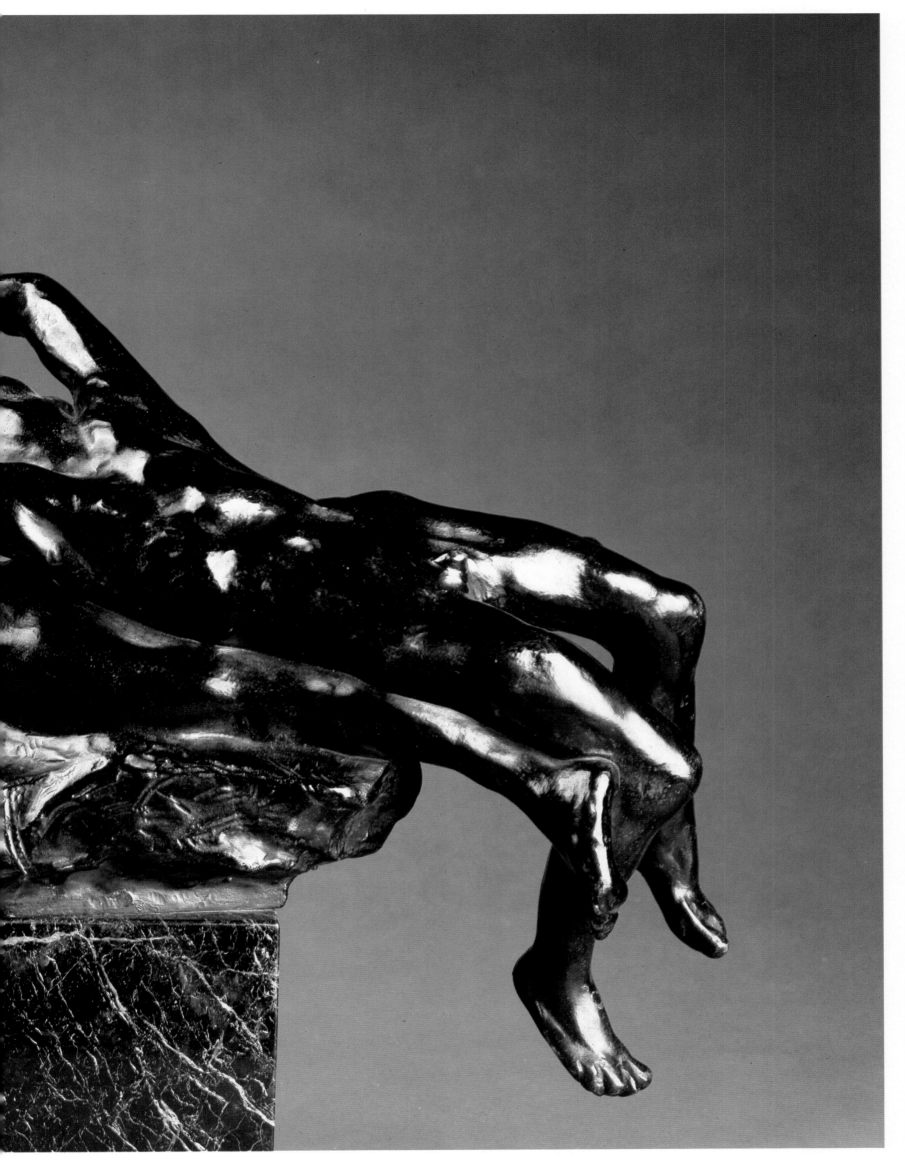

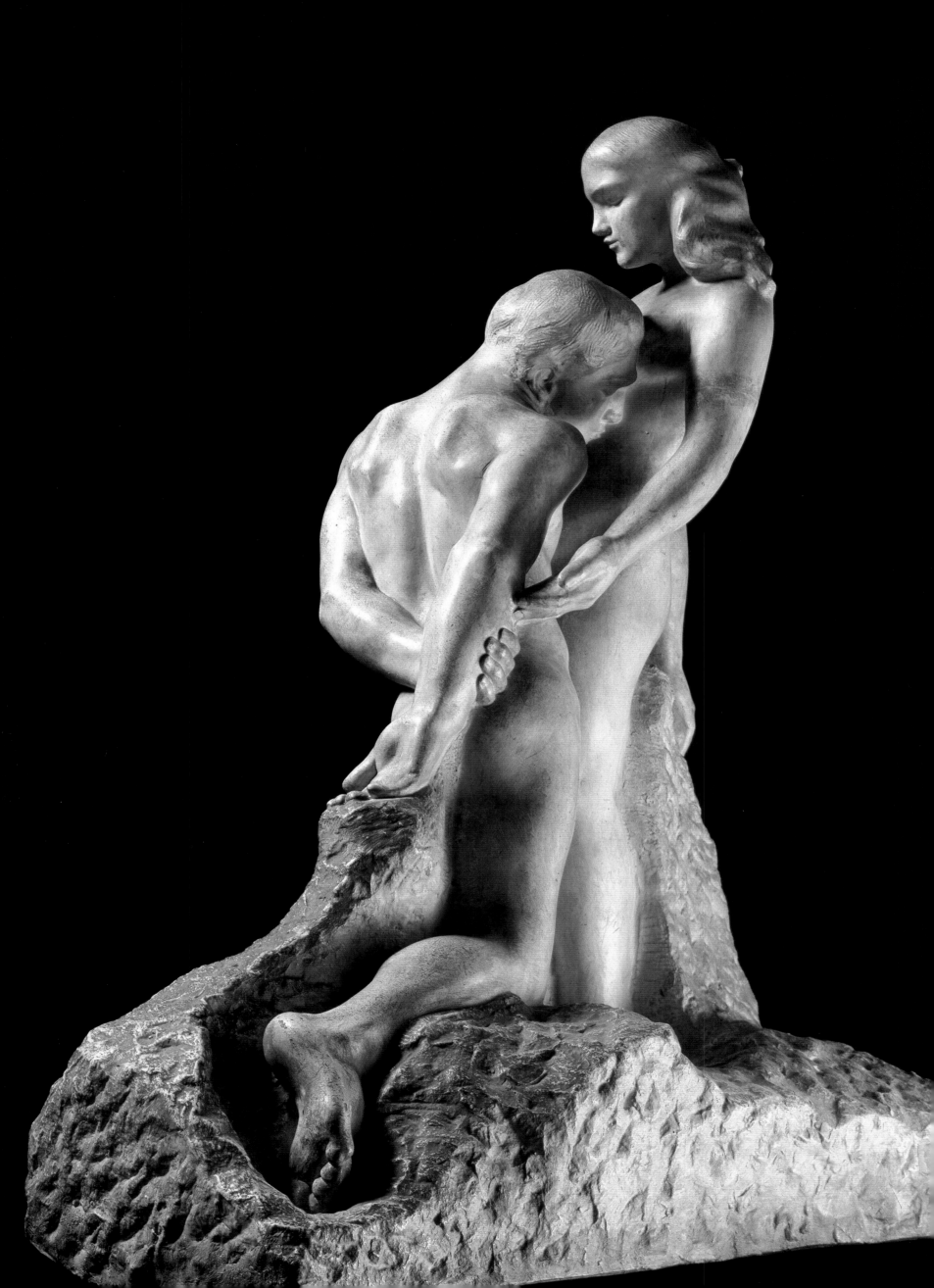

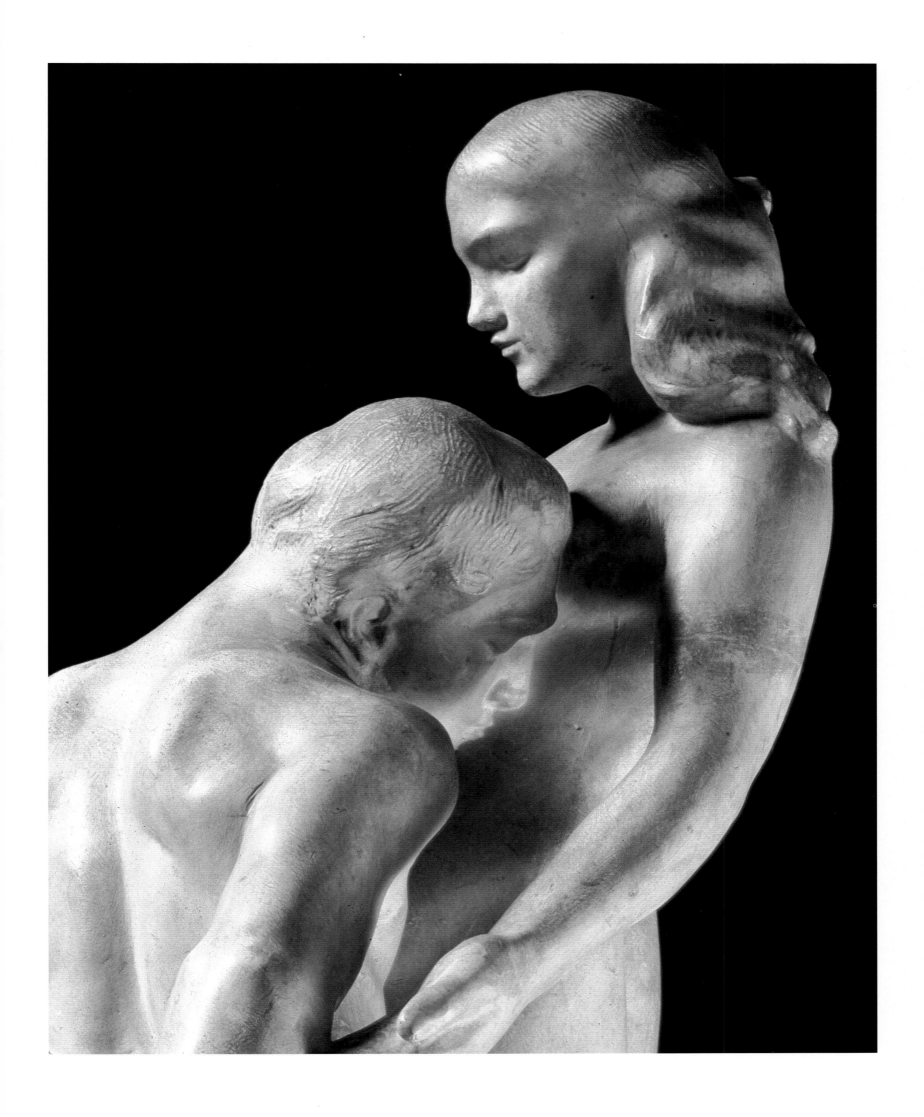

Eternal Idol, 1889
Plaster
28¾×23¼×16⅛ inches (73.2×59.2×41.1 cm)
Musée Rodin, Paris S 1044

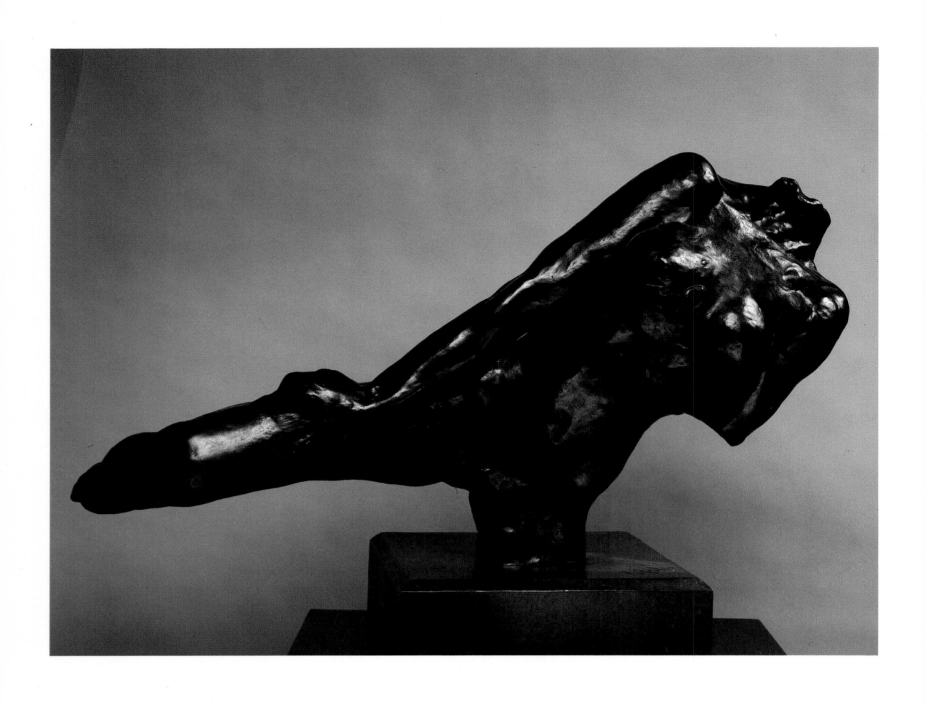

Above:
Flying Figure, c. 1890-91
Bronze
20½×29½ inches (52×74.9 cm)
The Metropolitan Museum of Art, New York
Gift of the B Gerald Cantor Foundation, 1984

Right:
Brother and Sister, c. 1890
Bronze
15×7×7⅞ inches (38×18×20 cm)
Musée Rodin, Paris S 975

86

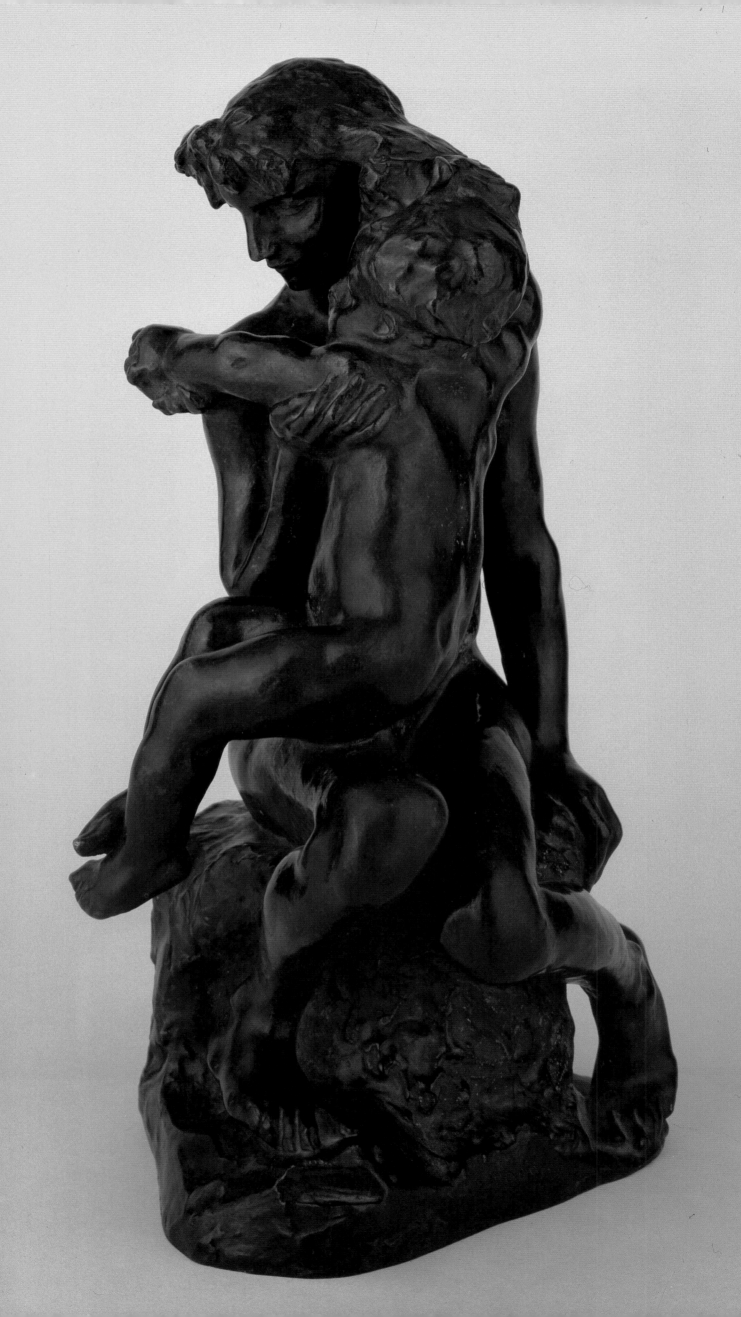

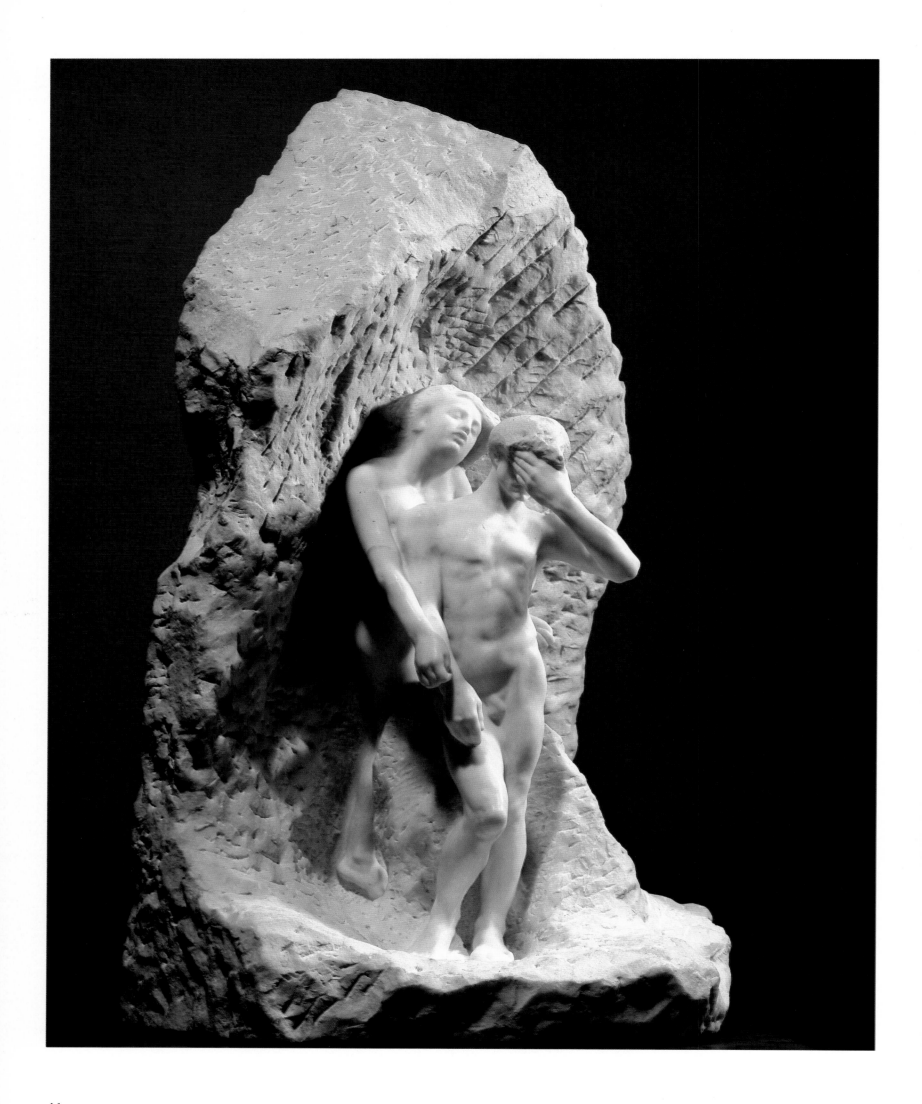

Above:
Orpheus and Eurydice, 1893
Marble
Height: 50 inches (127 cm)
The Metropolitan Museum of Art, New York
Gift of Thomas F Ryan, 1910

Right:
Meditation, 1896-97
Bronze
57½ × 23¼ × 17¾ inches (146 × 59 × 45 cm)
Musée Rodin, Paris S 792

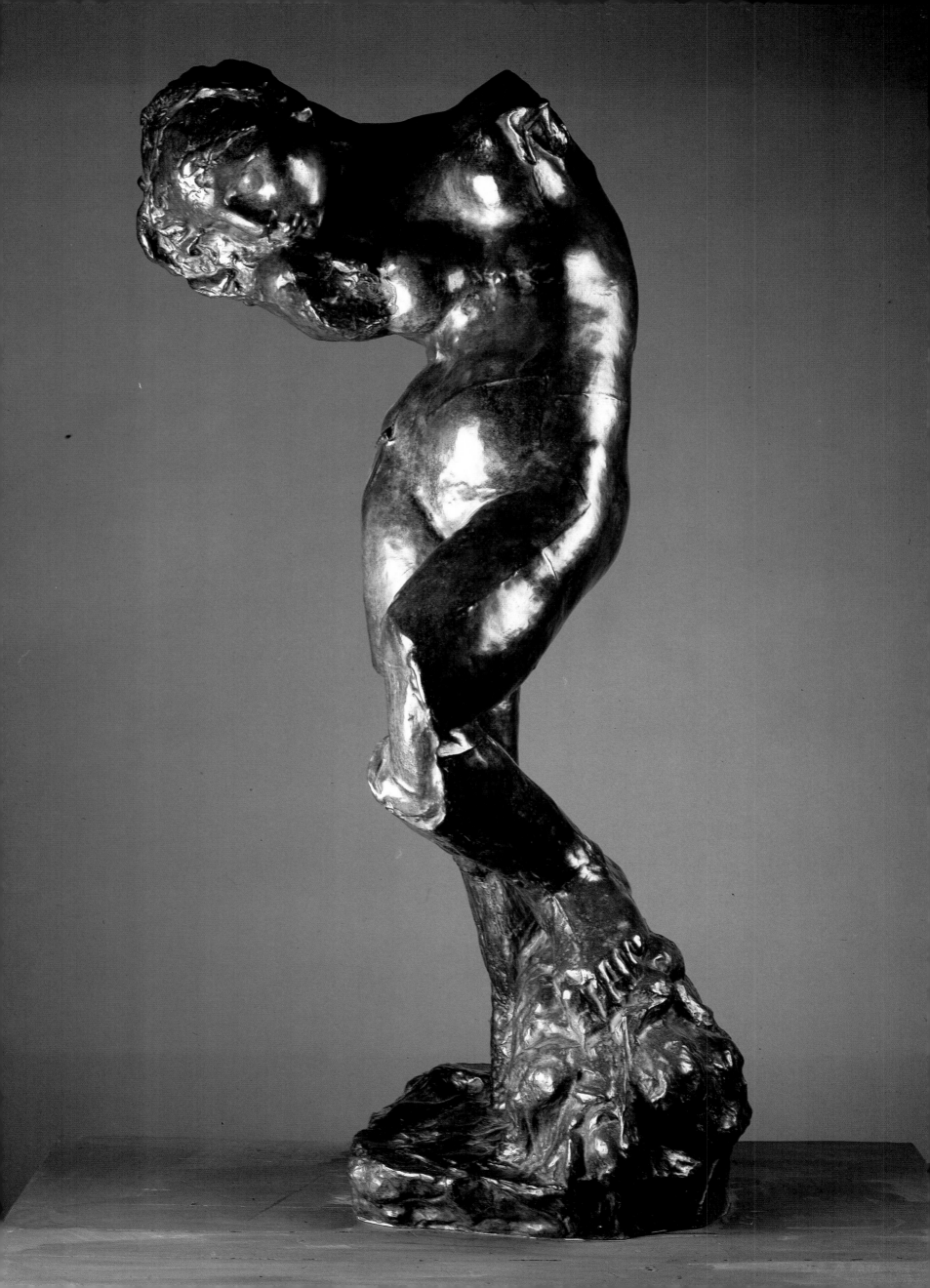

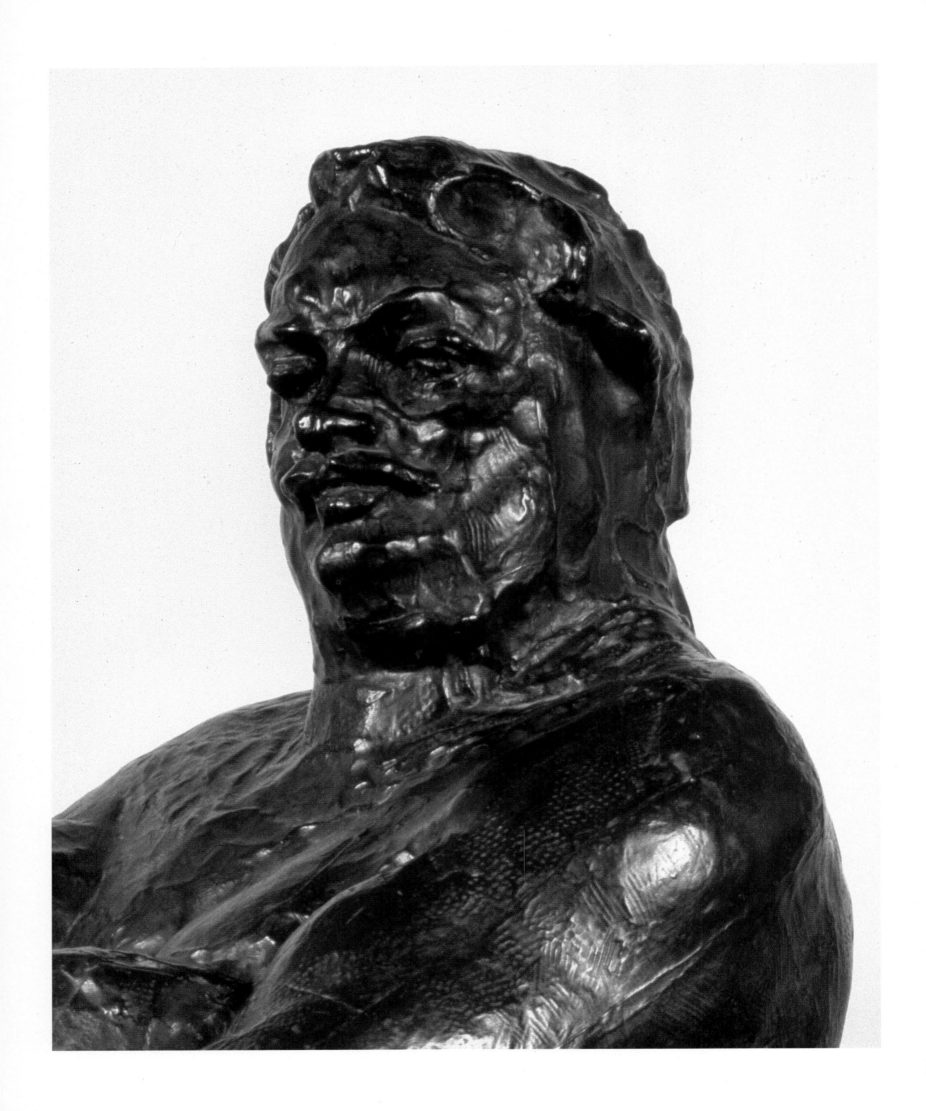

Balzac: Nude Study, 1892-93
Bronze
50 × 22 × 24½ inches (127 × 56 × 62.2 cm)
Musée Rodin, Paris S 1074

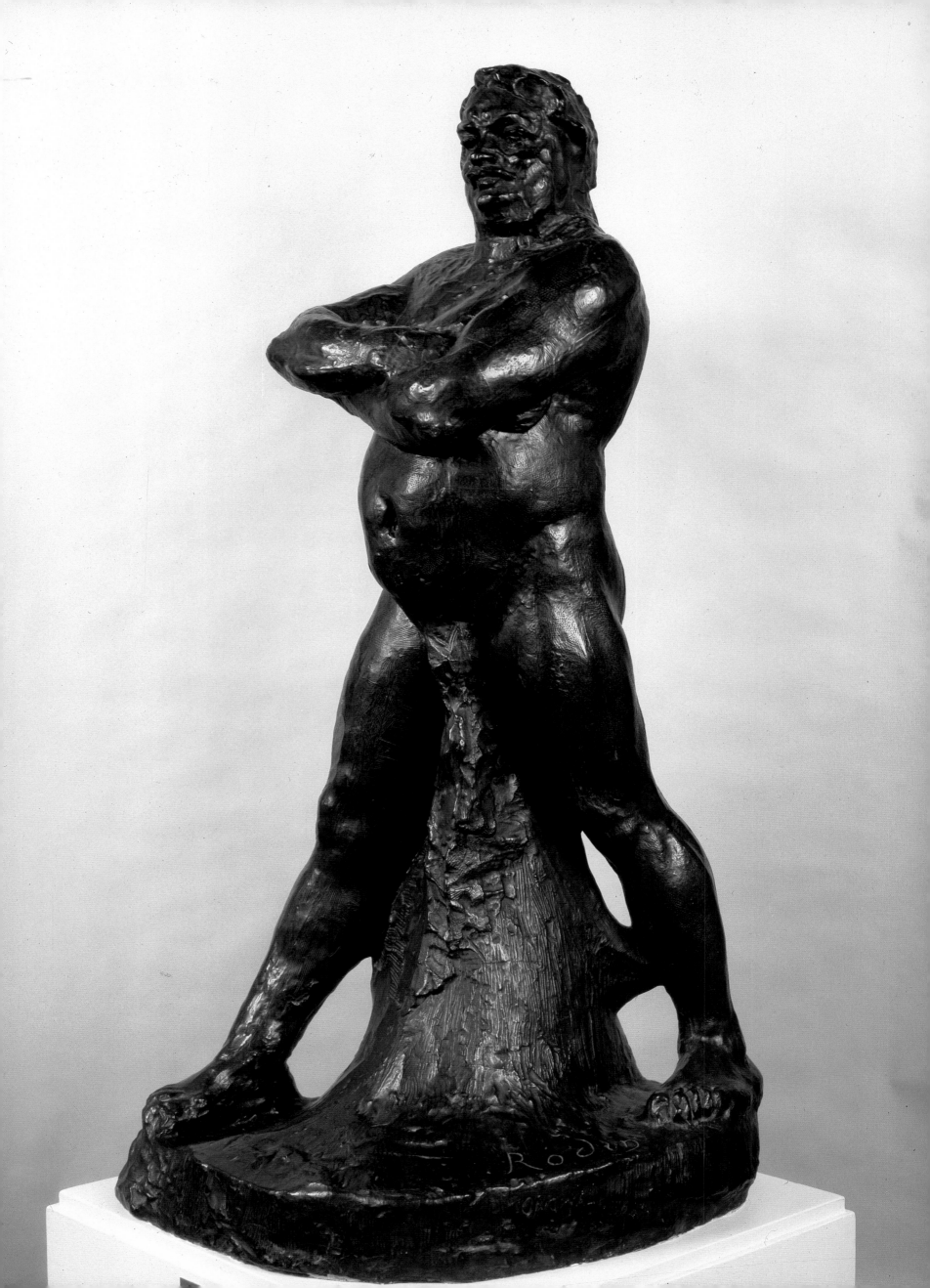

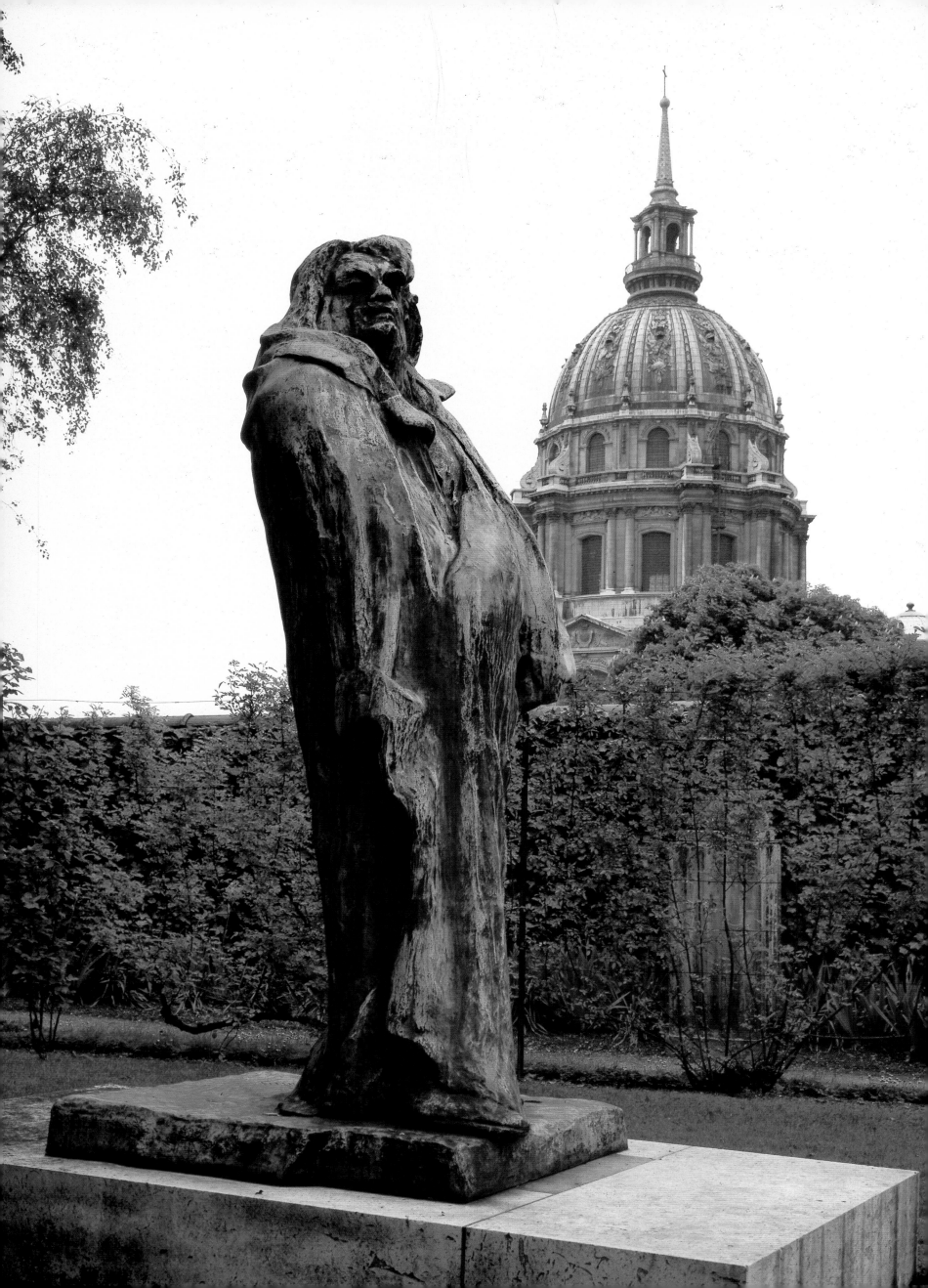

Left:
The Monument to Balzac, 1897
Bronze
106¼×47½×50⅜ inches
(270×120.5×128 cm)
Musée Rodin, Paris S 1296

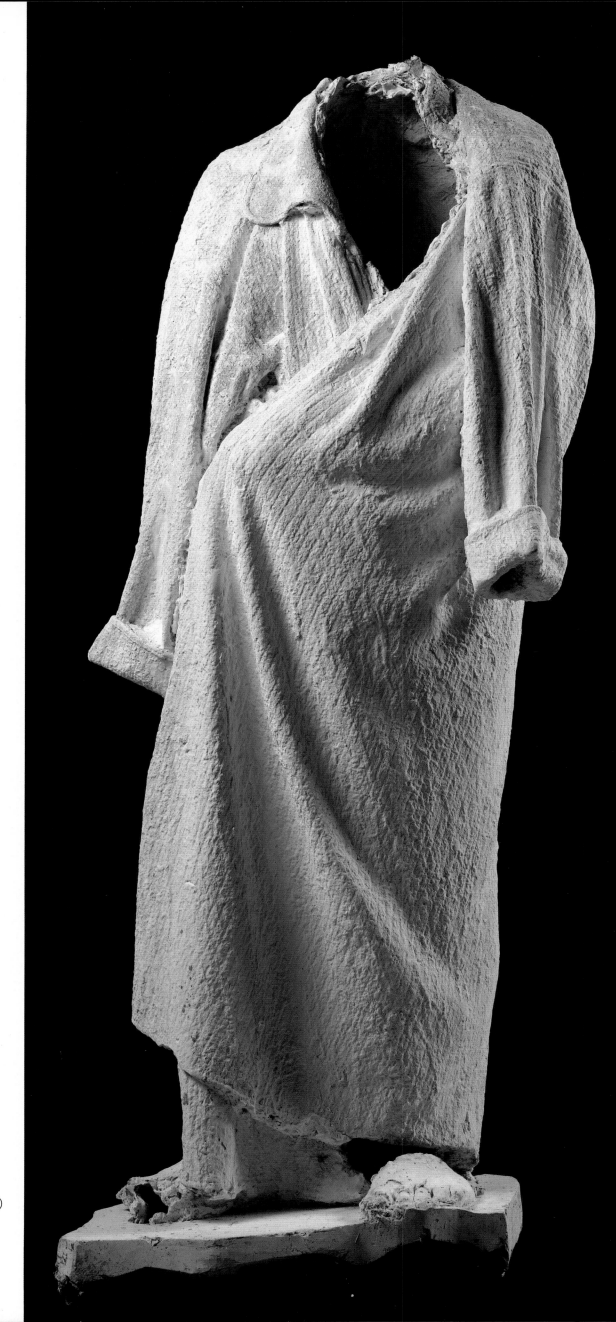

Right:
Balzac's Dressing Gown, 1893-99
Plaster and coated fabric
58¼×22⅝×16½ inches (148×57.5×42 cm)
Musée Rodin, Paris S 146

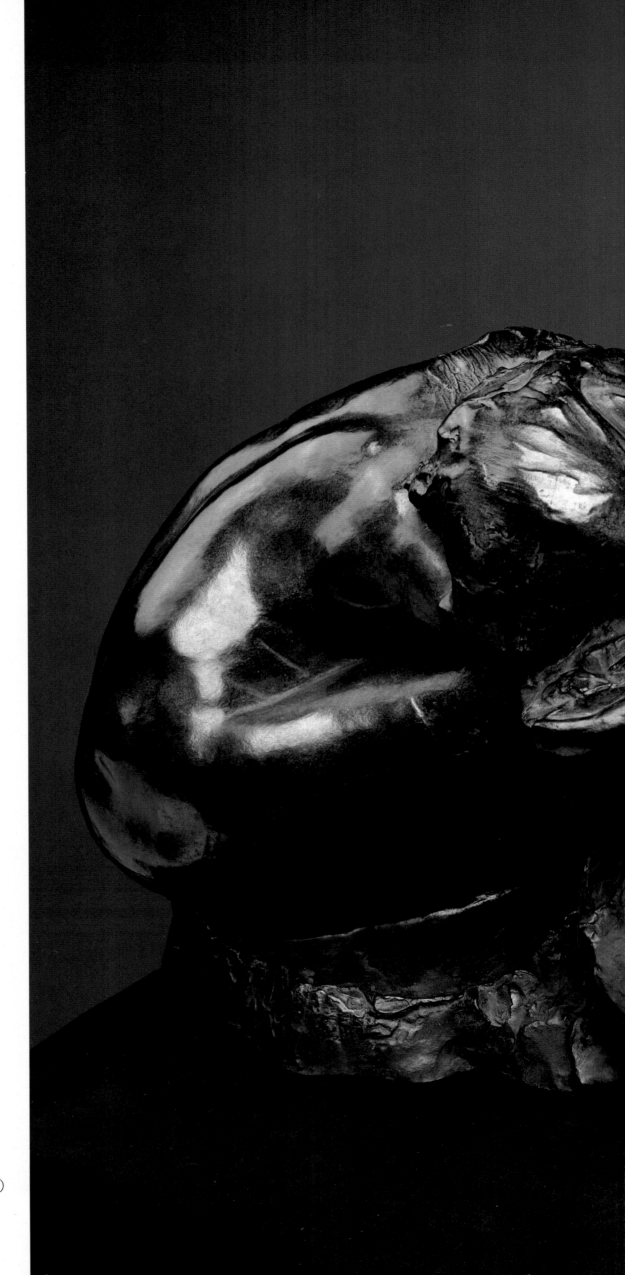

The Fall of an Angel, c. 1895
Bronze
15×27½×16½ inches (38×69.8×40.9 cm)
Musée Rodin, Paris S 1313

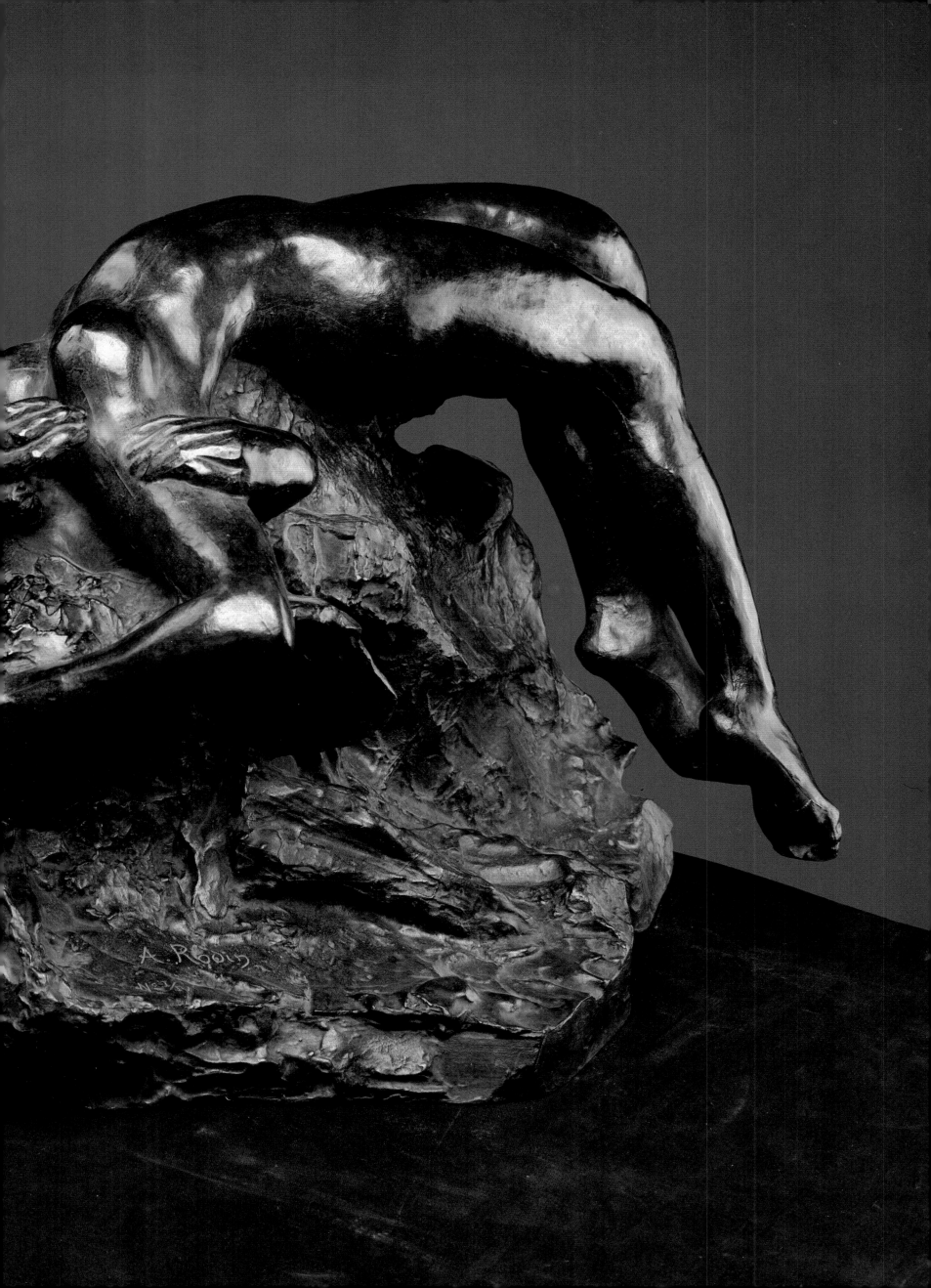

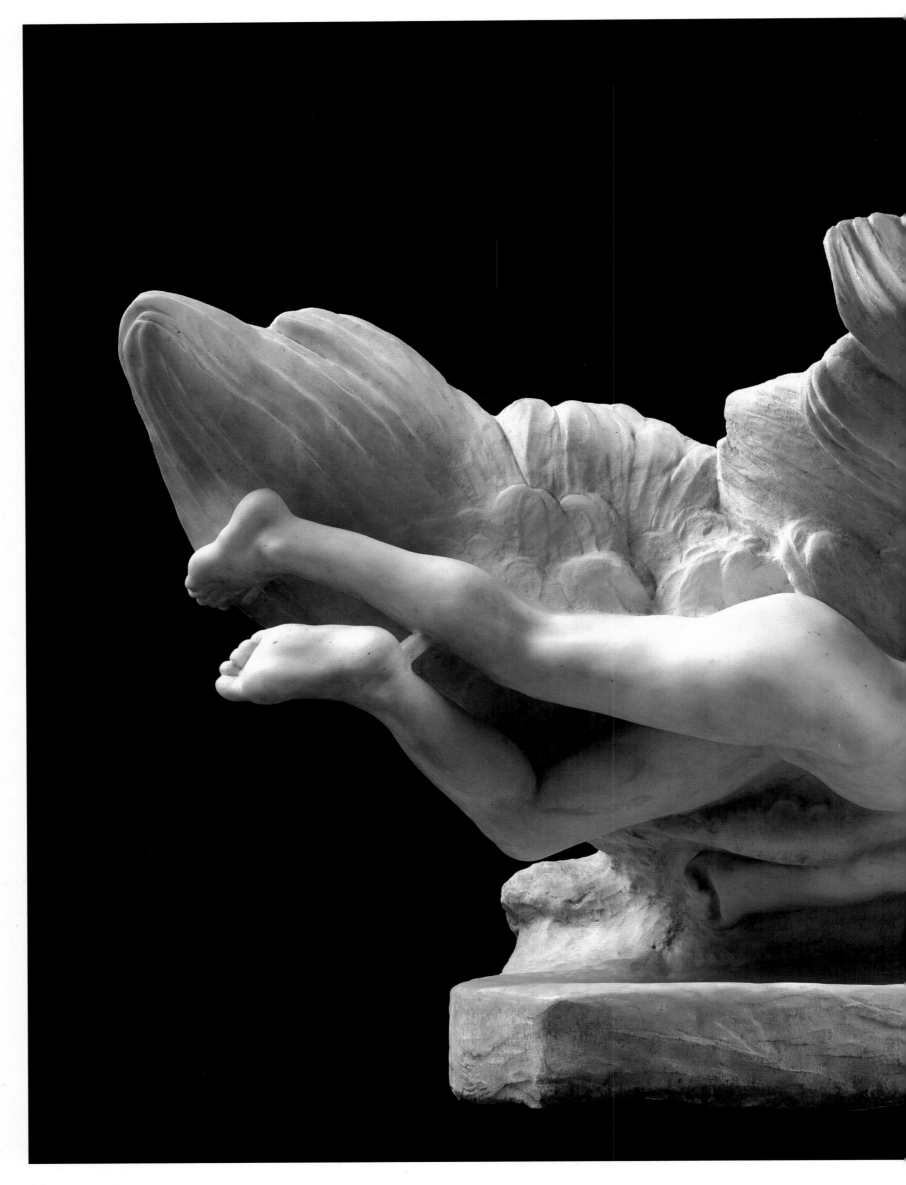

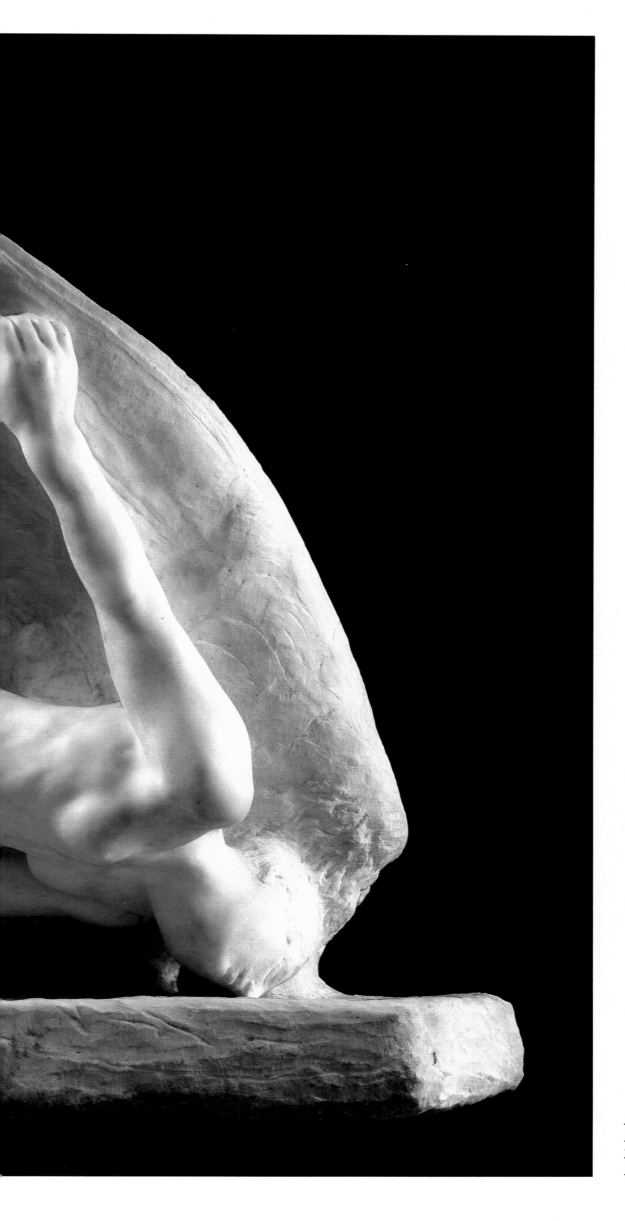

Illusion: Sister of Icarus, c. 1896
Marble
24⅜×37¾×20 inches (62×96×51 cm)
Musée Rodin, Paris S 1385

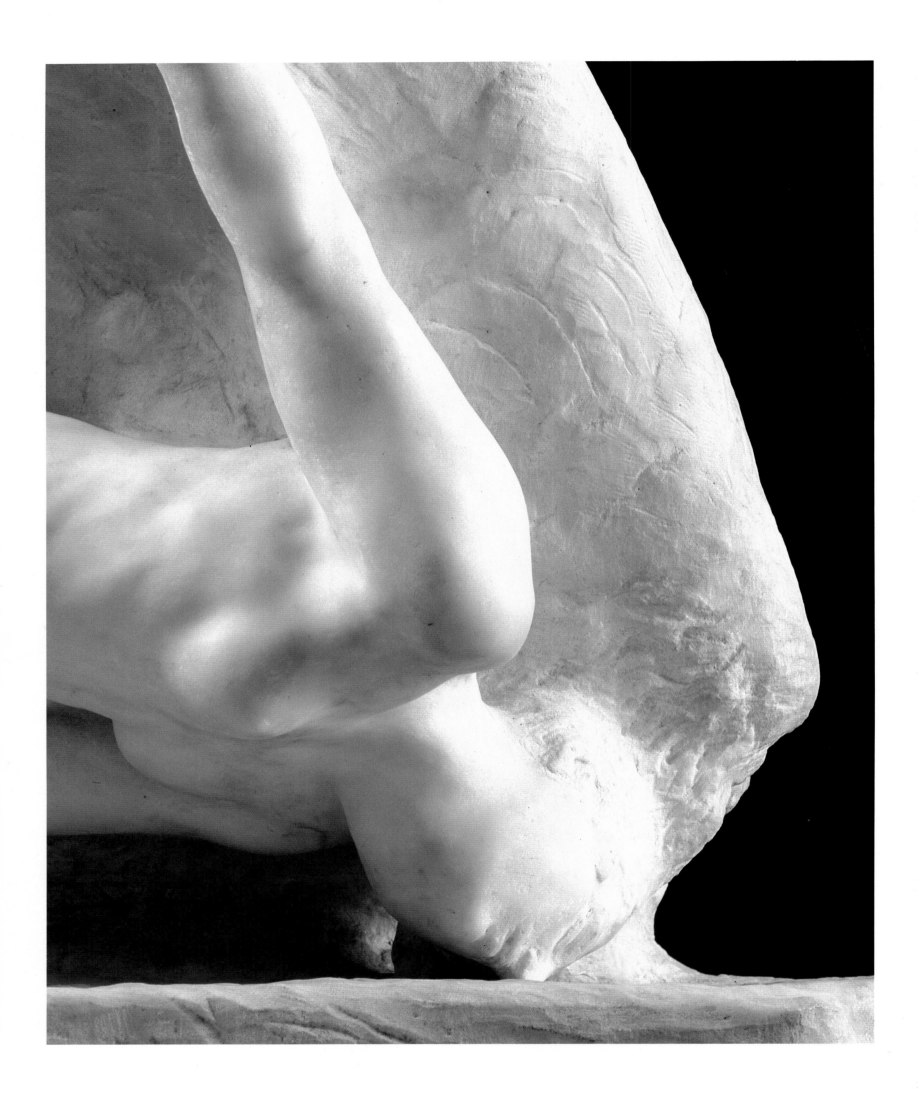

Above:
Illusion: Sister of Icarus (detail), 1896
Marble
24⅜×37¾×20 inches (62×96×51 cm)
Musée Rodin, Paris S 1385

98

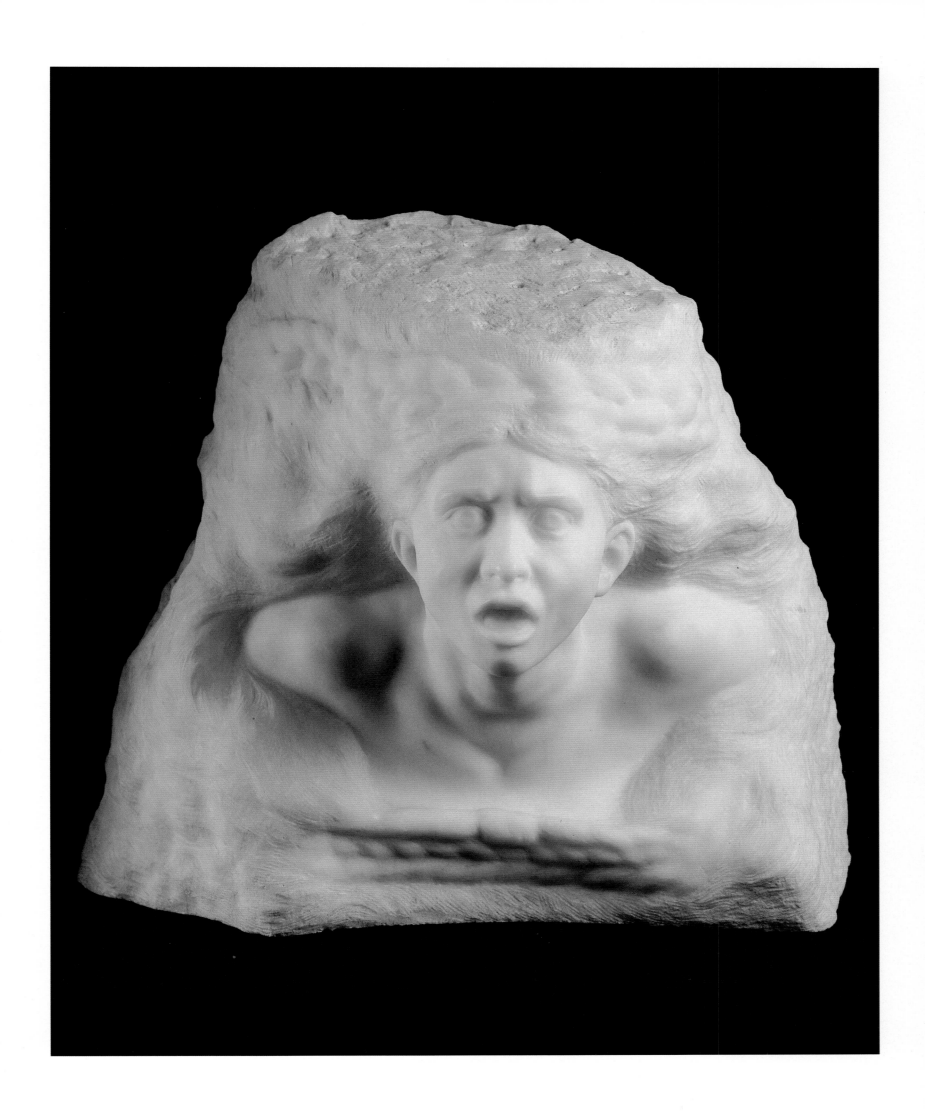

Above:
The Tempest, 1898
Marble
17½×19¾×11½ inches (44.3×50.3×29.3 cm)
Musée Rodin, Paris S 1092

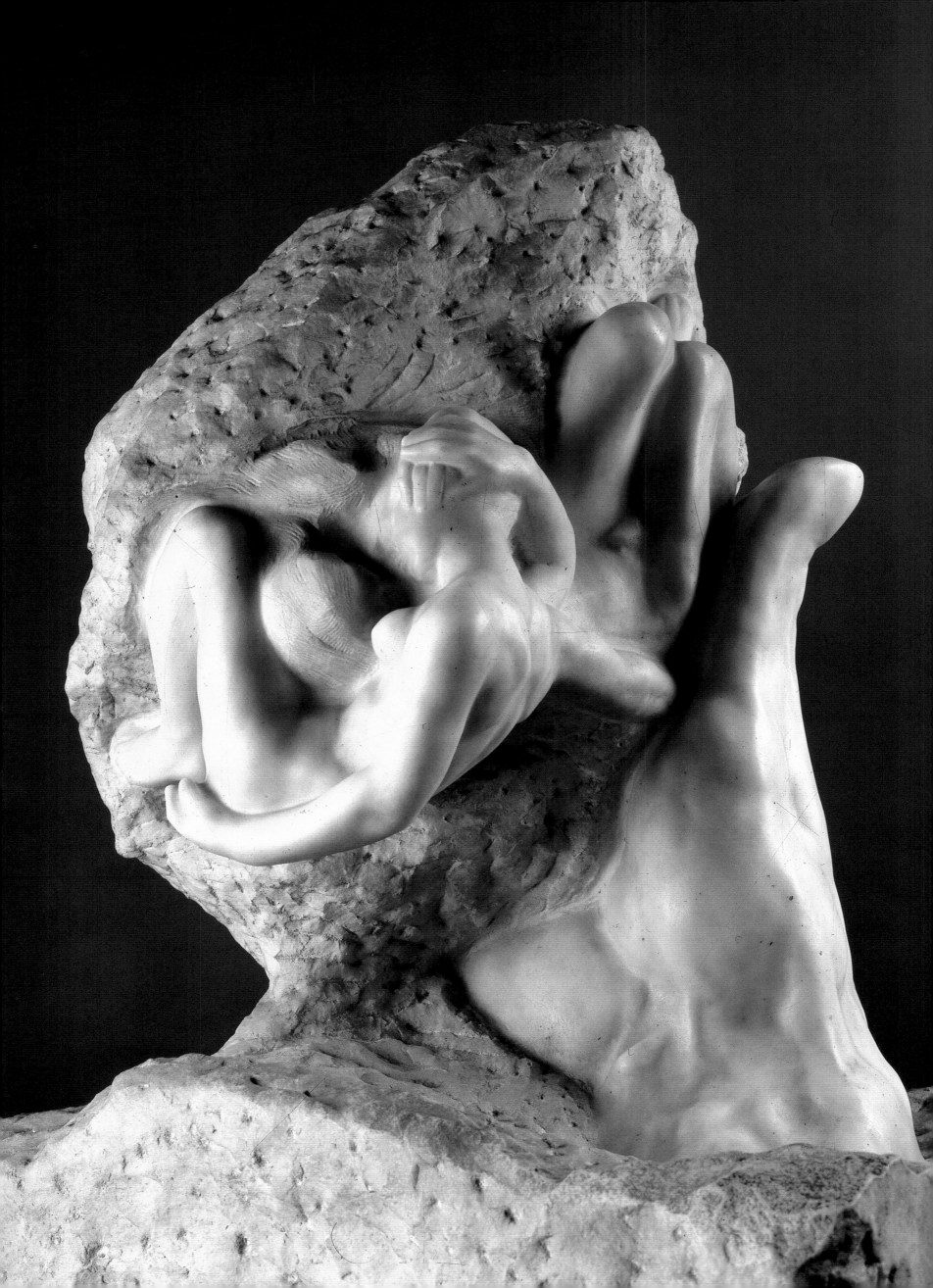

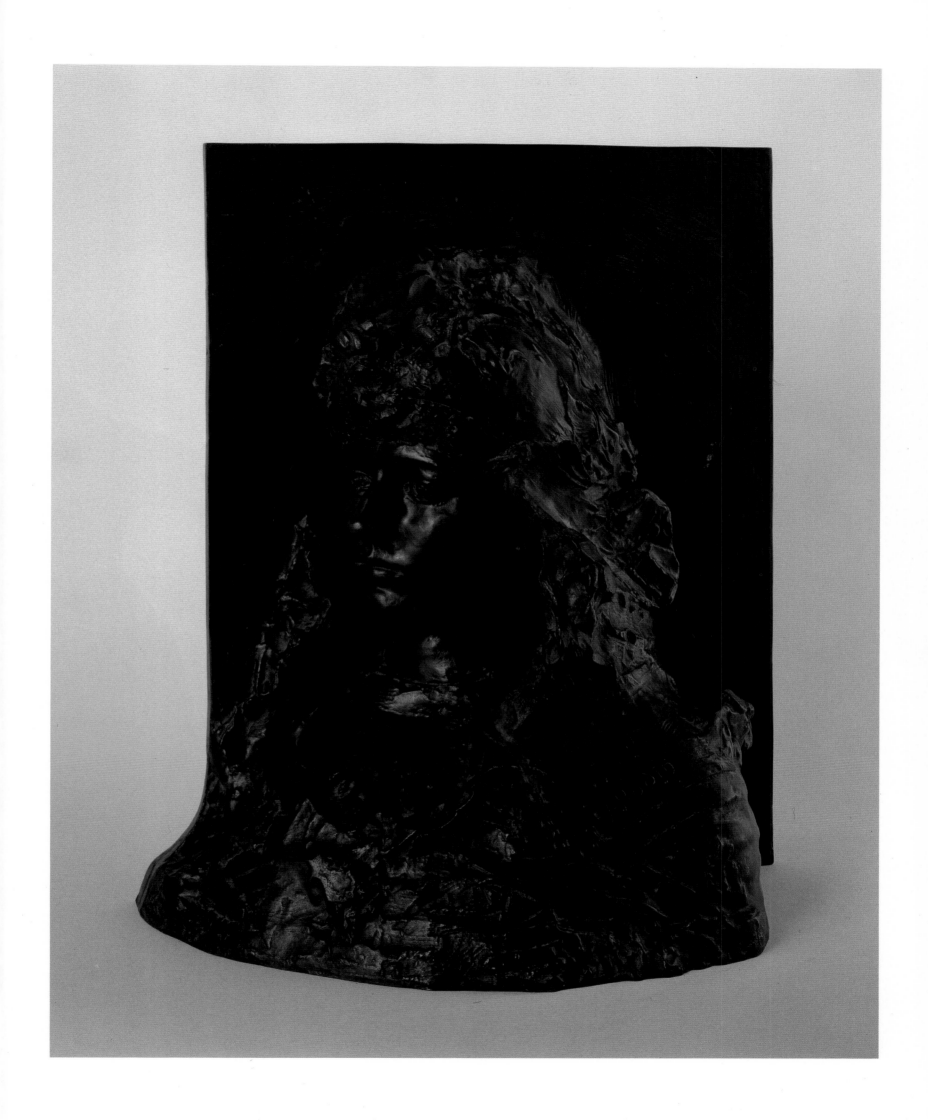

Left:
The Hand of God, 1898
Marble
37×32½×21⅝ inches (94×82.5×54.9 cm)
Musée Rodin, Paris S 988

Above:
France, 1904
Bronze
22½×16⅞×11⅜ inches (57×43×29 cm)
Musée Rodin, Paris S 490

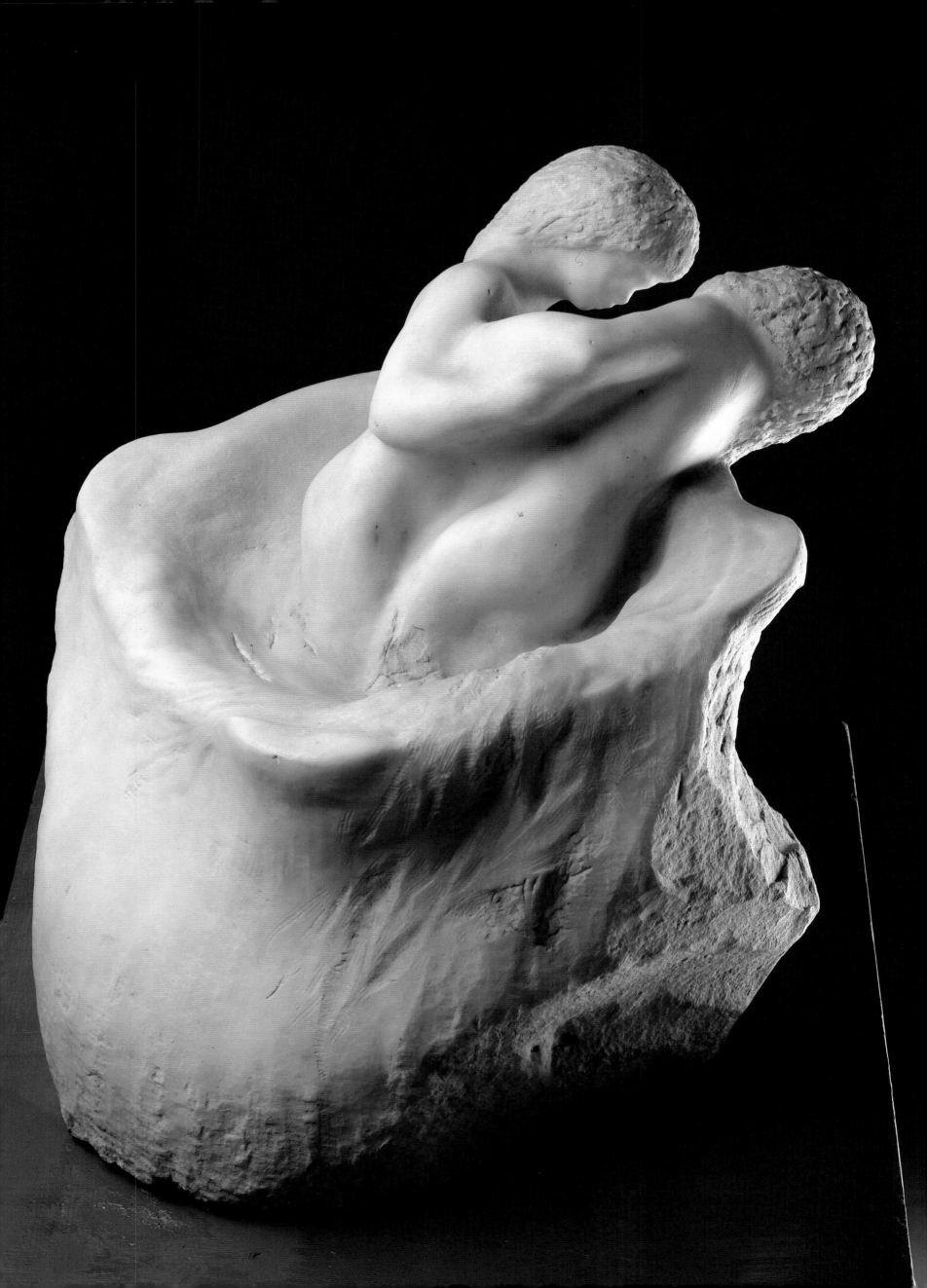

Left:
Flowers in a Vase, before 1907
Marble
19½×24¼×19⅞ inches
(49.5×61.5×50.5 cm)
Musée Rodin, Paris S 1418

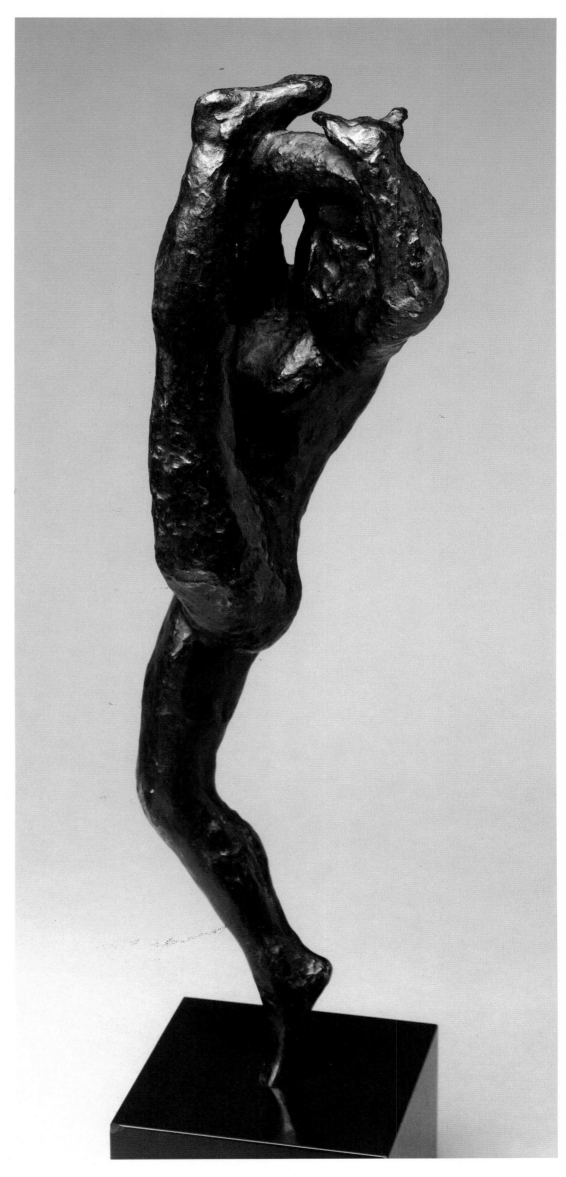

Right:
Dance Movement G, c. 1910-13
Bronze
Height: 15½ inches (39.4 cm)
The Metropolitan Museum of Art,
New York
The Gift of B Gerald Cantor Foundation,
1984

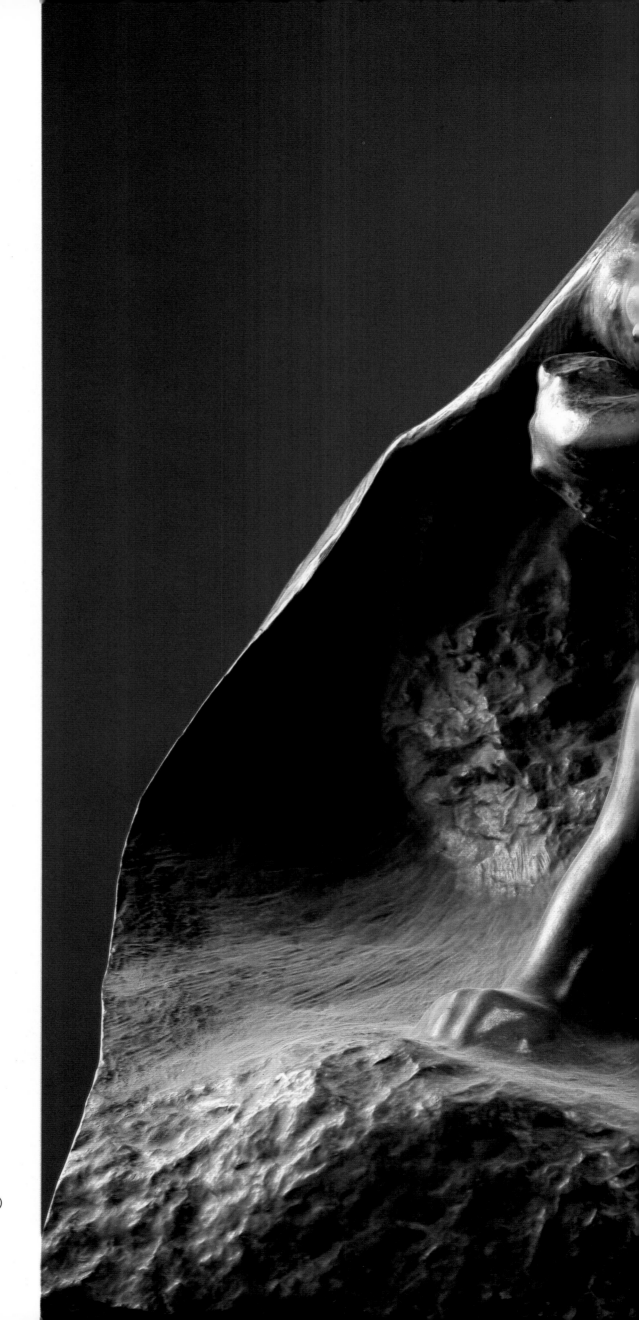

The Oceanides, before 1910
Bronze
19¼×33⅞×21⅝ inches (49×86×55 cm)
Musée Rodin, Paris S 590

104

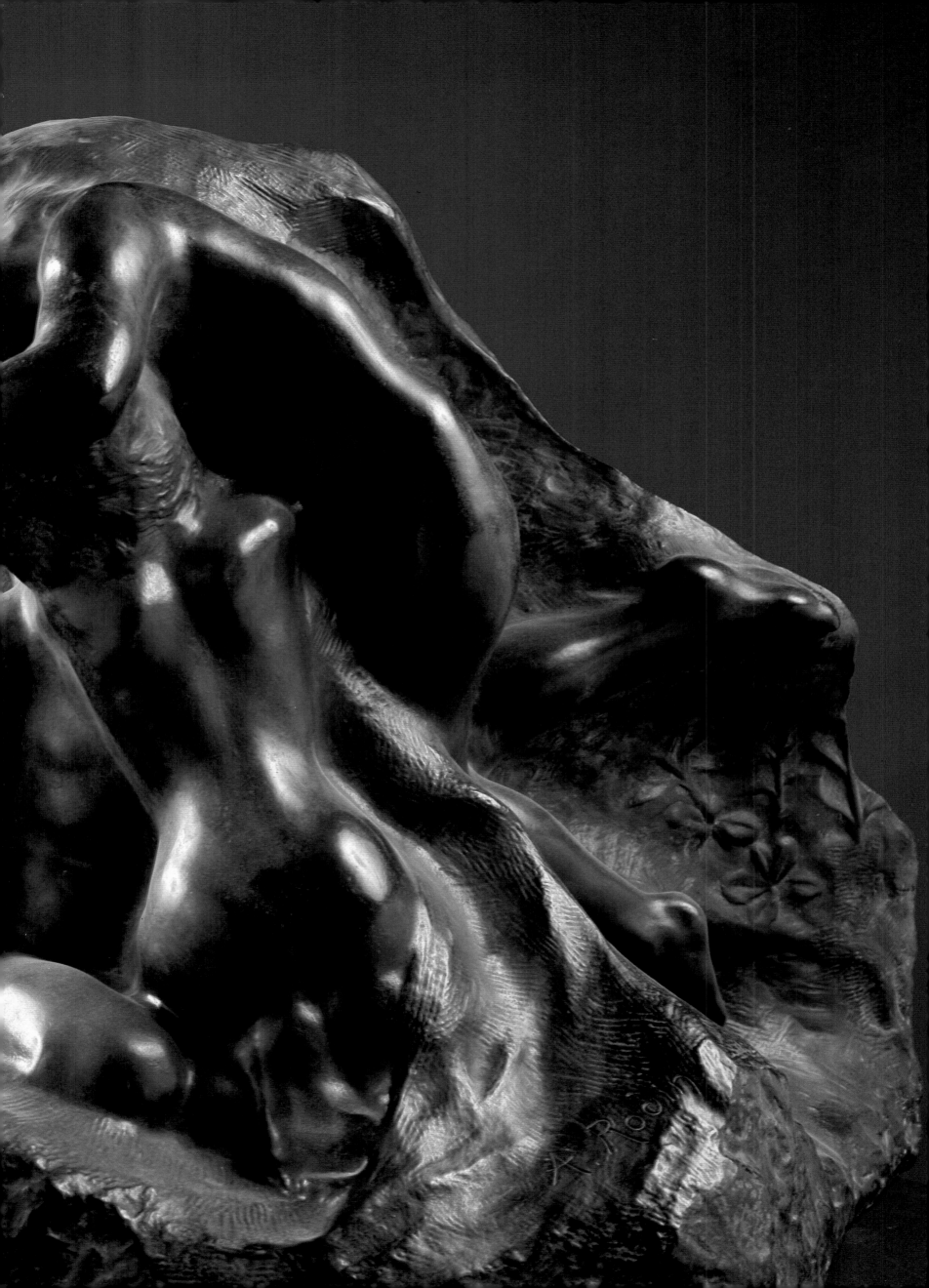

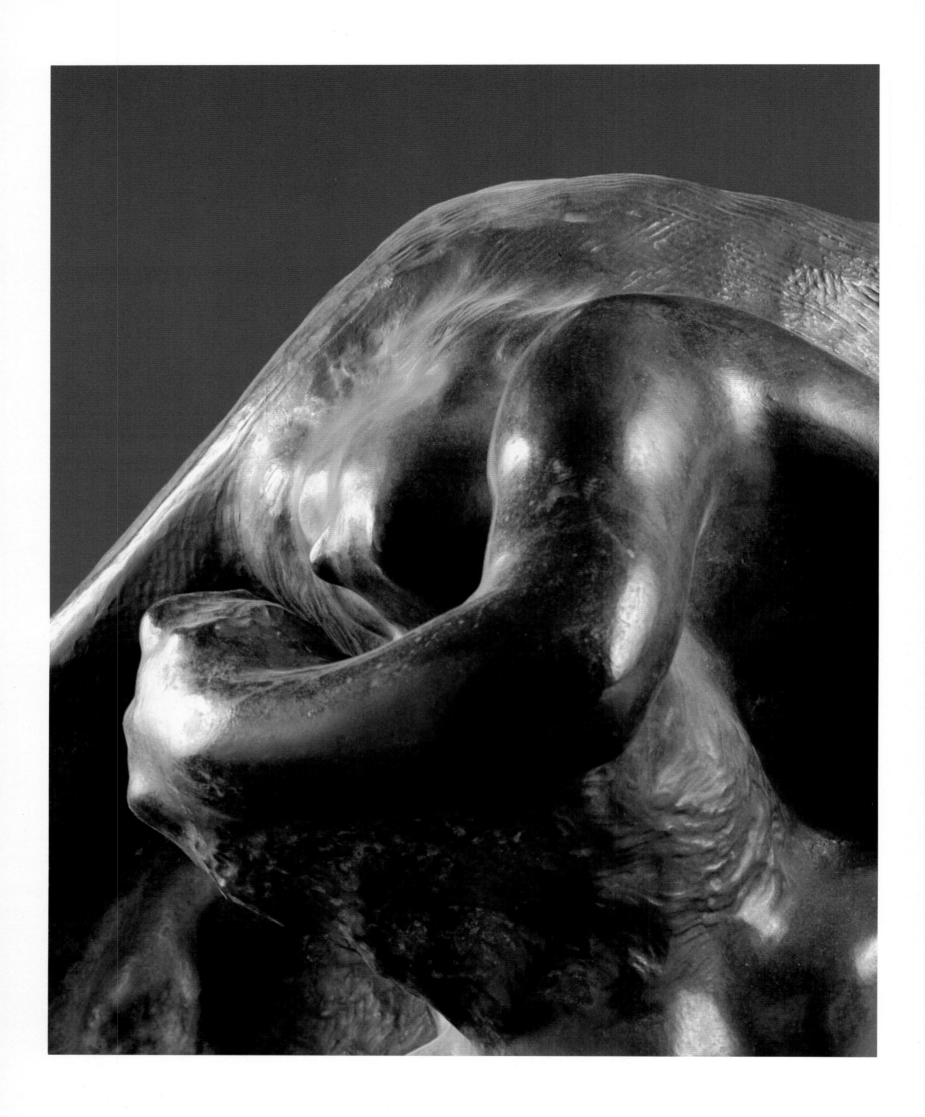

Above:
The Oceanides (detail), before 1910
Bronze
19¼×33⅞×21⅝ inches (49×86×55 cm)
Musée Rodin, Paris S 590

Right:
Gustav Mahler, 1909
Bronze
13⅜×9½×8⅝ inches (34×24×22 cm)
Musée Rodin, Paris S 812

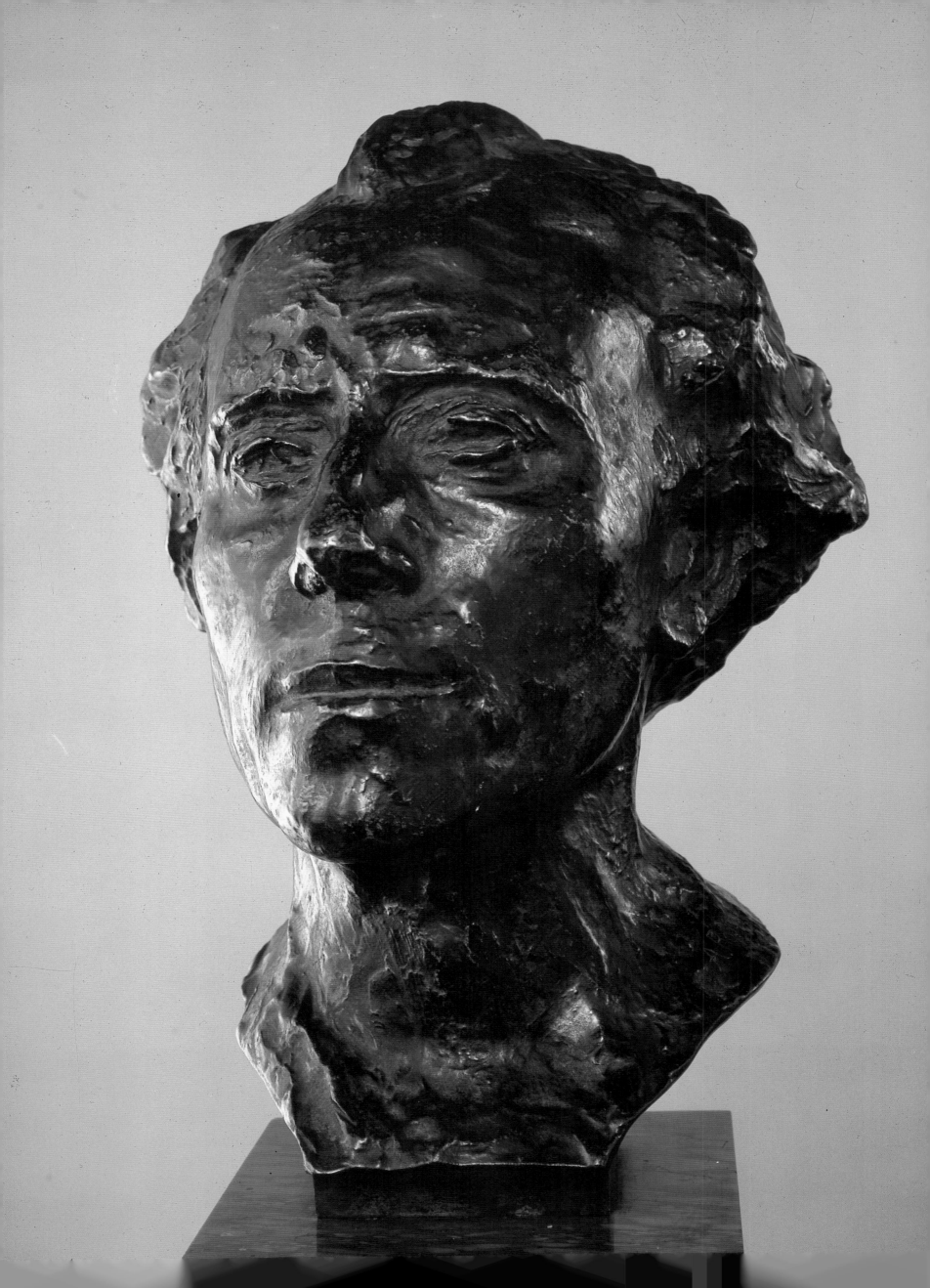

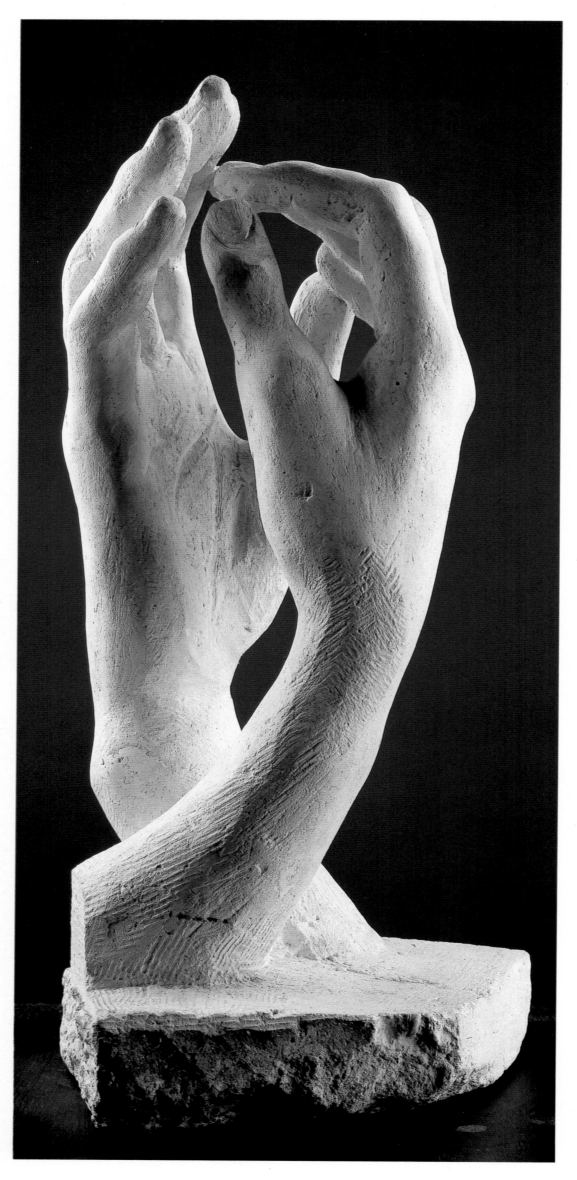

Left:
The Cathedral, 1908
Stone
25¼×12½×13¾ inches (64×31.8×35 cm)
Musée Rodin, Paris S 1001

Right:
Mask of Hanako, the Japanese Actress,
1908-11
Pâte de verre
8⅝×4¾×3½ inches (21.9×12×8.9 cm)
The Rodin Museum, Philadelphia
Museum of Art
Given by Jules Mastbaum

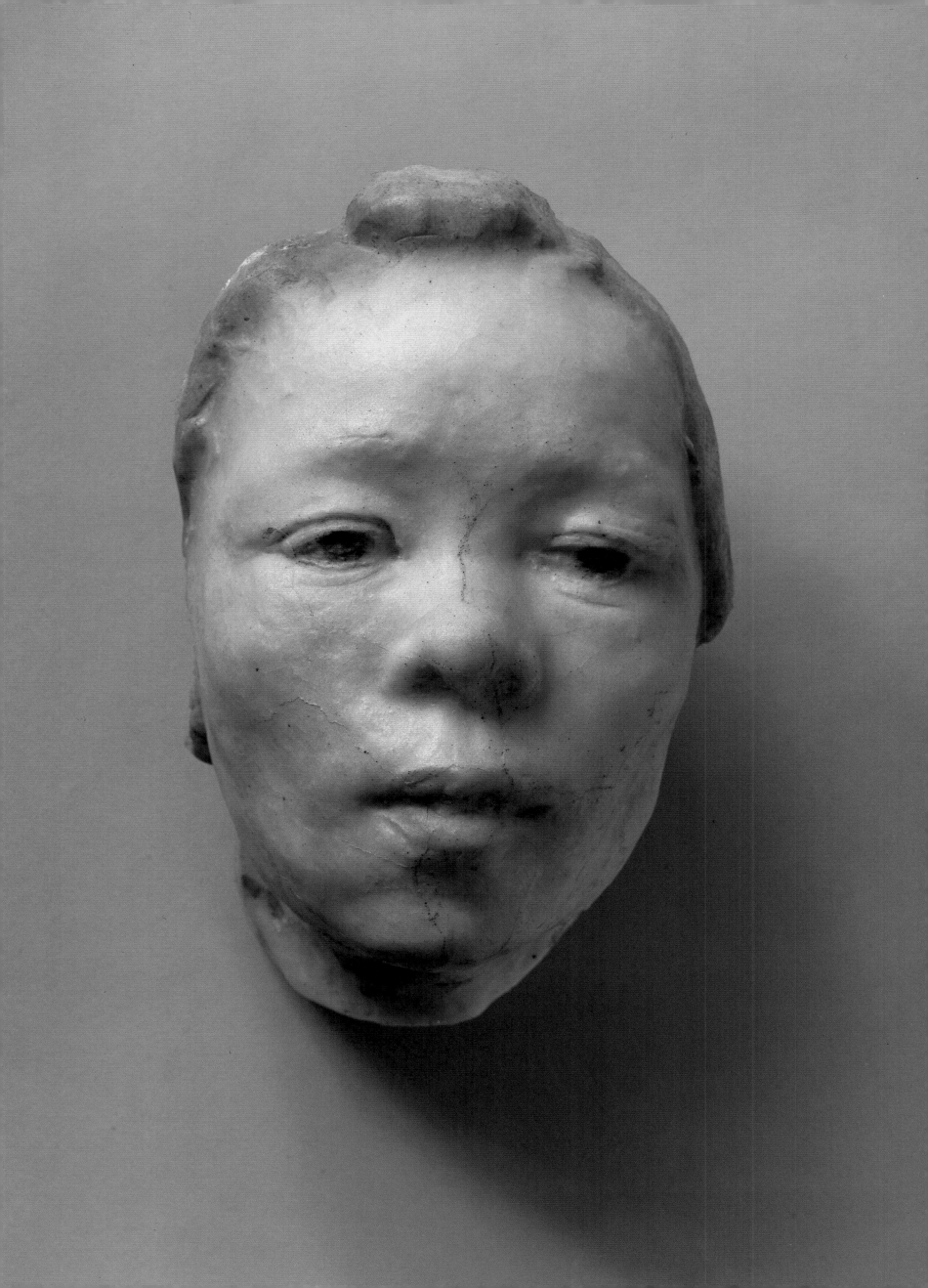

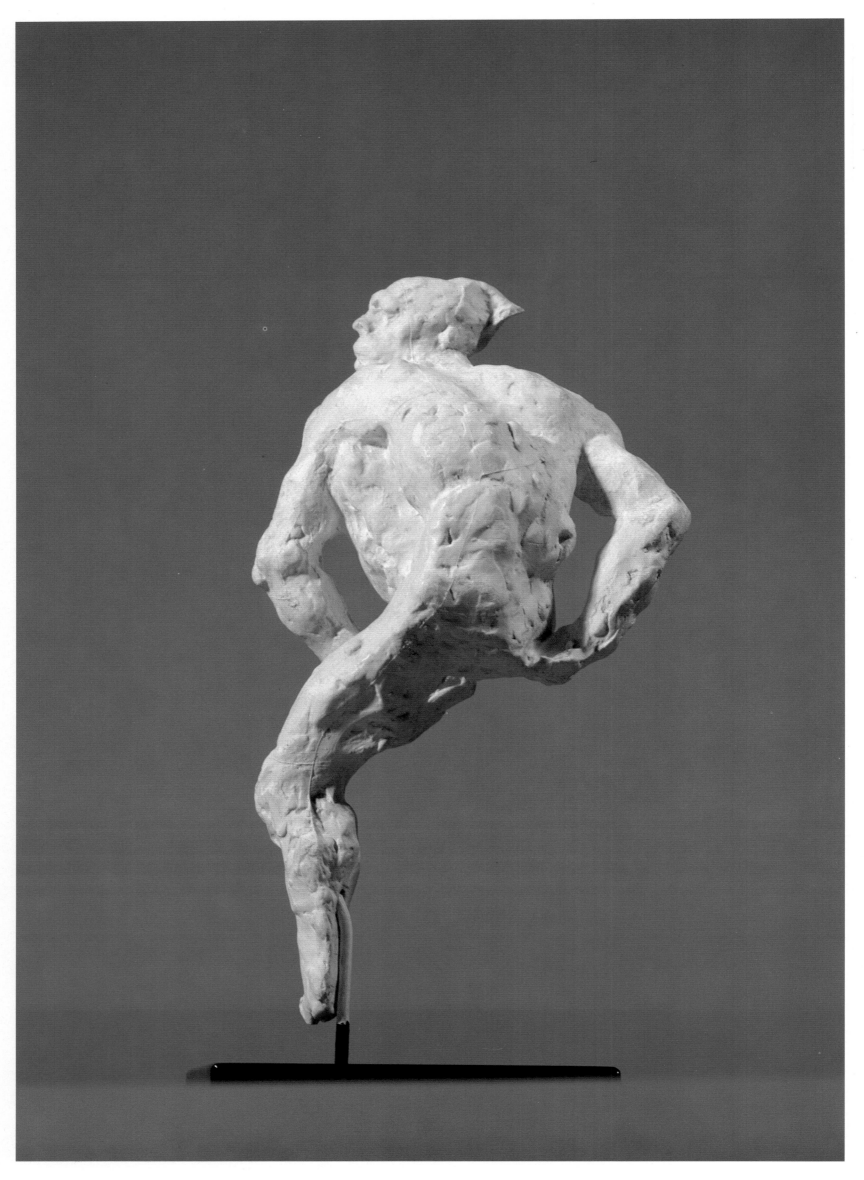

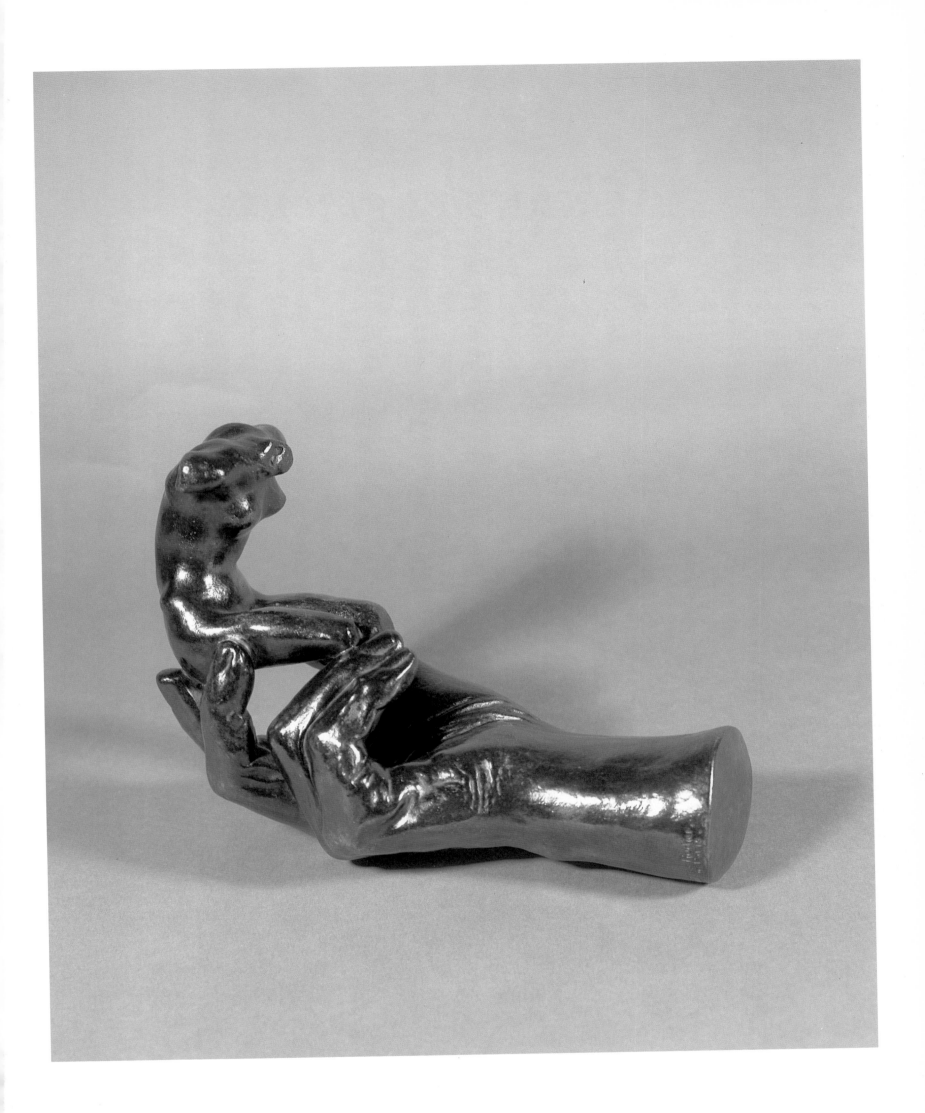

Left:
Nijinsky, 1912
Plaster
7½ × 3¾ × 3½ inches (19 × 9.5 × 9 cm)
B Gerald Cantor Collection, New York

Above:
Hand of Rodin with a Torso, 1917
Bronze
6⅛ × 8¾ × 4⅛ inches (15.2 × 22.2 × 10.5 cm)
B Gerald Cantor Collection, New York

Acknowledgments

The publisher would like to thank Martin Bristow who designed this book, Liz Montgomery, the picture researcher, and Aileen Reid, the editor. We would also like to thank the following institutions and agencies for supplying the illustrations:

The Art Institute of Chicago: pages 8, 23 (above left and below; all three the Alfred Stieglitz Collection)

The Bettman Archive: pages 6, 7, 9 (both), 10, 11, 12, 13 (right), 14, 16, 17, 20, 21, 22 (above and below right), 23 (above right)

The Iris and B Gerald Cantor Collection, New York: pages 22 (below left), 39, 66, 67, 110, 111 (all photographs by David Finn from the book *Rodin and his Contemporaries: The Iris and B Gerald Cantor Collection*)

Indianapolis Museum of Art: pages 60-61 (Gift of B Gerald Cantor)

Maryhill Museum of Art, Goldendale, Wa: page 34 (Gift of B Gerald Cantor Foundation)

The Metropolitan Museum of Art, New York/ Gift of the B Gerald Cantor Foundation, 1984: pages 40, 86, 103

The Metropolitan Museum of Art/Gift of Thomas F Ryan, 1910: page 88

Musée Rodin, Paris/Photo Denis Bernard: pages 26, 62-63, 64-65, 81

Musée Rodin, Paris/Photo Christian Bonnard: pages 35, 47, 87, 101

Musée Rodin, Paris/Photo Eric Emo: page 52

Musée Rodin, Paris/Photo Bruno Jarret/ ADAGP: pages 1, 2, 27, 30, 31, 32, 37, 38, 44, 45, 50, 51, 53, 54, 55, 56-57, 58, 59, 68, 69, 74, 77, 80, 82-83, 84, 85, 89, 92, 93, 94-95, 96-97, 98, 99, 100, 102, 104-105, 106, 107, 108

Musée Rodin, Paris/Photo Adam Rzepka/ ADAGP: pages 33, 36, 40, 41, 42, 43, 48-49, 70-71, 72-73, 75, 76, 78-79, 90, 91

New York Public Library: pages 18, 25 (both)

Philadelphia Museum of Art: pages 15, 26, 29, 109, (The Rodin Museum, Philadelphia; Gift of Jules E Mastbaum)

UPI/Bettman: pages 13 (left) 19

Wadsworth Atheneum, Hartford, Ct/Gift of Samuel P Avery: page 46